...isms
UNDERSTANDING ART

STEPHEN LITTLE

HERBERT PRESS · LONDON
an imprint of A&C Black

Contents

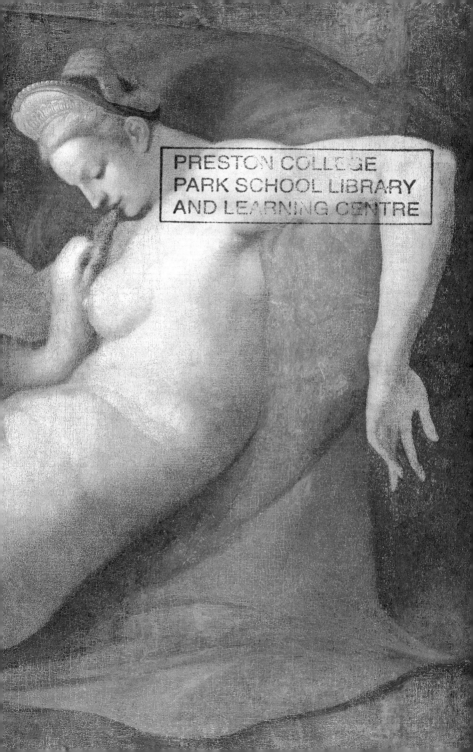

...isms

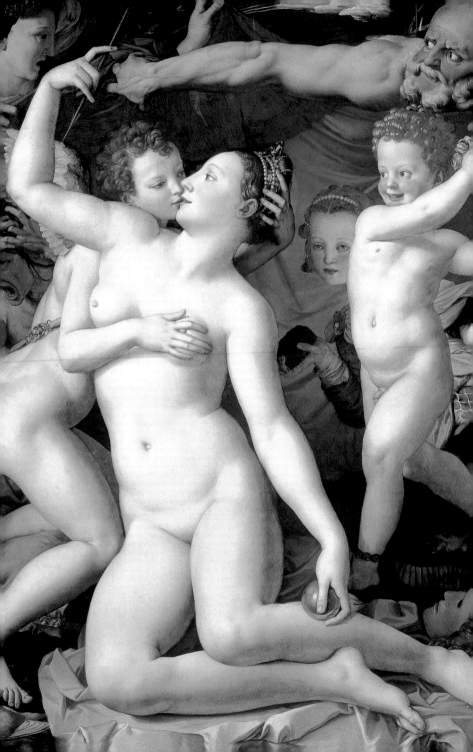

Introduction

This book is a helpful introduction to many of the 'isms' which have formed the history of Western art from the early Renaissance to the present day. It's not an exhaustive summary of all isms, but covers the most important. Four types of ism are defined below. Acquainting yourself with these definitions will make using this book more enjoyable – and give you an understanding of the ways in which art history is shaped and contested by artists, critics and historians. Some isms are defined by artists, some are identified retrospectively by historians, others encompass broad artistic trends and some are part of wider movements that extend through and beyond the arts into other areas of culture.

Before you begin to use *Isms* it is important to remember that some art and artists belong to more than one ism and some belong to none. Isms aren't always hard-and-fast categories, and within each ism there are sometimes developments, changes and disagreements which can constitute significant differences between artists gathered under the one ism. No definition of an ism can be definitive or final. For this reason, it is always valid to ask what a particular ism is and how an artist or art work relates (or does not relate) to that ism.

Sometimes, it is easier to define an ism by saying what it is not, or what it was reacting against, than by giving a simple definition of its central characteristics. Some isms are very defined, some are very vague, and thinking about isms necessitates that you become comfortable shifting between details and generalities, perhaps substituting questions for answers in the process. Some isms are defined as much by the questions they raise as by the answers they provide. Why did Cubists enjoy collage? One reason was that it enabled them to confuse the vertical surface of the art work with the horizontal surface of a tabletop – and there you have part of a helpful definition of Cubism: It plays with our perception (and misperception) of horizontal and vertical surfaces and makes use of collage to do so.

It wasn't until the 19th century that many artists began to gather themselves into self-defining isms, such as 'Impressionism' and 'Naturalism'. By the 20th century, and the advent of Modernism, most artists, at some point in their career, were actively involved in defining and shaping an ism as a specific artistic movement. This trend continues into the 21st century, but artists are now more reluctant to situate their work in relation to isms, fearing that isms too easily succumb to fashion.

Ism is a flexible guide to art history which will add to your knowledge and enjoyment. It is not intended to test your ability to label or identify art at 40 paces!

THE FOUR TYPES OF ISM

1 A TREND WITHIN THE VISUAL ARTS
e.g. Perspectivism, Illusionism

These isms are specific to the visual arts and constitute a broad trend affecting the work of many different artists. Perspectivism, for instance, features in the work of most Renaissance artists, but none of those artists would have described themselves as 'Perspectivists'. This type of ism identifies a trend in the visual arts so as to enable us to evaluate more easily its role and importance.

2 A BROAD CULTURAL TREND
e.g. Romanticism, Classicism

These isms affect the arts as part of their impact on culture in general and are the broadest of the four types of ism defined here. Some artists might identify with the ism, some do not, but the work of most artists can be discussed in relation to the ism because the ism is widely prevalent in the culture in general. Romanticism affected culture and politics in the 19th century. Some artists identified themselves as Romantics – or identified with Romantic values – and some did not, but Romanticism was so broad a cultural trend that most work from this period can be discussed in relation to it. For instance, we can ask: what is Romantic about the work of Delacroix? And we can also ask: why did Ingres resist Romanticism?

3 ARTIST-DEFINED MOVEMENT
e.g. Futurism, Suprematism

The 20th century was the high point of isms defined and promoted by artists themselves. These isms can be approached as relatively self-contained groups of artists sharing and defining common goals and values. Many, such as the Futurists, issued manifestos and made public statements about the importance or significance of their ism, its aspirations and sense of relation (or no relation) with the art of the past and the future. These are often the easiest isms to discuss and define accurately.

4 RETROSPECTIVELY APPLIED LABEL
e.g. Mannerism, Post-Impressionism

Some isms are defined by critics or historians and their meaning or applicability is often contested. The term 'Mannerism' was invented, not by 'Mannerist' artists themselves, but by artists hostile to their work. Art historians explore the evolution of these terms. Many of them, like Mannerism, begin life as pejorative and derogatory, and become established terms of reference for the art of particular periods. Even so, what is meant by 'Mannerism' is still debated and contested, and the history of the meaning of 'Mannerism' is as much a part of art history as Mannerist art itself.

Usually, art historians apply such terms to identify common elements in the work of different artists. Post-Impressionism was coined by Roger Fry in an effort to draw attention to a common spirit in the work of artists as diverse as Gauguin and Delaunay.

BCT Symbols are used to distinguish between the four different types of ism outlined in this introduction. This means you can tell at a glance whether an ism is a broad cultural trend **BCT**, a trend within the visual arts **TVA**, an artist defined movement **ADM** or one which has been defined by later critics and historians, that is, a retrospectively applied label **RAL**.

INTRODUCTION
The first section of each ism is a brief introduction to the ism, giving a succinct summary of its main features.

KEY ARTISTS
This is a list of the most important artists related to the ism. If you explored the work of the key artists you would acquire a comprehensive knowledge of the ism.

KEY WORDS
These words sum up the key concepts, styles or issues relating to the ism. The key words provide a map of associations which will enable you to quickly chart an ism and enable easier recollection of it.

MAIN DEFINITION
The main definition explores the ism in more depth than the brief introduction, explaining the significance of the ism, its history and the ideas, methods or stylistic features which distinguish it from, or relate it to, other isms.

KEY WORKS
Each ism is illustrated with one or two key works selected from one of the world's leading museums. The key works

24 Monumentalism **TVA**

Monumental art is defined by its physical scale, the breadth of its subject matter and its ambition to be of lasting significance. During the Renaissance, powerful patrons encouraged the development of monumental art, a trend which continued into the Baroque era.

LEON BATTISTA ALBERTI (1404–72); DONATO BRAMANTE (c. 1444–1514); FILIPPO BRUNELLESCHI (1377–1446); LORENZO GHIBERTI (1378–1455); GIORGIO DA CASTELFRANCO called GIORGIONE (1477–1510); HUGO VAN DER GOES (c. 1440–82); ANDREA MANTEGNA (c. 1430–1506); MICHELANGELO BUONARROTI (1475–1564); RAFFAELLO SANZIO called RAPHAEL (1483–1520); JACOPO ROBUSTI called TINTORETTO (c. 1518–94)

political ambition; grandeur; intellectual synthesis; Olympian

Pope Julius II, who sat on the Papal throne from 1503 to 1513, initiated the monumentalism of the High Renaissance when he commissioned the architect Bramante to rebuild St Peter's in Rome. The politically ambitious pope instructed Bramante to design and build something which would dwarf all the most significant monumental buildings of the ancient world, including the Parthenon and the Basilica of Constantine.

Bramante's original design for St Peter's (1506) was entirely symmetrical and envisaged four identical facades. He died in 1514 and the building was still under construction in 1546 when Michelangelo took charge of the project. St Peter's was still incomplete when, in turn, Michelangelo died in 1564. The dome which he designed was not finished until 1590.

Michelangelo also excelled in monumental painting and sculpture. His frescoes in the Sistine Chapel feature hundreds of nudes arranged into an epic narrative of man's creation, fall, redemption and judgement. His giant figures all have heroically muscular bodies. Michelangelo's *David*, the first monumental Renaissance sculpture, measures four metres high and was commissioned as a symbol of the Florentine Republic.

KEY WORKS in Rome

• *The Last Judgement*, 1534–41, MICHELANGELO BUONARROTI, The Sistine Chapel, St Peter's, Rome
The Last Judgement is monumental in scale, as are the Olympically-proportioned figures who throng around Christ, but it is also an enormous intellectual achievement, synthesising Christian theology with Classical mythology. Christ in judgement dominates the top of the fresco while at the bottom right, Charon, a figure from Classical mythology, ferries souls across the river Styx to Hades, the world of the dead.

• *Fragments of the Statue of Constantine*, Palazzo dei Conservatori, Campidoglio, Rome
Michelangelo modelled the Campidoglio into one of the most important urban environments created during the Renaissance. The public square gives the impression of a city governed by order and grandeur, but the monumental scale of the Campidoglio asserts, more than Rome's power, Michelangelo intended it to synthesise natural, spiritual and political authority. as such, it became the perfect home for fragments of a monumental statue of Constantine.

OTHER WORKS in Rome

St Peter's, Rome, 1506–1590, BRAMANTE and MICHELANGELO

The Creation of Adam, 1508–12, MICHELANGELO, Sistine Chapel, the Vatican, Rome

The Fall of Man, 1508–12, MICHELANGELO, Sistine Chapel, the Vatican, Rome

Moses, c. 1513–15, Tomb of Julius II, MICHELANGELO, St Peter's, Rome

Classicism; Secularism; Absolutism

Rococo; Medievalism; Pre-Raphaelitism; Aestheticism; Secessionism; Modernism; Post-Modernism

Monumentalism 25

have been chosen because they best exemplify the features of the ism which are discussed in the introduction, key words and main definition.

OTHER WORKS

This list is a supplement to the Key Works. All the Other Works are good examples of the ism which they have been chosen to illustrate. They are also to be found in the same museum as the illustrated Key Work(s). This will enable you to explore an ism in more detail during your gallery or museum visit.

⊚ SEE ALSO

Isms are often inter-related with each other. Those listed under See Also share an affinity, idea or method with the ism under discussion…

⊖ DON'T SEE

… And Isms are often antithetical to each other! Or predicated on mutually exclusive, and incompatible, assumptions, methods or ideas. The isms listed under Don't See are, in some way, out of tune with the ism which has just been discussed.

Other resources included in this book
LIST OF ARTISTS

Artists who have been identified as Key Artists are gathered in this alphabetical list for ease of reference. The List of Artists also includes dates of birth and death, where known and where relevant, as well the ism or isms with which the artist is most closely identified.

GLOSSARY

This contains technical terms which have been used in definitions of isms (i.e. foreshortening) as well as a general selection of terms that you are likely to come across as you tour museums and galleries but which haven't necessarily been used in any of the definitions (i.e. lithography).

TIMELINE

The timeline shows the lifespan of all the isms covered in the book. You will notice that the isms which are broad cultural trends, or broad trends within the visual arts, tend to be of longer duration than isms defined by artists, critics or historians. Isms defined by artists are the easiest to date because of the availability of historical evidence and the active role which artists, particularly Modernists, have taken in announcing the beginning or the demise of movements which they have help shape. Isms defined by critics or historians are sometimes less easy to date. Often, the period covered by an ism is among the features of the ism which are contested by critics and historians. Usually however, there is a general consensus about rough times (i.e. not necessarily 1894, but definitely by the end of that decade). In such cases, the timeline has followed the general consensus. Broad trends, both in culture and the visual arts, are the most difficult to date as they are the most likely to figure in the work of successive generations of artists.

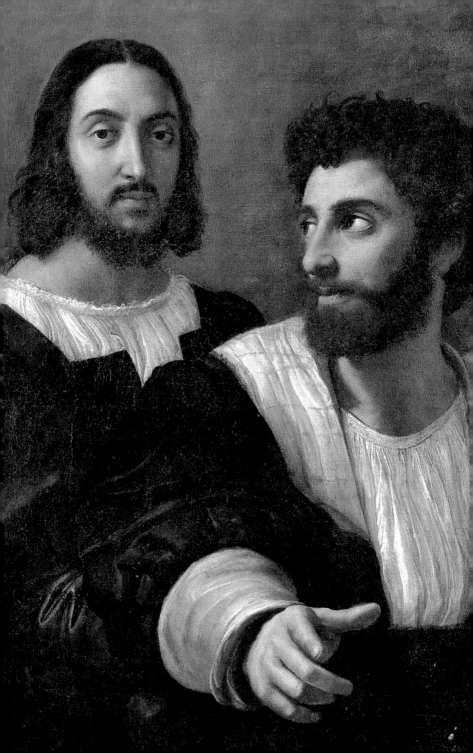

I

RENAISSANCE

Renaissance

Renaissance means 'rebirth' and refers to a period in the development of Western art and culture beginning in 1300 and ending in 1600. It was a time of rediscovery, ambition and change, dominated by a number of trends and contradictions. It is usually associated with Italy, in particular Florence, Venice and Rome, but Northern Europe also contributed to the Renaissance, particularly in the development of Naturalism.

order; symmetry; perspective; Classical; space; movement

The Renaissance witnessed a 'rebirth' of interest in the Classical past in which individuals, rather than academic institutions, took the lead. The study of ancient Greece and Rome was central to Renaissance Humanism. This is a broad, philosophical trend in which questions about human relationships (social, religious and political) are answered by the use of reason and reflection on experience, rather than by reference to spiritual authorities. The central, immensely ambitious, and ultimately self-contradictory project of the Renaissance was the synthesis of Classical, or Humanist, values with Christianity. Giorgio Vasari, author of the *Lives of the Most Excellent Italian Artists, Painters and Sculptors* (1550 and 1568) thought that Renaissance artists had excelled the Classical past because they had achieved this union.

Humanism was a driving force behind the emergence of Classical subject matter in Renaissance art, most notably the gods and heroes of pagan mythology and history, as well as the revival of Classical architecture with its rational principles of design and its emphasis on symmetry and proportion. Accurate representations of nature also became more important during the Renaissance. Artists were determined to master systematic methods of representing the world, the most obvious example of which was 'linear perspective'.

KEY WORKS in the Uffizi, Florence

→ *Madonna and Child (Madonna of the Caves)*, c.1446, ANDREA MANTEGNA
Like many other Renaissance artists, Mantegna was heavily influenced by Classical sculpture. His Christ Child has incredible physical solidity. Mantegna situates his Madonna and Child in an ordinary Italian landscape. This emphasises their common humanity. Only the Madonna's halo distinguishes her from ordinary women.

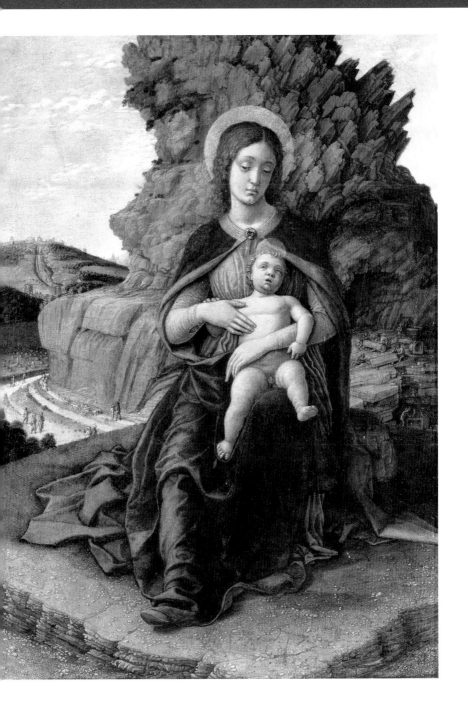

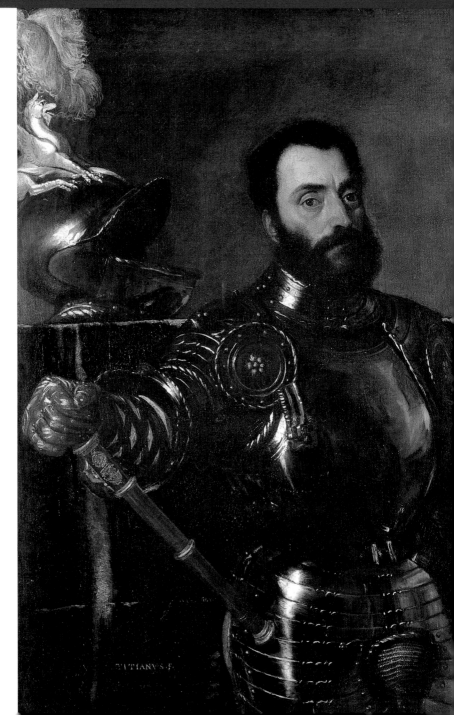

As Renaissance artists competed with each other in determined attempts to surpass the art of the ancient world, their status changed, raising them above craftsmen and artisans. Artists' individual talents, innovations and ideas began to acquire greater cultural importance. It is no wonder, then, that the Renaissance is associated with artistic genius. But behind such a figure as Leonardo da Vinci lay the political ambitions of successive popes (who hoped to unify Italy against the threat of French conquest and re-establish Rome as a centre of power) and important patrons. Meanwhile, Classical theories about the nature of the state fed a new-found confidence in the expression and consolidation of secular power.

← *Francesco Maria della Rovere*, 1536–8, TITIAN
During the Renaissance, artists like Titian achieved new levels of naturalistic detail. Armour begins to gleam with reflected light as Renaissance artists capture the effects of light and shadow on different surfaces. Titian's portrait is rich in such naturalistic effect. It is also a strong statement of secular power and authority.

OTHER WORKS in the Uffizi, Florence

Madonna and Child with Two Angels, c.1464, **FRA FILIPPO LIPPI**

Primavera, 1477–80, **SANDRO BOTTICELLI**

Pieta, 1493–4, PIETRO VANNUCCI called **PERUGINO**

The Baptism of Christ, c. 1475, **ANDREA VERROCCHIO** and **LEONARDO DA VINCI**

The Holy Family (The Doni Tondo), 1504, **MICHELANGELO BUONARROTI**

Madonna and Child with Young Saint John (Madonna del Cardellino), 1505–6, RAFFAELLO SANZIO called **RAPHAEL**

Usually known as International Gothic, this was an elegant variant of Gothic art which was current in Western Europe between c.1375 and c.1425. Both are characterised by their emphasis on decoration, pattern and colour.

FRA ANGELICO (c1400–1455); **JACOPO DI CIONE** (1362–c.1398); **GENTILE DE FABRIANO** (c.1385–1427); **LIMBOURG BROTHERS** (all dead by c.1416); **LORENZO MONACO** (c.1370–c.1423); **GIOVANNI DEI GRASSI** (rec. 1389–98); ANTONIO PISANO, called **PISANELLO** (c.1395–1455); **GIOVANNI DAL PONTE** (c.1385–c. 1440)

courtly; idealised; ceremonial; divine

International Gothic developed from a more general Gothic style with which it shares certain similarities. Lacking a coherent theory of perspective, figures and objects in Gothic art are usually arranged for decorative effect rather than to give the impression that they inhabit 'real' space. Distortions of size and scale are common in all forms of Gothic art. The most typical feature is the tendency to give central figures, such as kings, queens, Christ or the Virgin Mary, larger bodies than other, less important figures.

International Gothic developed alongside the Renaissance and included work by some early Renaissance artists such as Fra Angelico. It has been described as 'self-conscious' and unfairly characterised as conservative and backward-looking in comparison to the art of the Renaissance. At its best, the International Gothic style combines decorative design, rich colour and poetic detail, often with lavish use of gilding. Its subject matter is usually religious and tends to focus on heavenly splendour and the meeting of earthly and divine courts. Its secular subject matter was generally idealised, or stereotypical, focusing on courtly activities such as hunting or the reading of illuminated books.

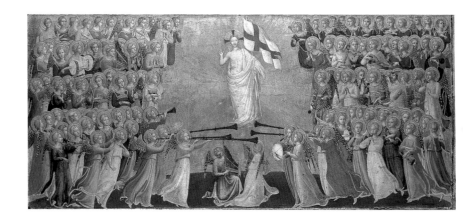

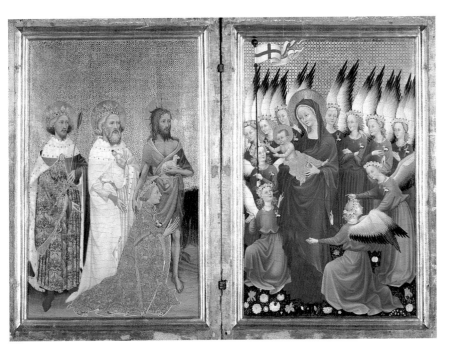

KEY WORKS in the National Gallery, London

▲ *The Wilton Diptych: Richard II presented to the Virgin and Child by his Patron Saint John the Baptist and Saints Edward and Edmund*, c.1395–9, ENGLISH OR FRENCH SCHOOL
The artist who created this portable altarpiece for King Richard II of England could have been English, French or Italian. hence the 'internationalism' of International Gothic. Extravagant use of gold leaf made this a suitable object for the private devotions of a King. Richard is shown with two former Kings, Edward and Edmund, who were both revered as Saints. The Diptych represents the ceremonial presentation of the King of England to the King of Heaven. Typically, the figures are arranged for decorative effect with little sense of spatial depth.

◄ *Christ Glorified in the Court of Heaven*, c.1423–4, FRA ANGELICO
This altar-piece panel for the Church of San Domenico in Fiesole, Italy, shows a crowded scene of celestial celebration in which the brightly coloured clothes of saints and angels contrast beautifully with Fra Angelico's extensive use of gold leaf.

OTHER WORKS
in the National Gallery, London

The Crucifixion, c.1368–70 JACOPO DI CIONE

The Madonna and Child with Angels (The Quaratesi Madonna), 1425, GENTILE DA FABRIANO

The Coronation of the Virgin with Saints, 1407–9, LORENZO MONACO

The Ascension of Saint John the Evangelist, with Saints, c.1410–20 GIOVANNI DAL PONTE

 Naturalism; Medievalism; Pre-Raphaelitism

 Perspectivism; Illusionism; Humanism; Classicism; Secularism

Classicism

Many Renaissance artists associated the Middle Ages with cultural decline and distanced themselves from it. Instead, they studied the arts of ancient Greece and Rome whose achievements they aspired not only to emulate but to surpass. In this, they were typical of a general fascination with the values of classical Greece and Rome.

LEON BATTISTA ALBERTI (1404–72); SANDRO BOTTICELLI (c.1445–1510); DONATO BRAMANTE (c.1444–1514); FILIPPO BRUNELLESCHI (1377–1446); DONATO DI BETTO BARDI, called DONATELLO (c.1386–1466); ANDREA MANTEGNA (c.1430–1506); TOMMASO GUIDI called MASACCIO (1401–28); MICHELANGELO BUONARROTI (1475–1564); RAFFAELLO SANZIO, called RAPHAEL (1483–1520); PIETRO VANUCCI called PERUGINO (c.1450–1523); TIZIANO VECELLIO, called TITIAN (c.1485–1576)

ratio; symmetry; proportion; synthesis; myth; scholarship

The influence of the Classical past made itself felt in all areas of the arts. Whether in architecture, sculpture or painting, Renaissance artists aspired to create works which were unified by the coherent principles of design which they discerned in Classical art and architecture. Renaissance Classicism is also characterised by a revival of Classical subject matter drawn from Classical mythology and history.

In painting, Masaccio revolutionised the representation of space through consistent use of perspective. He did more than borrow Classical motifs; he made a conscious effort to work on the basis of Classical principles.

Donatello made a similar contribution to sculpture. His *David* was the first free-standing male nude created since antiquity. Contemporaries praised it for its lifelikeness and its forceful sense of movement,

although there is some dispute about which Classical myth it actually represents. Some think it is Mercury carrying the head of Argus.

The most dramatic break with the medieval past was initially made by Renaissance architects, notably Brunelleschi and Alberti, who abandoned Gothic architecture and re-established a Classical architectural vocabulary. They studied Italy's many surviving Classical buildings and revived the principles of their construction – rather than just imitating features of their style. Brunelleschi and Alberti designed their buildings on the basis of mathematical ratios with the aim of achieving a symmetrical, unified design. Many of their buildings were directly inspired by, or modelled on, Classical buildings. Bramante's Tempietto in Rome (1502–11) was modelled on the Roman Temple of Hercules Victor.

Another architect, Sebastiano Serlio, codified the principles of Classical architecture so comprehensively that his work defined the standards of Classical architecture for generations of architects.

Bramante and Alberti helped revive the Classical belief that nature (of which man is the highest expression) is governed by rational laws which we can understand and apply to our own creations.

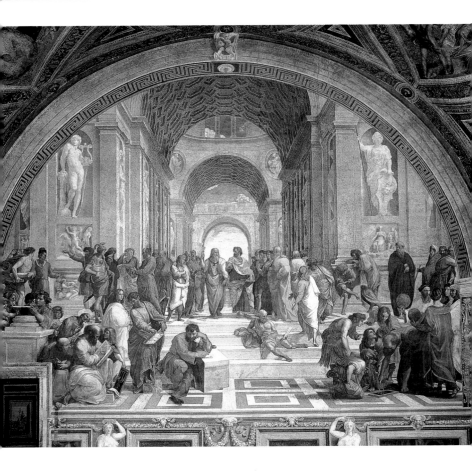

KEY WORKS in the Vatican, Rome

 The School of Athens, 1510–11, Stanza della
Segnatura, RAFFAELLO SANZIO called **RAPHAEL**
Raphael decorated this room with a representation
of the School of Athens, which was founded by the
Classical philosophers Plato and Aristotle and closed
by the Church in AD 529. The School of Athens was
the most important centre of philosophy in the Classical
world. Raphael's work is a highly complex synthesis
of Classical philosophy and Christian theology and it is
considered to be one of his greatest masterpieces. Plato
and Aristotle are in the centre of the painting, flanked
on either side by statues of Apollo and Athena. The
building, Classical in its architecture and represented
in perfect perspective, is actually a painterly rendition
of the new St Peter's.

OTHER WORKS in Rome

Delivery of the Keys, 1482, **PERUGINO**, Sistine Chapel,
the Vatican, Rome

The Tempietto, 1502–11, **DONATO BRAMANTE**,
St Peter's, Rome

Galatea, 1513, **RAPHAEL**, Villa Farnese, Rome

Equestrian Statue of Marcus Aurelius, 161–80 AD,
Piazza del Campidoglio, Rome

 Naturalism; Perspectivism; Illusionism;
Secularism; Humanism; Monumentalism;
Academicism; Neo-Classicism; Cubism

International Gothicism; Dadaism; Surrealism

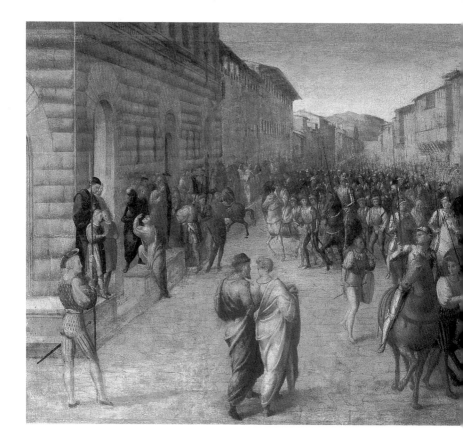

Secularism is a general tendency to discuss human relationships – private and public – independently of religious values, customs and institutions. During the Renaissance the amount of art influenced by, or exploring, secular themes increased. Secularism also includes subjects, figures and principles drawn from Classical (or pagan) myth and history.

LEON BATTISTA ALBERTI (1404–72); GIOVANNI ANTONIO BOLTRAFFIO (c.1467–1516); SANDRO BOTTICELLI (c.1445–1510); DONATO BRAMANTE (c.1444–1514); FILIPPO BRUNELLESCHI (1377–1446); VITTORE CARPACCIO (c.1463–c.1526); DONATO DI BETTO BARDI called DONATELLO (c.1386–1466); GIORGIO DA' CASTELFRANCO called GIORGIONE (c.1477–1510); LEONARDO DA VINCI (1452–1519); ANDREA MANTEGNA (c.1430–1506); MICHELANGELO BUONARROTI (1475–1564); SEBASTIANO DEL PIOMBO (c.1485–1547); TIZIANO VECELLIO called TITIAN (c.1485–1576)

reason; paganism; political power; the individual

Leon Battista Alberti's treatise on architecture, *De re aedificatoria*, rejected the medieval tradition of designing buildings to symbolise Christian truths. Instead, he advocated the symmetrical forms, mathematical ratios and human-

in this development, working successfully under royal patronage.

Important contemporary events, with a focus on prominent public figures, provided an obvious source of secular subject matter during the Renaissance. Other factors in the secularization of Renaissance art include: urbanisation; the consolidation of secular power; increasing wealth which created new patrons for the arts; and the steady growth of a market in art which explored Classical themes, imagery and principles. This secular trend flourished a century later in the Baroque era.

KEY WORKS in the Uffizi, Florence

← *Entry of Charles VIII into Florence*, c.1518, FRANCESCO GRANACCI
This large scale work in the grand manner by Granacci celebrates the triumphant progress of Charles VIII, King of France, through Italy. Charles conquered Pavia, Florence, Rome and Naples before being forced to retreat. His military campaign was responsible for the spread of Renaissance art through France.

↓ *Birth of Venus*, c.1482, SANDRO BOTTICELLI
Botticelli's seductive depiction of an event from classical mythology – the goddess at the moment of her birth from the sea – makes it representative of the secular tendency in the Renaissance .

scaled proportions of Classical architecture. Much of the art and architecture commissioned by the Church during the Renaissance was intended to create an impression of continuity and inheritance from the Classical era. It gradually became impossible to think about civilisation and art in purely theological terms.

A crucial shift in this period was the increasing importance given to easel painting. Commissioned for private homes, easel paintings became highly desirable and gave artists a new source of income and competition outside commissions for church decorations. Titian played a significant role

OTHER WORKS in the Uffizi, Florence

The Venus of Urbino, c.1538, TITIAN

Flora, c.1515, TITIAN

The Death of Adonis, early 1500s, SEBASTIANO DEL PIOMBO

The Poet Cassio, c.1490–1500, GIOVANNI ANTONIO BOLTRAFFIO

Warriors and Old Men, 1493–1500, VITTORE CARPACCIO

 Humanism; Classicism; Idealism; Perspectivism

 Sectarianism; Pietism

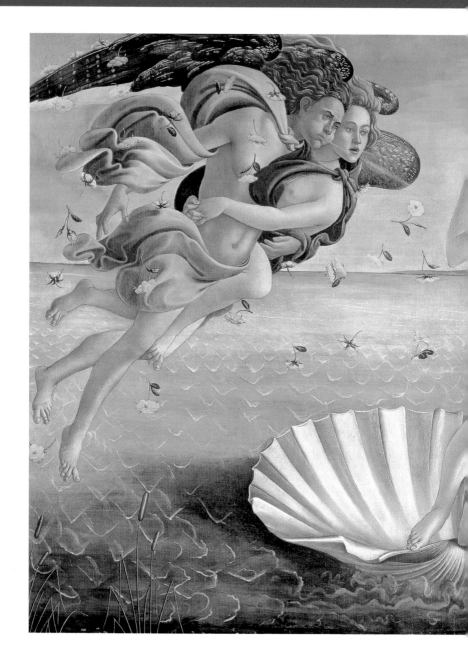

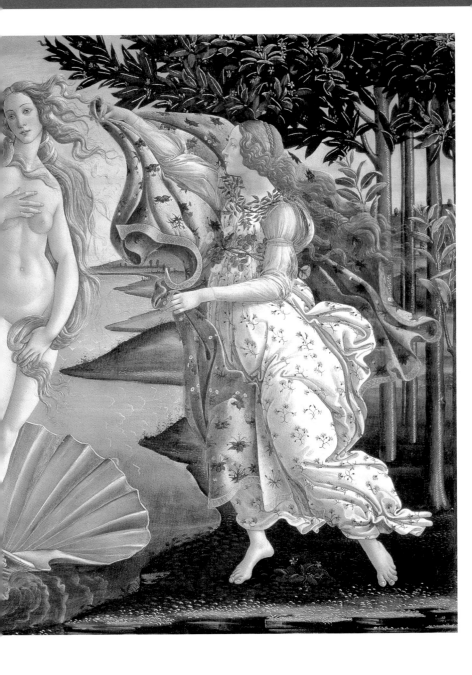

Monumental art is defined by its physical scale, the breadth of its subject matter and its ambition to be of lasting significance. During the Renaissance, powerful patrons encouraged the development of monumental art, a trend which continued into the Baroque era.

LEON BATTISTA ALBERTI (1404–72); DONATO BRAMANTE (c.1444–1514); FILIPPO BRUNELLESCHI (1377–1446); LORENZO GHIBERTI (1378–1455); GIORGIO DA' CASTEL FRANCO called GIORGIONE (1477–1510); HUGO VAN DER GOES (c.1440–82); ANDREA MANTEGNA (c.1430–1506); MICHELANGELO BUONARROTI (1475–1564); RAFFAELLO SANZIO called RAPHAEL (1483–1520); JACOPO ROBUSTI called TINTORETTO (c.1518–94)

political ambition; grandeur; intellectual synthesis; Olympian

Pope Julius II, who sat on the Papal throne from 1503 to 1513, initiated the monumentalism of the High Renaissance when he commissioned the architect Bramante to rebuild St Peter's in Rome. The politically ambitious pope instructed Bramante to design and build something which would dwarf all the most significant monumental buildings of the ancient world, including the Parthenon and the Basilica of Constantine.

Bramante's original design for St Peter's (1506) was entirely symmetrical and envisaged four identical facades. He died in 1514 and the building was still under construction in 1546 when Michelangelo took charge of the project. St Peter's was still incomplete when, in turn, Michelangelo died in 1564. The dome which he designed was not finished until 1590.

Michelangelo also excelled in monumental painting and sculpture. His frescoes in the Sistine Chapel feature hundreds of nudes arranged into an epic narrative of man's creation, fall, redemption and judgement. His giant figures all have heroically muscular bodies. Michelangelo's *David*, the first monumental Renaissance sculpture, measures four metres high and was commissioned as a symbol of the Florentine Republic.

KEY WORKS in Rome

▸ *The Last Judgement*, 1534–41, MICHELANGELO BUONARROTI, The Sistine Chapel, St Peter's, Rome
The Last Judgement is monumental in scale, as are the Olympically-proportioned figures who throng around Christ, but it is also an enormous intellectual achievement, synthesising Christian theology with Classical mythology. Christ in judgement dominates the top of the fresco while at the bottom right, Charon, a figure from Classical mythology, ferries souls across the river Styx to Hades, the world of the dead.

↓ Fragments of the *Statue of Constantine*, Palazzo dei Conservatori, Campidoglio, Rome
Michelangelo modelled the Campidoglio into one of the most important urban environments created during the Renaissance. The public square gives the impression of a city governed by order and grandeur, but the monumental scale of the Campidoglio asserts more than Rome's power. Michelangelo intended it to synthesise natural, spiritual and political authority: as such, it became the perfect home for fragments of a monumental statue of Constantine.

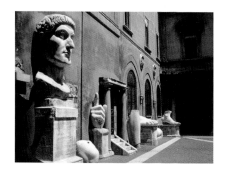

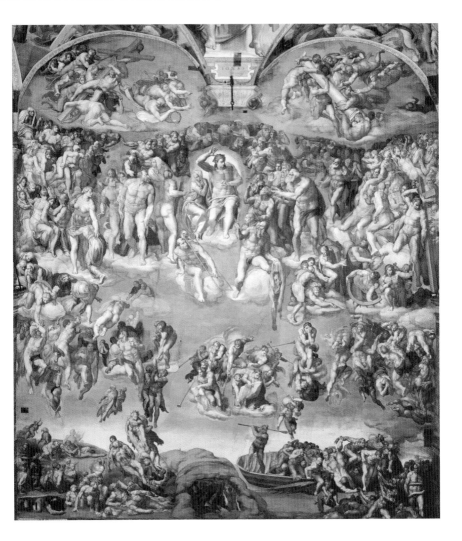

OTHER WORKS in Rome

St Peter's, Rome, 1506–1590, **BRAMANTE**
and **MICHELANGELO**

The Creation of Adam, 1508–12, **MICHELANGELO**,
Sistine Chapel, the Vatican, Rome

The Fall of Man, 1508–12, **MICHELANGELO**,
Sistine Chapel, the Vatican, Rome

Moses, c.1513–15, Tomb of Julius II, **MICHELANGELO**,
St Peter's Rome

Classicism; Secularism; Absolutism

Rococo; Medievalism; Pre-Raphaelitism;
Aestheticism; Secessionism; Modernism;
Post-Modernism

Virtually synonymous with the Renaissance, Humanism has two main components: the revival of interest in the art and values of the Classical world, and a renewed sense of the individual's ability to understand and change both himself and the world by seeking rational, rather than religious, answers

GIOVANNI BELLINI (c.1430–1516); DONATO DI BETTO BARDI called **DONATELLO** (c.1386–1466); **DOMENICO GHIRLANDAIO** (1449–1494); GIORGIO DA' CASTELFRANCO called **GIORGIONE** (c.1477–1510); **LEONARDO DA VINCI** (1452–1519); **MICHELANGELO BUONARROTI** (1475–1564); RAFFAELLO SANZIO called **RAPHAEL** (1483–1520); JACOPO ROBUSTI called **TINTORETTO** (c.1518–94); TIZIANO VECELLIO called **TITIAN** (1485–1576)

reason; philosophical enquiry; private scholarship; human emotion; friendship; optimism

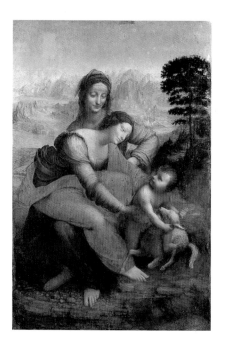

The term 'Humanist' was first used in the 14th century to refer to teachers of the Roman liberal arts (geometry, grammar, poetry, rhetoric and moral philosophy). Gradually, it came to be used of any educated person with a serious interest in the Classical world and in the value of human emotions and relationships.

Although it was primarily a literary and scholarly movement, Humanism encouraged a new interest in artists as 'great men' who could play an important role in the discovery of the Classical past and human nature. Humanism began the transition from a world in which artists were craftsman to one in which they had significant things to say about the world.

By emphasising the importance of reason and rational enquiry, Humanism challenged the traditional domination of theology with its elevation of the Divine and prostration of the earthly as sinful and corrupt. Artists began to represent holiness in ordinary people: after centuries of gilded splendour as the Queen of Heaven, the Virgin was depicted as a humble girl. This trend is clearly evident in Leonardo and ultimately led to the work of Caravaggio.

Humanists believed in the importance of education because they were convinced that the rational powers of the human mind could grasp the logical patterns of the universe. Such reasoning inspired the belief that art could be codified into rules for the purposes of teaching. This, in turn, led to the founding of art Academies to ensure the correct application of such rules. In France, the artist who most influenced Academic teaching was Poussin, a self-confessed Humanist and one of the first great artist-intellectuals.

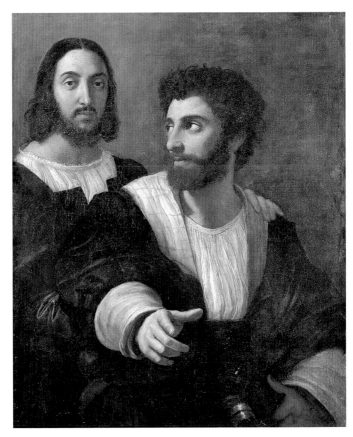

KEY WORKS in the Louvre, Paris

◀ *The Virgin and Child with Saint Anne*, 1510,
LEONARDO DA VINCI
In this work the Virgin sits on Saint Anne's knee and
both smile down at Christ who is mischievously pulling
the ears of a lamb. Leonardo distinguishes these central
figures in the Christian religion by portraying them with
ordinary, human emotion.

↑ *Portrait of the Artist with a Friend*
(Traditionally described as *His Fencing Master*), c.1518
RAFFAELLO SANZIO called **RAPHAEL**
Humanism, like much Classical philosophy, emphasised
the importance of friendship over romantic or sexual
love. Raphael's portrait with his friend is indicative of
this trend. It is an affectionate and intimate portrayal
of friendship in which purely human emotional bonds
are celebrated and affirmed.

OTHER WORKS in the Louvre, Paris

Portrait of an Old Man and a Young Boy, c.1480,
DOMENICO GHIRLANDAIO

The Virgin and Child, c.1490, **DOMENICO
GHIRLANDAIO**

Portrait of Mona Lisa, (called *La Gioconda*), 1503–06,
LEONARDO DA VINCI

Portrait of a Lady at the Court of Milan, c.1490–95,
LEONARDO DA VINCI

Apollo and Marsyas, c.1509, **PERUGINO**

 Individualism; Idealism; Academicism;
Secularism; Naturalism; Baroque Classicism

 Absolutism; Materialism; Dadaism; Surrealism;
Post-Modernism

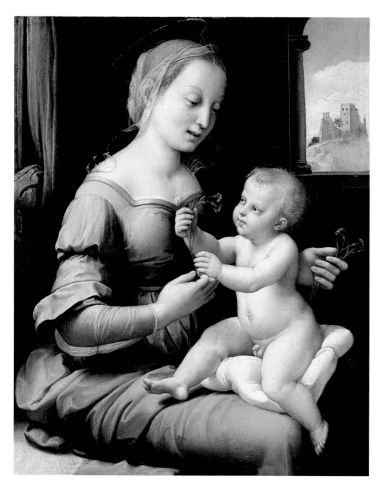

At its most general, Idealism asserts that the physical world is less important than the mind or the spirit which shapes and animates it. Idealists choose the soul, the mind or the psyche over the body, the material and the historical. When ideals (of appearance, or proportion for example) regulate the way an artist represents the world his work can be described as Idealist.

DONATO DE BETTO BARDI called **DONATELLO** (c.1386–1466); **ALBRECHT DÜRER**

(1471–1528); **LORENZO GHIBERTI** (1378–1455); LEONARDO DA VINCI (1452–1519); ANDREA MANTEGNA (c.1431–1506); TOMMASO GUIDI called **MASACCIO** (1401–28); **MICHELANGELO BUONAROTTI** (1475–1564); RAFFAELLO SANZIO called **RAPHAEL** (1483–1520).

permanence; eternal order; idea over observation; simplicity; clarity

Plato's Theory of the Forms was the most important Classical influence on Renaissance Idealism. The Ideas, or Forms,

contain all that is necessary and universal and are therefore perfect and unchanging while the material world is simply a deceptive procession of changing appearances which have no more reality than shadows.

The leading artists of the High Renaissance – Leonardo, Raphael and Michelangelo – are all associated with slightly different forms of Idealism. Michelangelo's was most identified with the Platonic Forms because of his reliance on 'disegno' (design). The term is used to describe art which is shaped by the artist's imagination rather than by his imitation, or copying, of a natural model. Michelangelo's art also idealised the body by giving it monumental proportions. His figures are usually astonishingly muscular.

Raphael's figures are equally idealised but they are characterised by sweetness of expression, serenity, elegance, clarity of line and beauty of colour rather than physical grandeur. Leonardo's Idealism was different again. It was characterised by an emphasis on finding the Divine in the perfectly human. Beauty, subtle facial expression, the unity of the figure with its setting and the elimination of unnecessary detail to suggest emotion, were all aspects of his Idealism.

Renaissance artists strove to paint the Ideal, not because they shied away from looking at the world, but because they wanted to capture the absolute and universal truth hidden within it.

KEY WORKS in the National Gallery, London

◄ *The Madonna of the Pinks*, c.1506–7, RAFFAELLO SANZIO called **RAPHAEL**
Raphael studied Leonardo's *Benois Madonna* (Hermitage, St Petersburg) before painting his own *Madonna of the Pinks*. Leonardo's work encouraged Raphael to portray the Madonna and Child in more human terms, giving them a very ordinary, earthly pleasure in each other. However, Raphael still idealised them in his own way. Both figures are beautiful, in form and colour. The composition is also very simple. This reinforces the viewer's impression of simplicity and clarity – two important ideals which Raphael constantly pursued in his work.

↓ *Leda and the Swan*, c.1530, after MICHELANGELO BUONARROTI
This work after Michelangelo shows his ideal human physique in all its Olympian grandeur. Michelangelo's bodies were shaped by his concept of the ideal rather than by observation of actual bodies. His figures have the same proportions as monumental sculptures.

OTHER WORKS in the National Gallery, London

Saint Catherine of Alexandria, c.1507–8, **RAPHAEL**

Madonna and Child (The Mackintosh Madonna), c.1510–12, **RAPHAEL**

The Virgin of the Rocks (The Virgin with the Infant Saint John adoring the Infant Christ accompanied by an Angel), c.1493–9 and c.1506–8, **LEONARDO DA VINCI**

The Virgin and Child with Saint Anne and Saint John the Baptist, c.1499–1500, **LEONARDO DA VINCI**

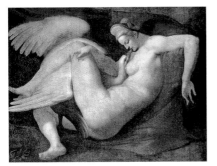

 Humanism; Academicism; Neo-Plasticism; Aestheticism; Secessionism; Neo-Classicism

 Caravaggism; Realism; Social Realism; Mannerism; Expressionism; Dadaism; Surrealism; Post-Modernism

Perspectivism covers a variety of techniques for representing space by creating the illusion of three dimensions on a two dimensional surface such as a canvas or paper. Perspective developed as a coherent body of rules and theories during the early Renaissance of the mid 15th century but, by the High Renaissance of the late 15th century, the most advanced artists, notably Leonardo da Vinci, were already exploring its limitations and ambiguities.

LEON BATTISTA ALBERTI (1404–72); GIOTTO DI BONDONE (c.1270–1337); FILIPPO BRUNELLESCHI (1377–1446); VINCENZO DI BIAGIO CATENA (c.1470–1531); LORENZO DI CREDI (c.1459–1537); PIERO DELLA FRANCESCA (c.1415–92); FRANCESCO GRANACCI (1477–1543); ANDREA MANTEGNA (c.1431–1506); TOMMASO GUIDI called MASACCIO (1401–28); PIETRO VANNUCCI called PERUGINO (c.1445–1523); PAOLO UCCELLO (c.1397–1475); LEONARDO DA VINCI (1452–1519)

3-dimensional; depth; linear; aerial; unified; receding; continuous

Giotto was one of the first artists to create the illusion of space in his paintings by representing buildings from the side so that the walls seemed to slope away from the viewer into an imaginary space 'within' the painting. He used several techniques to create similar effects of depth. Other artists, notably in Northern Europe, created depth by painting distant objects smaller.

The great innovation in perspective came with Brunelleschi's experiments with mathematically constructed perspective and Alberti's *On Painting* (1435 and '36). Both artists established what is known as linear perspective. Other terms in use include mathematical, scientific, geometrical, optical and Renaissance perspective, but

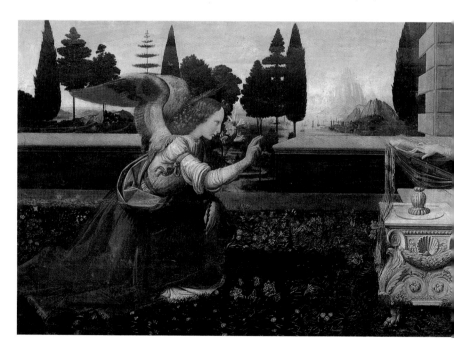

linear perspective is the most commonly used term.

The technique adopts a 'single vanishing point' on the horizon – with two significant effects for painting. All imaginary or actual lines in the painting which recede towards the horizon converge on the single vanishing point. Secondly, the scale of everything in the painting can be strictly worked out in relation to the single vanishing point.

Leonardo da Vinci was the first to achieve convincing 'aerial perspective' – a term he invented. In our perception of the world, objects which are further away look paler and bluer through the effects of atmosphere. Aerial perspective applies this principle in art to create the impression of space through careful control of colour and tone.

KEY WORKS in the Uffizi, Florence

 Annunciation, 1474, LEONARDO DA VINCI
In the *Annunciation* Leonardo makes dramatic and convincing use of linear perspective. Everything in the painting recedes towards a single vanishing point on the horizon. This gives the impression that the angel and the Virgin share the same, unified space which extends continuously all around them.

 Episodes of the Battle of San Romano, c.1456, PAOLO UCCELLO
The angle of the lances lying on the right and left of the battlefield show that Uccello had an understanding of perspective which helps create an impression of spatial depth. However, the perspective is not yet entirely unified as figures in the background are slightly out of scale and the painting concentrates on the action in the foreground at the expense of spatial depth.

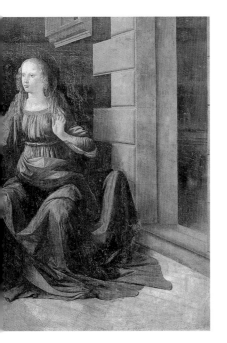

OTHER WORKS in the Uffizi, Florence

Pieta, c.1493–4, PERUGINO

The Annunciation, c.1480, **LORENZO DI CREDI**
(Linear and Aerial Perspective)

Entry of Charles VIII into Florence, c.1518,
FRANCESCO GRANACCI

The Supper at Emmaus, 1520–30,
VINCENZO DI BIAGIO CATENA

Portrait of an Unknown Man, c.1503–4,
RAPHAEL (Aerial Perspective)

Illusionism; Naturalism; Classicism; Realism;

International Gothicism; Mannerism; Modernism; Post-Modernism

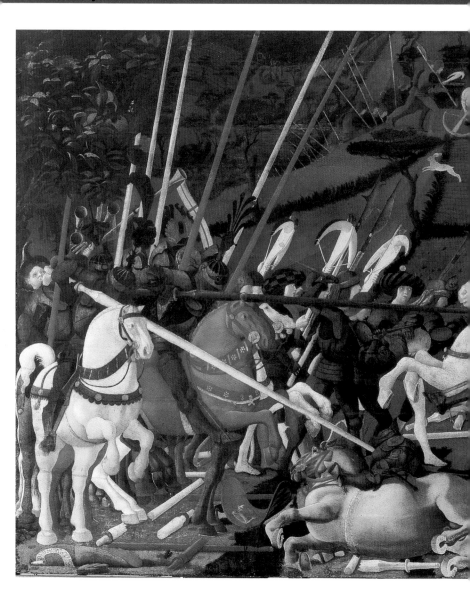

Illusionism is a very specific variant of Naturalism in which the artist attempts to trick the viewer into mistaking painted objects for real objects. It is central to Renaissance art which was heavily influenced by the Classical ambition to create art which could be mistaken for living things.

DONATO BRAMANTE (c.1444–1514); ANTONIO ALLEGRI called CORREGGIO (c.1494–1534); DONATO DI BETTO BARDI called DONATELLO (c.1386–1466); JAN VAN EYCK (c.1390–1441); ANDREA MANTEGNA (c.1431–1506)

deception; imitation; trompe l'oeil; quadratura; foreshortening

The two key technical terms used in Illusionism are 'trompe l'oeil' and 'quadratura'. 'Trompe l'oeil is French for 'deceive the eye' and is normally used to refer to a painting which tricks the viewer into thinking he is looking at a real apple, rather than a painted apple, for example. The term is mostly used in relation to still life paintings or other works which represent smaller objects in intimate, often domestic spaces.

'Quadratura' refers to larger scale deceits in which a painting, or fresco, is confused with the building in which it is displayed. The artist achieves this by imitating the building's architecture in his art work. Consequently, quadratura is usually site-specific. It is more persuasive if the setting is always lit in the same way. The artist can then incorporate the effect of the building's lighting in his art work.

The techniques of Illusionism include foreshortening, perspective and chiaroscuro. They were all developed in the early Classical period (c.480–450 BC) and were fully exploited by the Renaissance artists.

Mantegna was the first Renaissance artist to use Illusionistic ceiling decoration. He deceptively 'expanded' the dimensions of the bridal chamber in the Gonzaga family's Ducal Palace. This innovative use of quadratura inspired Correggio's decoration of the cupola of San Giovanni Evangelista, Parma. Both are outstanding examples of a form of Illusionism called *di sotto in sù* which means 'from below upwards'.

KEY WORKS in the Ducal Palace of the Gonzaga Family, Mantua

→ *The Camera degli Sposi*, Ducal Palace of the Gonzaga Family, 1465–74, ANDREA MANTEGNA
Standing in the *Camera degli Sposi* and peering upwards is like being in a well. The ceiling seems to open to the sky through a round wall. The effect is particularly disconcerting for a bridal chamber; it creates a sense of public intrusion into a private environment. Mantegna uses foreshortening, most noticeable in the figures of the putti, and quadratura, to dramatic, illusionistic effect.

OTHER WORKS in Italy from the Renaissance period

The cupola of S. Giovanni Evangelista, Parma, 1520–4, CORREGGIO

The dome of Parma Cathedral, Parma, 1526–30, CORREGGIO

OTHER WORKS in Italy from the Baroque period

Allegory of Divine Providence and Barberini Power, Gran Salone, Barberini Palace, Rome, 1633–39, PIETRO DI CORTONA,

[*Five Ceilings*], Pitti Palace, Florence, 1640–47, PIETRO DI CORTONA

The Assumption of the Virgin, 1625–7, S. Andre della Valle, Rome, GIOVANNI LANFRANCO

 Perspectivism; Naturalism

 Modernism; Post-Modernism

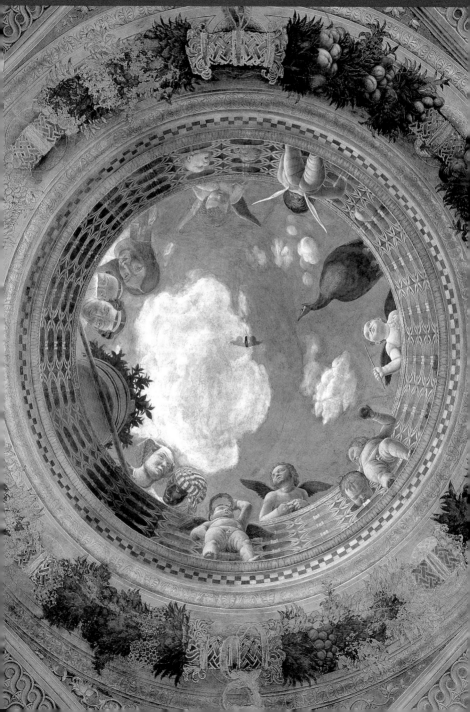

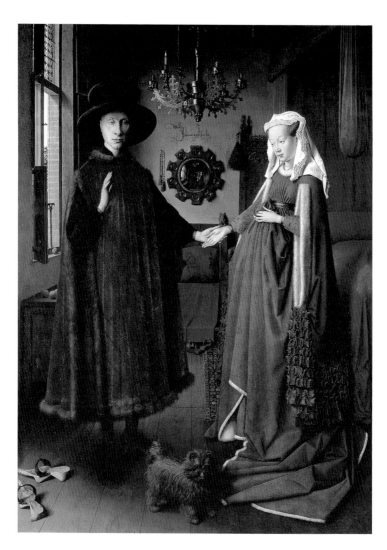

Naturalism is the representation of the world with a minimum of abstraction or stylistic distortion. It is characterised by convincing effects of light and surface texture and by evocation of feelings and moods. It re-emerged as a central, dominating trend in Western art during the Renaissance.

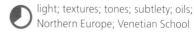

GIOVANNI BELLINI (c.1433–1516); PIETER BRUEGEL (c.1525–69); JAN VAN EYCK (c.1390–1441); HUGO VAN DER GOES (c.1440–82); GIORGIO DA'CASTELFRANCO called GIORGIONE (c.1477–1510); LEONARDO DA VINCI (1452–1519)

light; textures; tones; subtlety; oils; Northern Europe; Venetian School

Renaissance Naturalism is characterised by a general, overall impression of fidelity to natural appearance. This is achieved by conveying light, texture, colour and tone in all their variety, but with complete consistency.

Naturalism offered Renaissance artists an opportunity to re-envisage what art is and increase its cultural importance. Leonardo da Vinci's development of aerial perspective, for instance, was an attempt to achieve a more convincingly Naturalistic style of painting in which strict rules of composition, such as linear perspective, were less apparent to the viewer. The best Renaissance artists strove to apply perspective unobtrusively and soon began to criticise artists whose use of it was too obvious, thereby disrupting our perception of the art work by drawing our attention to one aspect of its composition.

Two other contributions were decisive in the development of Naturalism. Jan van Eyck achieved astonishing levels of Naturalistic detail in the depiction of light and texture which made him famous across Europe. Artists working in Venice emphasised colour and mood over the line and form preferred by Florentine artists. The Venetian Colourists, as they are sometimes called, included Bellini, Tintoretto, Veronese, Giorgione and Titian. Giorgione

is credited with establishing atmospheric landscape as a vehicle for human emotions and moods. Naturalism led, in subsequent years, to the development of landscape and still life painting which were still rare during the Renaissance.

KEY WORKS in the National Gallery, London

◄ *Portrait of Giovanni (?) Arnolfini and his Wife: The Arnolfini Portrait*, 1434, JAN VAN EYCK
Van Eyck has been described as the inventor of oil painting. While this is not entirely accurate he was certainly the first to reveal its potential as a medium suited to Naturalism. The subtle and convincing impression of light on differently textured surfaces, such as clothes and a brass chandelier, makes *The Arnolfini Portrait* one of the most significant works in the history of Naturalism.

↓ *Madonna of the Meadow*, 1500, GIOVANNI BELLINI
If Van Eyck's work represents the triumph of Naturalism in relation to light and texture, Bellini's represents the triumph of Naturalism as a means of conveying recognisable moods and emotions in painting. His *Madonna of the Meadow* is full of tenderness, conveyed through ordinary, 'natural' posture without exaggerated gesture. It is an intimate work, where the warmth and sorrow of the Madonna seem part of nature itself. The background shows Venetian farmland rather than an idealised landscape.

OTHER WORKS in the National Gallery, London

The Baptism of Christ, 1450s, PIERRO DELLA FRANCESCO

Venus and Mars, c.1485, SANDRO BOTTICELLI

The Virgin of the Rocks, 1493–9 and 1506–8, LEONARDO DA VINCI

The Ambassadors, 1533, HANS HOLBEIN THE YOUNGER

Landscape with a Footbridge, 1518–20, ALBRECHT ALTDORFER

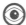 Humanism; Classicism; Illusionism; Perspectivism; Realism

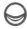 Mannerism; Absolutism; Modernism; Post-Modernism

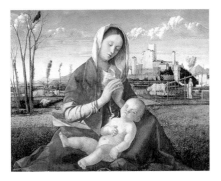

 In its broadest sense, Mannerism refers to art produced in the latter half of the 16th century, after the High Renaissance and prior to the Baroque. The term has also been used pejoratively, particularly in the 18th and 19th centuries, when Mannerism was often considered a superficial decline from the heights of the High Renaissance.

NICCOLÒ DELL'ABATE (c.1509–c.71); GIUSEPPE ARCIMBOLDO (1527–1593); AGNOLO BRONZINO (1503–72); ANTONIO ALLEGRI called CORREGGIO (c.1489–1534); GIROLAMO FRANCESCO MARIA MAZZOLA called PARMIGIANINO (1503–40); JACOPO CARUCCI called PONTORMO (1494–1556); GIOVANNI BATTISTA DI JACOPO ROSSO called ROSSO FIORENTINO (1496–1540); (1495–1540); ANDREA DEL SARTO (1486–1530)

contortion; ambiguity

The Italian writer Vasari first used the term 'mannerism' in the 16th century to denote 'stylish' painting full of elegance and sophistication. From the 18th century the reputation of Mannerist painters declined. In comparison to the work of the High Renaissance masters – Michelangelo, Leonardo and Raphael – they were perceived as less capable artists. Features of Mannerist style, such as the odd poses and elongation of figures, were dismissed as symptoms of mere virtuosity and the pursuit of effect. In the 20th century, however, Mannerism was increasingly studied as a distinct, late phase of the Renaissance.

Mannerists ascribed less importance to harmonious, balanced compositions than the artists of the High Renaissance and the entire movement can be understood as a rejection, or modification, of High Renaissance Classicism. Mannerism is characterised by a greater diversity of subject matter, poses, perspectives and colour to which Classical line, harmony and perspective are subordinated. In relation to the human figure, the Mannerists contorted what the High Renaissance idealised. Figures in Mannerist paintings often seem to be caught mid-movement, in awkward poses, and with disproportional features while the viewer, on the other hand, is encouraged to identify an unfolding story within the painting. The morals and emotions of Mannerist painting are less heroic than those of the High Renaissance. There is greater ambiguity and more room for a confusion of interpretation. These features of Mannerism made it distasteful to those who valued the directness, grandeur and simplicity of the High Renaissance.

KEY WORKS in the National Gallery, London

↓ *An Allegory of Cupid with Venus*, 1540–50, AGNOLO BRONZINO
This richly coloured Mannerist composition is typically crowded with gesticulating figures in curious poses. The young girl in the background is not an idealised figure but a hybrid who might represent the deceptive nature of pleasure. The complex, allegorical meaning

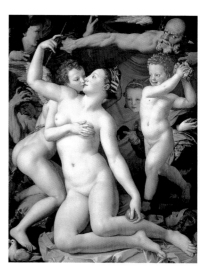

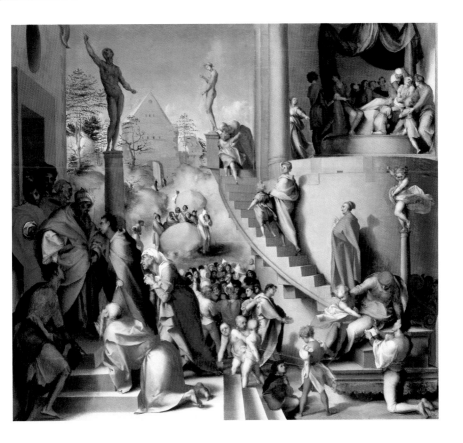

of this painting is no longer clearly understood and it is a prime example of the interpretive confusion which is typical of Mannerism.

↑ *Joseph with Jacob in Egypt*, 1518,
JACOPO CARUCCI called **PONTORMO**
This Mannerist painting tells four stories simultaneously: Joseph introducing Jacob to Pharaoh; Joseph on a cart hearing a petition; Joseph climbing a staircase to visit Jacob; and Jacob blessing Joseph's sons on his deathbed. The painting also includes a child on a pillar mimicking classical poses. The simple, unified space of the High Renaissance has been replaced by overlapping dramatic environments in which perspective and proportion are not strictly observed and in which the heroic, grand and monumental have been replaced by a brightly coloured clutter of detail.

OTHER WORKS in the National Gallery, London

The Madonna and Child with Saint John the Baptist and a Female Saint, probably Saint Anne, 1540–50,
AGNOLO BRONZINO

The Madonna and Child with Saints, 1526–7,
PARMIGIANINO

The Mystic Marriage of Saint Catherine, 1527–32,
PARMIGIANINO

Joseph Sold to Potiphar, 1515, **PONTORMO**

Pharaoh with his Butler and Baker, 1515, **PONTORMO**

 Gesturalism; Emotionalism; Allegoricism

 Naturalism; Perspectivism; Illusionism; Classicism; Neo-Classicism; Academicism; Realism; Modernism; Post-Modernism

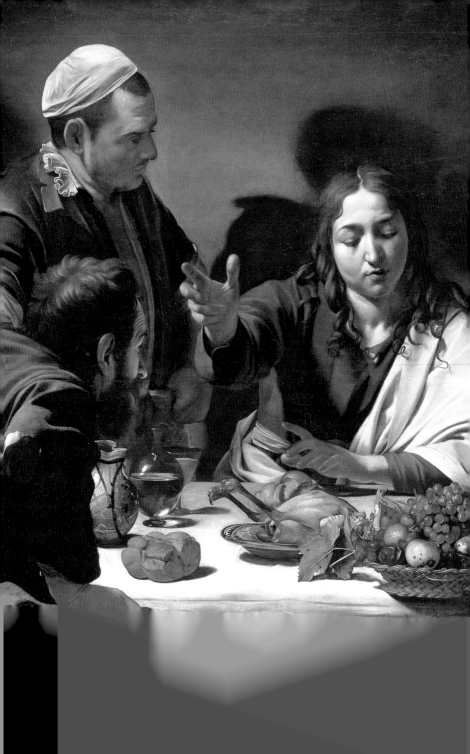

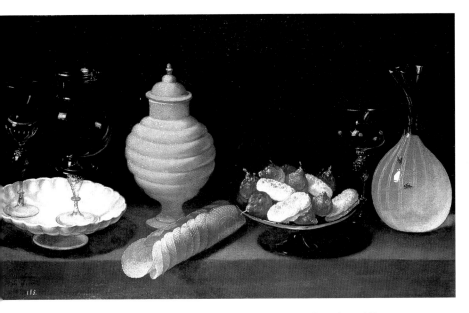

KEY WORKS in the Prado, Madrid

↑ *Still Life with Sweets and Glassware*, 1622,
JUAN VAN DER HAMEN

Still life – paintings of everyday objects ranging from
vases to fruit and flowers – became very popular during
the Baroque period, especially in the Dutch Republic.
The market for paintings increased as more and more
people could afford art for their homes. Baroque still life
inspires contemplation and meditation, as well as
admiration of the artist's skill. Its beauty is often
melancholy, inviting the viewer to contemplate life's
transience.

↓ *The Triumph of Bacchus (The Drinkers)*, 1628,
DIEGO VELÁZQUEZ

Bacchus was the Roman god of wine, worshipped by
the Greeks as Dionysus. On the most basic level he was
associated with drunkenness, but more significantly
with artistic inspiration and the fertilization of earth and
soul. Two figures look out directly from the painting,
involving the viewer in the scene, perhaps as an
observer, perhaps as a fellow drinker. This manipulation
of the viewer is a hallmark of Baroque art. Bacchus
looks to one side, allowing us to study his face to
discern his thoughts and feelings which remain
unknowable. Velázquez leaves us uncomfortably
suspended between involvement and detachment.

OTHER WORKS in the Prado, Madrid

Maria Ruthwen, the Painter's Wife, c.1639,
ANTHONY VAN DYCK

Parnassus (Apollo and the Muses), c.1631–33,
NICOLAS POUSSIN

Artemesia, 1634, REMBRANDT HARMENZ VAN RIJN

Peasant Dance, c.1636–40, PETER PAUL RUBENS

The Trinity, c.1635–6, JUSEPE DE RIBERA

Las Meninas, DIEGO VELÁZQUEZ

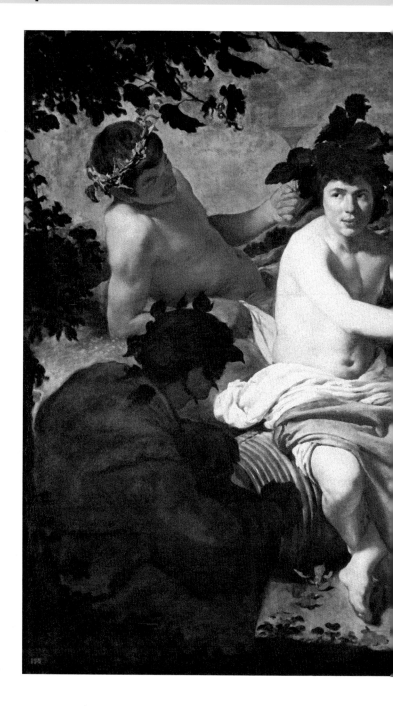

Allegorical painting has a meaning hidden in its subject matter which the viewer must 'read'. Allegory differs from symbol in that it usually has a clear or precise associative meaning and does not require an intuitive response from the reader. For example, a still life painting of rotting fruit is allegorical of the shortness of human life.

CLAUDE LORRAIN (1600–82); NICOLAS POUSSIN (1594–1665); PETER PAUL RUBENS (1577–1640); JAN VERMEER (1632–75); SIMON VOUET (1590–1649)

propaganda; hidden truths; still-life; allusive complexity

Allegory was popular in Baroque art. Many painters wanted to enjoy the same high status as poets and used allegory as a way of introducing painterly equivalents of allusion and metaphor.

Allegorical painting requires the viewer to have a working knowledge of Classical literature, mythology and history, as well as Christian theology and traditions. It relies on intellect and acquired knowledge, whereas the meaning of a symbol relies more on our emotional and intuitive response to it.

There are two main trends in Baroque allegorical painting, one public, the other private. Public allegorical painting attempts to influence the way we think about Church and State, usually by associating contemporary rulers with

Classical leaders, or the Church with the grandeur and authority of the Classical past. Typical examples represent contemporary rulers in Classical armour decorated with symbols of the gods of war and peace. The allegorical meaning is straightforward: the King is victorious like Caesar. For an allegorical painting to work, the allegory requires cultural consensus to make it intelligible. The Classical world was the most important source of allegorical subjects because it was admired throughout Catholic and Protestant Europe.

The private trend in Baroque allegorical painting explores morals and truths relating to our experience of life. Dutch and Flemish art in particular are associated with paintings of supposedly everyday situations which are allegorical of moral truths such as 'pleasure does not last'.

KEY WORKS in the Louvre, Paris

◀ *Spring*, or *The Earthly Paradise* 1660–4,
NICOLAS POUSSIN
This painting is the first of four illustrating the seasons. Poussin's allegory is complex. The entire series refers to Classical and Christian belief in natural order, exemplified by the contrasts, progression and repetition of the seasons. But each painting in Poussin's series is also allegorical of a particular time of the day and a particular phase in human history. Spring represents morning and the creation of humankind in the Garden of Eden. It conflates the repetition of the seasons (conceived as a cycle) with a unique starting point for time itself: the divine creation.

↓ *Public Felicity Surmounting Perils*, c.1623–25,
ORAZIO GENTILESCHI
This painting was commissioned by Marie de Medici, Queen Mother of France. It was intended as an allegory showing the Queen triumphing over the threat to royal power during the regency. An idealised female figure protectively gathers the symbols of state in her arms as she watches the sky and waits for the storm to pass. The work presents the claim that it is in the interest of public peace for Marie to defend the rights of her son Louis XIII to absolute governance of France.

OTHER WORKS in the Louvre, Paris

The Triumph of Flora, 1631, NICOLAS POUSSIN

The Presentation of the Portrait of Marie de Medici to Henry IV, c.1622–24, PETER PAUL RUBENS

Allegory of Wealth, 1630–35, SIMON VOUET

 Gesturalism; Baroque Classicism; Sectarianism; Absolutism; Classicism; Humanism; Academicism; Neo-Classicism

 19th Century; Modernism; Post-Modernism

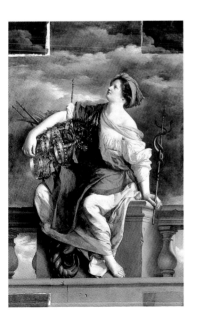

Baroque Classicism

Baroque Classicism was distinguished by three main developments which were all facilitated by the increase in private patrons wanting easel paintings for their homes; the Classical landscape which evokes mood; Poussin's reassertion of Classical principles of composition; and the codification of such principles as the foundation of Academic art education.

CHARLES LEBRUN (1619–90);
CLAUDE LORRAIN (1600–82);
NICOLAS POUSSIN (1594–1665)

nostalgia; golden age; landscape; stoicism; academic; philosophical

The new interest in the Classical past which distinguished the Renaissance from the middle ages continued into the Baroque era. The increase in private collectors during the 17th century was an important stimulant for the development of easel painting. Art for domestic spaces flourished during the Baroque and, with it, a preference for a more evocative,

suggestive, and intellectual Classicism suitable for private contemplation.

There are three main strands in Baroque Classicism, two of which are represented by Claude Lorrain and Nicholas Poussin. Lorrain's work contains Classical figures and buildings in evocative landscapes imbued with nostalgia. Lorrain rejected heroically proportioned figures. Instead, landscape dominates and the figures are usually small, their drama reduced to an almost humbly human scale.

Nicholas Poussin was the founder of French Classicism. He valued 'disegno' (design) and strove for harmony, balance and moral seriousness in his work in which form and colour are perfectly controlled.

A Classical school emerged in France which based itself on the work of Poussin, emphasising form and design, but not always with his talent. This became the basis of Academic art training which, in the Baroque era, and particularly in France, served a political function by providing 'official', State-sanctioned art. Academic Classicism achieved its greatest influence in the 18th and 19th centuries, when Art Academies flourished across Europe during the Enlightenment, and when Neo-Classicism was in the ascendant. Both David and Ingres, leading Neo-Classical painters, revered Poussin.

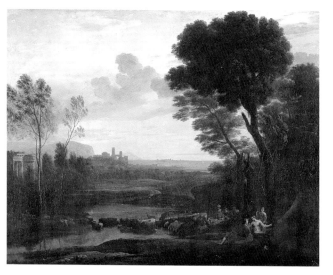

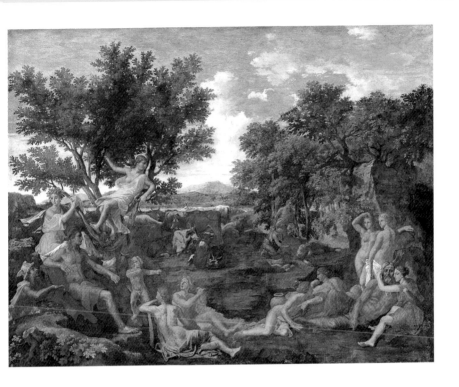

KEY WORKS in the Louvre, Paris

Landscape with Paris and Oenone, 1648,
CLAUDE LORRAIN
The mythological figures almost seem incidental in this
idealised landscape. Their presence ensures that we
'read' the landscape in the correct way and perceive it
as Classical. The story of Paris and Oenone is less
important than the landscape and the mood it evokes.
The story is almost lost in nature and it is this loss that is
allegorical of the golden age itself, now vanished, and
known only through stories.

Apollo and Daphne, 1625, NICOLAS POUSSIN
This is Poussin's last painting. It captures the moment
after Cupid has shot Apollo with a gold-tipped arrow,
making him fall in love with Daphne, and just before
he shoots Daphne with a lead-tipped arrow, ensuring
that she will never love Apollo in return. The stillness
in the painting suggests that this situation is a
permanent condition in the world and constitutes
part of the constant order underlying its endless
process of change.

OTHER WORKS in the Louvre, Paris

Alexander and Porus, c.1673, **CHARLES LE BRUN**

Ulysses Returns Chryseis to Her Father, c.1644,
CLAUDE LORRAIN

Seaport with Landing of Cleopatra at Tarsus, 1642–3,
CLAUDE LORRAIN

Acis and Galatea, c.1645–50, **FRANCOIS PERRIER**

 Allegoricism; Classicism; Humanism;
Idealism; Academicism; Neo-Classicism

 19th Century; Modernism;
Post-Modernism

Pietism

Pietism derives from 'pieta', meaning 'pity'. At its most general, Pietism refers to an attitude of spiritual devotion and concentration, but within the context of Baroque art and culture it refers to a form of religious devotion in which the art work itself plays a central role.

GIANLORENZO BERNINI (1598–1680); CLAUDIO COELLO (1642–93); PIETRO DA CORTONA (1596–1669); GIOVANNI BATTISTA GAULLI (1639–1709); LUCA GIORDANO (1634–1705); DOMENIKOS THEOTOCOPOULOS called EL GRECO (1541–1641); BARTOLOMÉ ESTEBAN MURILLO (1617/18–82); ANDREA POZZO (1642–1709); REMBRANDT HARMENSZ VAN RIJN (1606–69); PETER PAUL RUBENS (1577–1640); FRANCISCO DE ZURBARÁN (1598–1664)

devotional; austere; orthodoxy; public ritual; Counter Reformation

The Pietism of Protestant and Catholic Europe were informed by the different attitudes to church, tradition, authority and scripture which distinguished them.

Catholic art of the Baroque era emphasised intensely emotional encounters, usually featuring saints, martyrs and church hierarchs caught up in ecstatic or visionary experiences. This was especially the case in Spain where a tradition of very austere religious painting also developed alongside more typically Baroque religious art. Such works tended to illustrate episodes from the history of the Church or the lives of the saints and martyrs. Their purpose was to encourage a form of religious devotion which was both public and thoroughly orthodox. In Catholic Europe, Pietism was often a means of countering subversive Protestant privacy with an emotionally rich and highly public religious culture.

Protestant religious art tended to concentrate on the Bible, private prayer, and God's direct revelation of his will to the conscience of individual believers – in short, the key tenets which distinguish Protestantism from Catholicism. Crucially, Protestant Pietism did not allow art to play a central role in religious observance – a role which it denied to the visual arts and attacked as a form of idolatry (idol worship). The suppression of religious art in the Protestant Dutch Republic, following its liberation from Catholic Spain in 1609 resulted in the Dutch Golden Age of art, which was overwhelmingly secular in subject matter.

KEY WORKS in the Prado, Madrid

↓ *The Virgin Descending to Reward Saint Ildefonso,*
c.1660, BARTOLOMÉ ESTEBAN MURILLO
Ildefonso wrote many treatises about the Immaculate Conception and the virginity of Mary. Murillo shows the Virgin presenting the saint with a silvery-white chasuble which represents her virginity. Ildefonso's loyalty to the doctrine of Mary's virginity is rewarded with a gift which emphasises his role and status within the Church – an important lesson with which to reinforce piety.

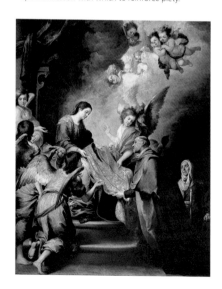

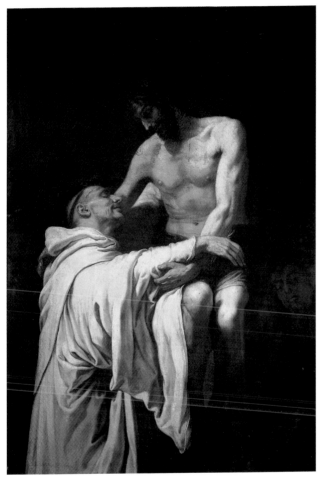

 Christ Embracing Saint Bernard, 1621–1625,
FRANCISCO RIBALTA
Saint Bernard lived in the 12th century and is revered
both for his contemplative writings and for founding
the Cistercian order. Ribalta portrays the saint without
his bishop's mitre, a traditional ommission. Bernard's
eyes are shut, emphasising his spiritual contemplation
of Christ, rather than a literal, physical encounter.
Ribalta's intention is to encourage us to emulate the
saint and contemplate Christ's love for his Church.

OTHER WORKS in the Prado, Madrid

The Triumph of Saint Augustine, 1664,
CLAUDIO COELLO

Saint Rose of Lima, c.1684–5, **CLAUDIO COELLO**

Saint Andrew and Saint Francis, c.1590–95, **EL GRECO**

The Immaculate Conception, c.1630,
FRANCISCO DE ZURBARÁN

Saint Euphemia, c.1635–40, **FRANCISCO
DE ZURBARÁN**

 Sectarianism; Gesturalism; Emotionalism;
Medievalism; Pre-Raphaelitism

Secularism; Rococo; Modernism;
Post-Modernism

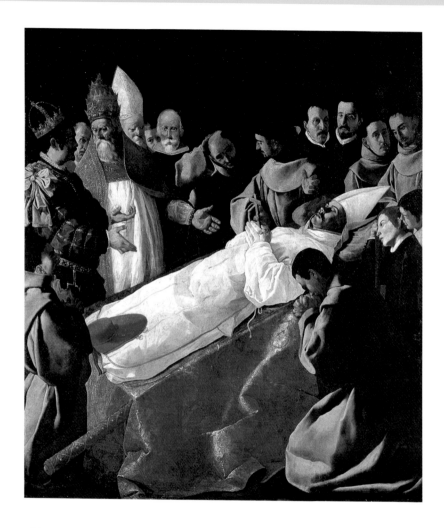

 Sectarianism is an adherence to the beliefs of a particular denomination or sect. It is usually typified by aggression or intransigence towards the views and practices of other religious groups. The Baroque era was dominated by Europe's division into Catholic and Protestant following the Protestant Reformation of the 16th century and the Catholic Counter–Reformation

GIANLORENZO BERNINI (1598–1680); GIOVANNI BATTISTA GAULLI (1639–1709); LUCA GIORDANO (1634–1705); DOMENIKO THEOTOCOPOULOS called EL GRECO (1541–1641); BARTOLOMÉ ESTEBAN MURILLO (1617/18–82); REMBRANDT HARMENSZ VAN RIJN (1606–69); PETER PAUL RUBENS (1577–1640); FRANCISCO DE ZURBARÁN (1598–1664).

religious conflict; devotion versus idolatry; private conscience

Sectarian conflict between Catholic and Protestant had an enormous impact on the art of the 17th century. At its most extreme, Protestantism resulted in iconoclasm – the destruction of 'idolatrous' religious images. Protestants criticised the Catholic cults of saints and relics as superstitious and denounced the Catholic Church's veneration of the Virgin Mary. Protestant art portrayed biblical stories, sermons and scenes of private devotion which emphasised the role of private conscience, the importance of Biblical study and the possibility of the individual enjoying a direct relationship with God unmediated by priests. Protestant religious art was usually conceived as an illustration of truth, but it was not considered a part of that truth itself, for it was never treated as an object of devotion.

In Catholic areas art was also put to sectarian use. The Counter-Reformation sought to protect the cults of saints, relics and the Virgin. In Spain, the clergy was the major source of artist commissions outside the Royal household. This trend ensured the orthodoxy of religious painting in many Catholic areas. Catholic art celebrated the lives and miracles of saints, relics and the Virgin as well as promoting the key articles of faith. Retablo altarpieces – combining sculpture and painting – created highly visual experiences for Catholic church-goers. If Protestant religious art focused on biblical texts, and remained wary of religious art in general, its Catholic counterpart promoted a more visual, ritual-based religious tradition in which art played a masterly role that was often as sensual as it was spiritual.

KEY WORKS in the Louvre, Paris

◄ *Lying-in-State of St Bonaventure*, 1629,
FRANCISCO DE ZURBARÁN
Zurbarán's work is typical of the Catholic Counter-Reformation in Spain. It shows the saint lying in state and wearing a mitre. Monks kneel in the foreground and the Pope gestures towards Bonaventure's corpse. This work emphasises the centrality of the Church's teachings and practices in Christian life, and celebrates holiness as a life of obedience to the Church.

◄ *St Matthew and the Angel*, 1661,
REMBRANDT HARMENSZ VAN RIJN
Protestants placed the authority of the Bible before that of the Church, believing the Bible to be divinely inspired. In this painting Rembrandt shows St Matthew writing his Gospel, the words being suggested to him by an angel sent from God. The look on his face is contemplative: he is testing the words against his conscience in the belief that God (not the Church) will guide him directly towards the truth.

OTHER WORKS in the Louvre, Paris

The Bible Lecture or Anne and Tobias, 1645,
GERRIT DOU

La Cuisine des Anges, 1646, **MURILLO**

The Birth of the Virgin, 1661, **MURILLO**

The Pilgrims at Emmaus, 1648, **REMBRANDT**

St Bonaventure at the Council of Lyons, 1629,
ZURBARÁN

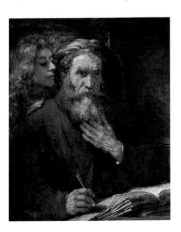

 Pietism; Absolutism; Emotionalism; Gesturalism

 Secularism; Rococo; 19th Century; Modernism; Post-Modernism

Gesturalism

Gesturalism denotes facial expressions and bodily postures which convey meanings that make an art work more intelligible. Gesture is an important aspect of all non-abstract art. Within the context of Baroque art, it also refers to the often complex groupings of figures in which a variety of gestures conveys a diversity of responses to the subject.

ANNIBALE CARRACCI (1560–1609); MICHELANGELO MERISI DA CARAVAGGIO (1571/2–1610); DOMENIKO THEOTOCOPOULOS called EL GRECO (1541–1641); GIOVANNI FRANCESCO BARBIERI called IL GUERCINO (1591–1666); NICOLAS POUSSIN (1594–1665); REMBRANDT HARMENSZ VAN RIJN (1606–69); PETER PAUL RUBENS (1577–1640); JAN VERMEER (1632–75)

facial expression; sensibilities; postures; complex narrative

Gesture is not the same as action, rather, it comments on action or reveals its meaning. In a painting which shows soldiers fighting, for instance, the fighting is not gestural. However, if a priest is shown in the foreground pointing at the sky with a look of joy on his face, both his pointing hand and facial expression can be understood as gestural. They comment on the action, suggesting Divine reward for loyal military service.

There are at least five distinct forms of gesturalism in Baroque painting. These include gestures which reveal or convey

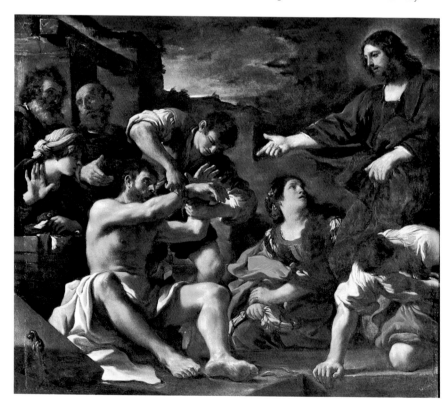

emotion and character. This was revered as a central goal of painting from the Renaissance onwards: the aim being to reveal the soul in the physical movements of the body.

Then there are gestures which indicate status and role and which are grounded, not in human emotion, but in social norms. This ranges from the portrait in which the sitter points at the books that indicate his learning, to the group portraits of physicians whose gestures indicate different aspects of their scientific enquiry.

Gesture also has the power to tell stories and indicate moral meanings, such as the example of the priest and the soldiers used above.

Gestures of everyday life, which convey private sensibilities and intimate feelings for the viewer's contemplation, are mostly associated with Dutch art, Vermeer in particular.

Finally, there is narrative gesture, which encompasses a wide range of different gestures in one painting to convey the full complexity of the event depicted. Baroque art often favoured crowded, dramatic scenes dominated by action. Such diversity of gesture in one painting heightened the viewer's dramatic and emotional involvement in its meaning.

KEY WORKS in the Louvre, Paris

The Raising of Lazarus, c.1619,
GIOVANNI FRANCESCO BARBIERI called **IL GUERCINO**
Il Guercino's *Raising of Lazarus* is typical of Baroque narrative gesture. Christ points at Lazarus as the ropes around his wrists (which symbolise our enslavement to death) are untied. On the left a woman raises her hand in a gesture of shock and surprise. The man behind her points at Lazarus explaining the significance of the event. The gestures guide the viewer through the painting: from Christ pointing at Lazarus (the miracle), to the shocked woman (emotional response) and back to Lazarus (the symbol) via the man in the background (the lesson).

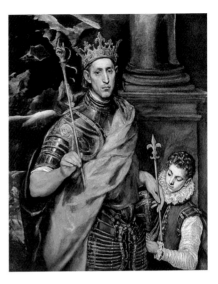

↑ *St Louis of France with a Page*, 1590s,
DOMENICO THEOTOCOPOULOS called **EL GRECO**
Saint Louis of France is portrayed holding a rod on top of which a hand is half-folded in the act of blessing. By depicting in this way a rod which is handed down from ruler to ruler, El Greco employs a subtle, politically significant use of a gesture that asserts the holiness, not just of St Louis, but of all the Kings of France descended from him.

OTHER WORKS in the Louvre, Paris

Acteon Changed into a Stag, c.1617,
FRANCESCO ALBANI

The Virgin Appearing to St Luke and St Catherine, 1592,
ANNIBALE CARRACCI

The Cheat with the Ace of Diamonds, c.1620–40,
GEORGE DE LA TOUR

The Last Supper, 1645, **LE NAIN brothers**

St John Baptizing, 1634–35, **NICOLAS POUSSIN**

Hersilia Separating Romulus from Tatius, c.1645,
NICOLAS POUSSIN

 Emotionalism; Pietism; Absolutism; Sectarianism; Caravaggism; Allegoricism; Mannerism; Academicism

 Modernism; Post-Modernism

Emotionalism

Baroque art appeals to, and often manipulates, viewers' emotions. It uses various techniques which minimise the literal and psychological distance between the art work and the viewer. The most characteristically 'Baroque' emotions are those associated with transformation or revelation characterised by a movement towards a powerful central subject, either divine or earthly.

MICHELANGELO MERISI DA CARAVAGGIO (c.1571–1610); DOMENIKO THEOTOCOPOULOS called **EL GRECO** (1541–1614); **BARTOLOMÉ ESTEBAN MURILLO** (c.1617–82); **JUSEPE DE RIBERA** (1591–1652); **DIEGO VELÁZQUEZ** (1599–1660); **FRANCISCO DE ZURBARÁN** (1598–1664)

transformation; submission; exclusion; elevation; ecstasy; piety; devotion

Baroque art presents moments of high drama and intense feeling as a means of appealing directly to our emotions. A typical technique is the use of chiaroscuro (the contrast between darkness and light in a painting) to give a painting greater dramatic impact. A face, illuminated by candlelight,

for instance, draws out our emotions at the same time as it draws in our gaze..

In many Baroque paintings the absence of any foreground gives the impression that the viewer is standing right beside the scene depicted in the painting. Again, the emphasis is on a response which bridges the emotional distance between us and the content of the painting.

At other times Baroque art arouses our emotions in order to reinforce feelings of exclusion and inferiority. This is particularly true of Baroque architecture and portraiture. Although Baroque architects loved grandeur as much as Renaissance architects, they subordinated the Classical principles of design to the building's overall emotional effect on those approaching and entering it. This is especially apparent in the interior decoration of the Palace of Versailles. Louis XIV employed painters and sculptors to create interiors which fulfil a simple function: they show all the arts in subordination to the King and united in overwhelming all those entering his presence.

This emotional union with a social or religious power which, at the same time, emphasises our subordination to that power, is the very essence of the Baroque art we associate with political absolutism and religious conformity.

KEY WORKS in the Prado, Madrid

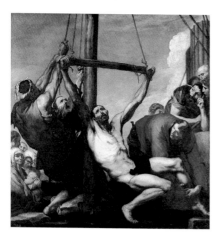

← *The Martyrdom of Saint Philip*, 1639, JUSEPE DE RIBERA
Ribera presents the martyrdom at the moment of maximum tension, just as the saint is about to be hoisted into the air. Ribera has minimised the foreground so that the viewer looks directly at the saint. His face is filled with suffering as he concentrates on God. The emotional intensity of the work is meant to move the viewer on Saint Philip's behalf and evoke feelings of sorrow, compassion and devotion in imitation of the Saint's virtuous example.

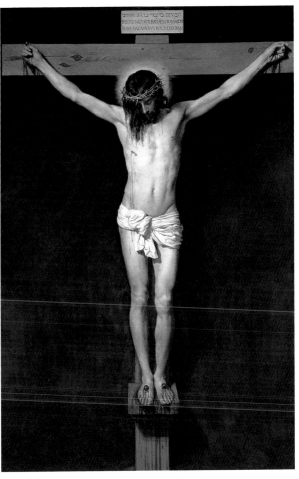

Christic on the Cross, c.1632, DIEGO VELÁZQUEZ
Velázquez's Christ on the Cross is astonishing in its realism. Its emotional immediacy is almost brutal. The viewer is confronted with Christ suffering on the cross in an image that dispenses with any depiction of the setting or other figures traditionally associated with the Crucifixion. There is no distancing foreground across which the viewer must look. Dramatic chiaroscuro prevents the viewer's gaze wandering away from Christ on the Cross. The viewer is alone with Christ in His suffering and death.

OTHER WORKS in the Prado, Madrid

David and Goliath, n.d., **CARAVAGGIO**

Saint Andrew and Saint Francis, c.1590–5, **EL GRECO**

Christ Carrying the Cross, c.1600–5, **EL GRECO**

The Holy Children with Shell, c.1678,
BARTOLOMÉ ESTEBAN MURILLO

The Immaculate Conception, c.1630,
FRANCISCO DE ZURBARÁN

 Gesturalism; Sectarianism; Pietism; Caravaggism; Naturalism; Romanticism

 Classicism; Baroque Classicism; Academicism; Neo-Classicism; 19th Century; Modernism; Post-Modernism

Caravaggism

In the first decade of the 17th century many Italian artists were influenced by the work of Caravaggio. He rejected the dominant Mannerist style, and Renaissance Idealism, in favour of greater Realism and dramatic painterly techniques, such as chiaroscuro. Caravaggio's influence also spread to Utrecht and reached its peak there in the 1620s and '30s.

GIOVANNI BATTISTA CARACCIOLO (1578–1635); MICHELANGELO MERISI DA CARAVAGGIO (c.1571–1610); ARTEMESIA GENTILESCHI (1593–c.1652); ORAZIO GENTILESCHI (1563–1639); GIOVANNI FRANCESCO BARBIERI called IL GUERCINO (1591–1666); GERRIT VAN HONTHORST (1592–1656); BARTOLOMMEO MANFREDI (1582–1622); JUSEPE DE RIBERA (1591–1652); GEORGES DE LA TOUR (1592–1652)

dramatic; chiaroscuro; close-up; erotic; physicality; reality; revelation

Caravaggio had an enormous impact on other artists and those who copied aspects of his work are known as Caravaggisti. Caravaggism is characterised by several traits, the first of which is its dramatic immediacy. Caravaggio's late work employed very strong chiaroscuro – the contrast between darkness and light. He also experimented with cropping his figures to give the impression that the dramas represented in his paintings were being observed close-up. These techniques, employed by the Caravaggisti, made their work vividly dramatic, strengthening the emotional impact and influencing subsequent Baroque art.

Caravaggism is also characterised by its greater realism. Rather than paint idealised figures the Caravaggisti preferred to follow the example of Caravaggio and paint religious figures as though they were ordinary people. Caravaggio's *Death of the Virgin* (Louvre, Paris) was rejected by the clergy who commissioned it. They were shocked to see the dead Virgin portrayed with her body swollen and her feet bare.

Lastly, Caravaggism carries with it a reputation for eroticism and physicality. The body seems to be simultaneously sexual and spiritual – a holistic appreciation of human nature. The covert refusal to show a preference for either the sexual or the spiritual is typical of the Caravaggisti.

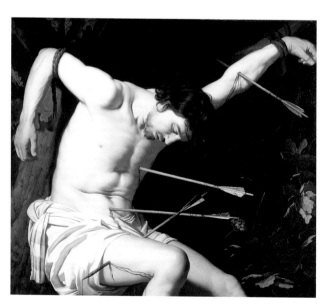

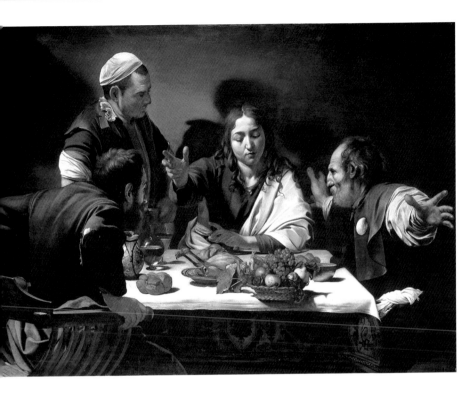

KEY WORKS in the National Gallery, London

↑ *The Supper at Emmaus*, 1601, MICHELANGELO
MERISI DA CARAVAGGIO
The disciple on the right stretches out both his arms
in shock. The effect of this is to bring the viewer closer
to the physical and emotional experience. The contrast
between the figures' movement and the still life on
the table is another common Caravaggisti technique for
strengthening dramatic immediacy. It is also implicitly
secular, suggesting that true prayer is a form of
private contemplation of human experience.

← *Saint Sebastian*, 1623, GERRIT VAN HONTHORST
Honthorst presents Saint Sebastian's body directly from
the side to give the impression that the viewer could
easily reach out and touch it. This physical immediacy
gives the painting greater dramatic power and erotic
tension – both of which are emphasised by placing the
saint's well-lit body against a dark background. Such
chiaroscuro is typical of the Caravaggisti.

OTHER WORKS in the National Gallery, London

Salome receives the Head of Saint John the Baptist,
1607–10, GERRIT VON HONTHORST

Christ Before the High Priest, 1617, **GERRIT VON
HONTHORST**

An Apostle, 1615–19, **JUSEPE DE RIBERA**

The Lamentation over the Dead Christ, early 1620s,
JUSEPE DE RIBERA

The Concert, 1626, **HENDRICK TERBRUGGHEN**

 Emotionalism; Gesturalism; Pietism;
Sectarianism; Realism; Materialism;
Social Realism

 Baroque Classicism; Idealism; Classicism;
Academicism; Neo-Classicism; Aestheticism;
Pre-Raphaelitism; Secessionism; Modernism;
Post-Modernism

Absolutism

Absolutism is a form of monarchical government in which the sovereign's rule is unchecked. It is most succinctly exemplified by Louis XIV's famous statement 'L'état, c'est moi' ('I am the State'). Absolutism depicts the pursuit, consolidation and expression of this power.

PHILIPPE DE CHAMPAIGNE (1602–74); ANTHONY VAN DYCK (1599–1641); CHARLES LE BRUN (1619–90); ADAM FRANS VAN DER MEULEN (1632–90); JOSEPH PARROCEL (1646–1704); HYACINTH RIGAUD (1659–1743); PETER PAUL RUBENS (1577–1640); THEODOOR VAN THULDEN (1606–69); DIEGO VELÁZQUEZ (1599–1660)

political power; virtue; propaganda; refinement; victory; royal patronage

Absolutism was derived from the older, feudal doctrine of the Divine Right of Kings. The Baroque period was the high-point of Absolutism as a form of government during which rulers openly expressed their belief in, and aspiration towards, absolute power. By the 18th century, the language of Absolutism was increasingly challenged by vested interests, public opinion, the Enlightenment, reform and revolution.

In France, under the reign of Louis XIV, history painting, allegorical painting and mythological subjects dominated the arts. These genres provided perfect canvases for Absolutist ideals and were used to aggrandize the power of Louis XIV and, through him, France's dominance of Europe. Royal commissions and Royal Academies were utilized to shape an official art and define public taste in which the person, power and preferences of the King were central.

Things were a little different in England. Rather than establish a Royal Academy, Charles I employed one of the era's greatest artists as 'court painter' to establish the popular image of the monarchy and set the trend in the visual arts. Van Dyck's portraits of Charles I and his court created an image of extreme refinement and understated piety. Similarly, in Spain, Philip IV appointed Velázquez court painter as part of a deliberate policy of re-establishing the glory of the Spanish monarchy through its art. Velázquez's portraits of Philip IV were more austere than any Royal portraits produced in France and England.

KEY WORKS in the Louvre, Paris

↓ *Louis XIV*, 1701, HYACINTHE RIGAUD
Rigaud's portrait of Louis XIV has all the formality of a piece of official art commissioned to provide a fitting image of absolute monarchy. The formal pose conveys confident authority. The sword emphasises Louis's military success. The legs are exposed to remind us of Louis's energy and vigour.

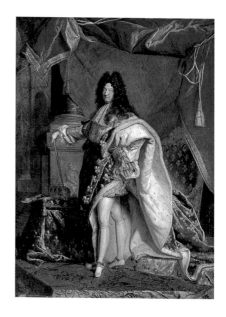

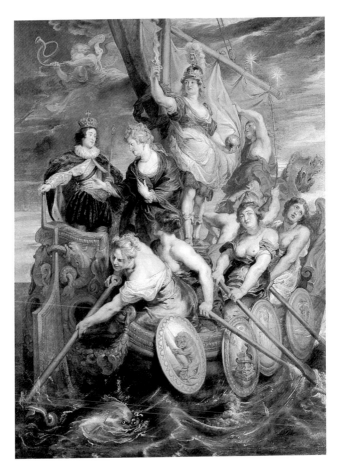

↑ *The Majority of Louis XIII*, **PETER PAUL RUBENS**
In this piece of propaganda, female figures representing the Virtues are rowing a boat which represents France. Louis XIII stands at the stern with his mother, Marie de' Medici. He wears a crown and is shown effortlessly guiding the Ship of State. The direction of the ship will be decided by Louis XIII alone, while the allegorical figures are meant to reassure us that Louis is both virtuous and victorious.

OTHER WORKS in the Louvre, Paris

Charles I, King of England, Hunting, c.1635,
ANTHONY VAN DYCK

Arrivée de Louis XIV au camp devant Maastricht,
c.1673, **ADAM FRANS VAN DER MEULEN**

Passage du Rhin par l'armée de Louis XIV, à Tolhuis 1699, 1699, **JOSEPH PARROCEL**

Coronation of Marie de' Medici, 1622–1625,
PETER PAUL RUBENS

Apotheosis of Henry IV, 1622–24, **PETER PAUL RUBENS**

L'Alliance de Louis XIV et de Philippe IV d'Espagne Représentation allégorique de la Paix des Pyrénées (1659), c.1660, **THEODOOR VAN THULDEN**

 Gesturalism; Emotionalism; Rococo;
Allegoricism; Monumentalism; Secularism

 Neo-Classicism; 19th Century; Modernism;
Post-Modernism

ROCOCO

This was a highly ornate, decorative style of art which was dominant in France during the reign of Louis XV (1715–74) and spread to other countries, most notably Austria and Germany. Rococo art favoured the complex, swirling forms of Baroque art but was airier and more graceful, preferring pleasurable, often voyeuristic, subject matter.

FRANÇOIS BOUCHER (1703–70);
JEAN-SIMÉON CHARDIN (1699–1779);
ÉTIENNE-MAURICE FALCONET (1716–91);
JEAN-HONORÉ FRAGONARD (1732–1806);
SEBASTIANO RICCI (1659–1734);
GIOVANNI BATTISTA TIEPOLO (1696–1770);
JEAN-ANTOINE WATTEAU (1684–1721)

decorative; voyeuristic; playfulness; titillation; ornate; contemplative; aristocratic; Madame de Pompadour; Louis XV

'Rococo' was originally a term of insult invented by a student of the Neo-Classical artist Jacques-Louis David. It described art which was as florid and busy as the shells and rocks used to line the walls of grottoes. The 'rococo' was closely associated with Louis XV's mistress Madame de Pompadour and was synonymous with feminised, corrupt, incompetent government and facile, erotic titillation. 'Rococo' is now used without such negative judgements.

Rococo began with the attempt to reform the teaching of Classical antiquity in the Academies. It introduced a greater playfulness and sensitivity to feelings and moods, exemplified by the work of Watteau. It also reacted against the formulaic insistence that artists work in the manner of Poussin, one of the leading figures of Baroque Classicism. Rococo

allowed art to abandon high seriousness in favour of eroticism, decoration and pleasure. It was interested in the world as a setting for imagined pleasures and reveries. Chardin and Watteau represent the Rococo at its most thoughtful and insightful.

Formally, Rococo was unlinear. The dominant line of Rococo art is an S-shape and the typical Rococo environment is the private room in which all the furniture, panelling and painting are elaborately decorated or carved in ornate, swirling shapes. Its formal similarity to the Baroque was significantly modified by its use of more obviously sensual colours (e.g. sky blue, rose pink) and its preference for easy, airy elegance and wit over more forceful emotional expression. After the decline of Rococo in the late 18th century, Neo-Classicists reasserted moral seriousness and austerity as their artistic principles, and looked back to Poussin for inspiration.

KEY WORKS in the Louvre, Paris

The Pilgrimage to Cythera, 1717, ANTOINE WATTEAU
Watteau's scene evokes a world of pleasure and beauty. His lovers, all in contemporary dress, have just made their offering to a statue of Venus, the goddess of love, and are returning home. There is a suggestion of loss and longing here, and an underlying fragility, which is uniquely Rococo. Watteau's feathery brush strokes have produced a ghost-like effect and silks that are shiny and translucent.

Bathers, c.1763–4, JEAN-HONORÉ FRAGONARD
Fragonard's *Bathers* is typical of Rococo's light-heartedness. This painting is unashamedly sensual and the viewer is instantly cast in the role of voyeur. The Rococo enjoyed glimpsing private worlds where women delight in their own bodies and indulge their capacity for pleasure. Every brush stroke conveys a playful sense of movement.

OTHER WORKS in the Louvre, Paris

Diane Sortant du Bain, 1742, FRANÇOIS BOUCHER

La Raie, 1725–1726, JEAN-SIMÉON CHARDIN

Les Curieuses, 1775–80, JEAN-HONORÉ FRAGONARD

Marie-Madeleine Guimard, 1769, JEAN-HONORÉ FRAGONARD

Hercule et Omphale, 1724, FRANÇOIS LEMOYNE

Caron Passant les Ombres, 1735, PIERRE SUBLEYRAS

Halte de Chasse, 1737, CHARLES-ANDRÉ, called CARLE VANLOO

Baroque, Allegoricism; Orientalism; Gesturalism

Academicism; Impressionism; Neo-Plasticism; Post-Modernism

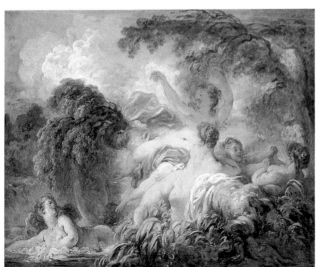

Academicism

Academicism is the codification of art into rules which can be taught in Academies. It promotes Classical ideals of beauty and artistic perfection and establishes a clear hierarchy within the visual arts, preferring grand narrative or history painting and advocating life-drawing and classical sculpture.

AGOSTINI CARRACCI (1557–1602); ANNIBALE CARRACCI (1560–1609); LUDOVICO CARRACCI (1555–1619); JACQUES LOUIS DAVID (1748–1825); CHARLES GLEYRE (1806–74); ANTOINE–JEAN GROS (1771–1835); JOSHUA REYNOLDS (1723–92); GEORGE STUBBS (1724–1806)

standards; rules; hierarchical; genre; life drawing; history; nobility; official art

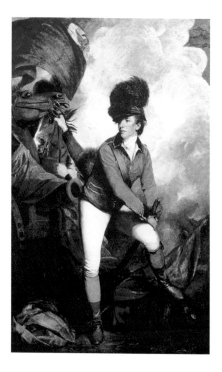

The history of the French Académie Royale de Peinture et de Sculpture typifies the conflicts aroused by Academic institutions and values. Poussin was the artist whose work and theories played the greatest role in first shaping Academicism. He emphasised subject, concept, structure and style. The subject must be noble, such as a battle or heroic action. The concept, such as nobility, must be intrinsic to the entire work and not added in as a theme. Structure should be as natural as possible but carefully arranged for coherence and fluidity so that the eye travels through the painting in a way which is appropriate to its subject and concept. Lastly, its style is a matter of individual talent in the handling of paint and the use of ideas. In this scheme, drawing was central. The values of Academicism were central to the Enlightenment project of discovering basic principles and ideals on which art could be securely established to ensure its beauty and truthfulness.

Many Academies were established around Europe in the 18th century and dominated the arts well into the 19th century. Most significant artists valued membership and actively pursued it.

Most of the major artistic movements of 19th century France developed outside and against Academic values. Romanticism, in particular, challenged the dominant Academic precept that art can be taught systematically. Many artists rejected the genres of Academic painting: the Grand Manner, mythical, religious and patriotic subjects and its emphasis on studying and drawing the human figure. The only significant change in Academic practice during the 19th century was the acceptance of landscape as a proper artistic genre – two centuries after it fully established itself during the Dutch Golden Age (1600–1700).

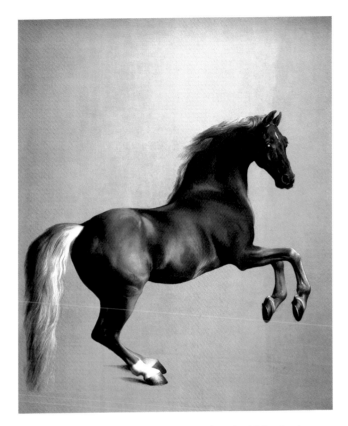

KEY WORKS in The National Gallery, London

Whistlejacket, 1762, **GEORGE STUBBS**
Stubb's *Whistlejacket* is an example of the meticulous attention to the figure which characterises Academic painting. Within the Academy tradition artists were expected to have a sound knowledge of anatomy. Stubbs's famous collection of engravings, *The Anatomy of the* Horse, was respected by artists and scientists alike.

Colonel Tarleton, 1782, **JOSHUA REYNOLDS**
Reynolds was one of the advocates of the 'grand manner' in painting. His *Colonel Tarleton* is a perfect example of the grand manner adapted for a portrait. The portrait displays Colonel Tarleton's military virtues – his nobility and bravery – and his personal triumph over everything base in human nature. His clothes are relatively plain and the activity in the background has been simplified to avoid any overt theatricality.

OTHER WORKS in The National Gallery, London

The Artist with his Wife and Daughter, 1748, **THOMAS GAINSBOROUGH**

The Morning Walk, 1785, **THOMAS GAINSBOROUGH**

Lord Heathfield of Gibraltar, 1787, **JOSHUA REYNOLDS**

Captain Robert Orme, 1756, **JOSHUA REYNOLDS**

Lady Cockburn and Her Three Eldest Sons, 1773, **JOSHUA REYNOLDS**

 Classicism; Humanism; Idealism; Baroque Classicism; Neo-Classicism

 Romanticism; Realism; Naturalism; Impressionism; Pre-Raphaelitism; Aestheticism; Symbolism; Secessionism; Modernism; Post-Modernism

Neo-Classicism

Neo-Classicism was the dominant artistic and intellectual movement in European art in the 18th and early 19th centuries. Neo-Classicism was motivated by a rejection of the Rococo, an interest in the Classical past as a means to understanding changes in the contemporary world, and the pursuit of moral seriousness which gave it strong connections with Academicism.

ANTONIO CANOVA (1757–1822); **JACQUES-LOUIS DAVID** (1748–1825); **JEAN-AUGUSTE-DOMINIQUE INGRES** (1780–1867); **ANGELICA KAUFFMANN** (1741–1807);

PIERRE-PAUL PRUD'HON (1758–1823); **JOSHUA REYNOLDS** (1723–92)

reason; order; enlightenment; virtue; scholarly; Classical values; new society

Neo-Classicism is closely identified with the Enlightenment of the 18th century and with the French Revolution. The Enlightenment was a broad intellectual movement which was characterised by its emphasis on reason and the rational. Enlightenment thinkers tended to look

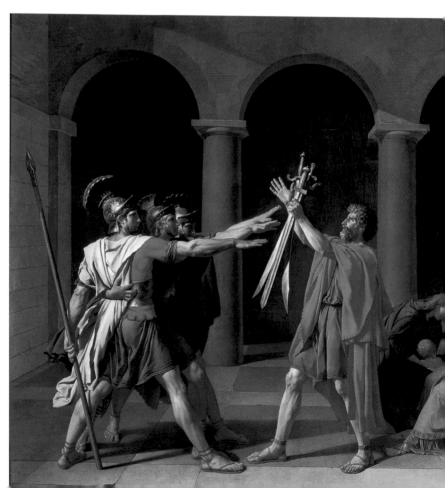

for universal rules, standards and goals in relation to which values and social practices ought to be judged, and objective, material means by which their benefits or disadvantages could be measured.

Neo-Classical art claimed an important role for itself as a shaper of morals and behaviour. Extensive archaeological excavation in Italy and Greece fuelled the study of the ancient world (its moral and aesthetic values, in particular) and encouraged a more rigorous sense of history and historical change. Neo-Classicists

weren't just reviving past styles but were attempting to use art to create a society which was both modern and virtuous.

Neo-Classical art tended towards a high moral seriousness verging on austerity. David is the most significant Neo-Classical painter of the period. Another, more contemporary influence on its moralising and rationalising impulse, was its rejection of the Rococo style which Enlightenment thinkers criticised and the French Revolutionists attacked because of its moral and political associations.

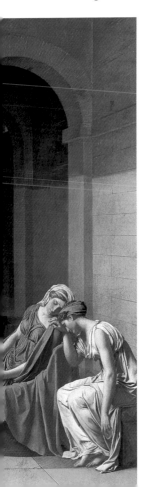

KEY WORKS in The Louvre, Paris

◄ *The Oath of the Horatii*, 1785, JACQUES-LOUIS DAVID
Neo-Classicism was not just a stylistic preference for classical imagery; it was an attempt to emulate the virtues of republican Rome. This painting is considered the manifesto of Neo-Classicism. It shows an episode from Roman history: the three Horatii brothers raise their arms to swear a solemn oath to conquer the enemy or die, while their father presents them with swords, and their sisters lament. Three arches in the background isolate the groups of figures and the stages of the story (oath; battle; grief). David emphasised virtues such as bravery, honour and loyalty, all of which were claimed by the Revolutionaries.

OTHER WORKS in The Louvre, Paris

The Love of Paris and Helen, 1789, JACQUES-LOUIS DAVID

Madame Récamier, 1800, JACQUES-LOUIS DAVID

Cupid and Psyche, 1798, BARON FRANÇOIS GÉRARD

The Apotheosis of Homer, 1827, JEAN-AUGUSTE-DOMINIQUE INGRES

Wounded Niobid, 1822, JAMES PRADIER

Empress Josephine in the Park at Malmaison, 1805, PIERRE-PAUL PRUD'HON

 Classicism; Humanism; Idealism; Academicism; Baroque Classicism

 Baroque; Mannerism; Rococo; Caravaggism; Modernism; Post-Modernism

THE 19TH CENTURY

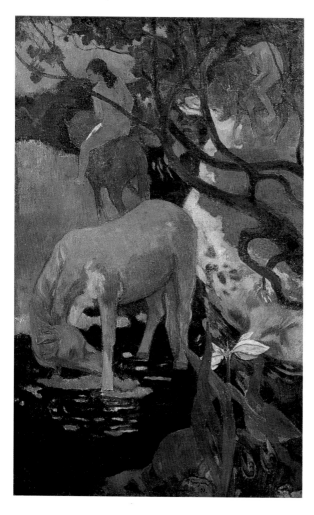

reaction; structure; non-academic; impressions; objectivity; subjective emotion; instincts; class politics; social vision; aesthete; empire; symbols; design

The art history of the 19th century opens with the dominance of Neo-Classicism, the art of moral high seriousness and political purposefulness, which was soon challenged by Romanticism. The Romantics believed the individual was the engine-force of history and progress. They emphasised the emotional, the irrational, the mystical, the intuitive and the symbolic over and above the completely rational and rule-bound. Romanticism began the process of freeing the artist from the authority of the Academies, social utility and the weight of public opinion, convention and good taste.

During the 19th century artists increasingly rejected the authority of Art Academies and reacted with greater ambivalence towards the commercial art trade in which conservative bourgeois taste played a significant role. These developments led towards a new era of experimentation in which France played a central role and artists became freer to explore the boundaries of art.

Realism also challenged the ideals of the Academies and public opinion by broadening the subject matter of art to include images of everyday life – often images of poverty or labour.

Impressionism abandoned the convention for representing natural appearance as solidly modelled forms. Impressionists replaced line and form with flashes of colour which convey the

impression of appearance but none of the solidity of objects. They also painted in the open air, thereby rejecting the Academic tradition of working in a studio from preparatory drawings.

Cézanne, Van Gogh and Gauguin can be considered the forefathers of the 20th century's many Modern-isms. They all shared a common commitment to an individual vision of what art is or can be. Between them, they consolidated a massive shift in the way artists thought about themselves. This was as significant as their many innovations in methods of representation and subject matter. Artists increasingly came to think of themselves as possessing a vision to which they had to remain true, even if that meant rejecting financial reward and social status. By the end of the 19th century the most avant-garde artists identified their artistry with their authenticity as individuals.

KEY WORKS in the Musee d'Orsay, Paris

← *The White Horse*, 1898, PAUL GAUGUIN
Gauguin used areas of pure, flat colour in his paintings. This enabled him to concentrate more on the design of his work and less on creating impressions of spatial depth or physical volume. This approach, and his fascination with a lost golden age of natural innocence, produced paintings rich in symbol and emotion. Gauguin inspired generations of artists to use their work to explore and express truths drawn from their life experience.

↓ *The Balcony*, 1868–9, EDOUARD MANET
In this work the people who buy art have themselves become the subject of art. Manet broke with Academic convention by painting broadly and loosely, as can be seen in the gloves and face of the woman on the right. Manet's paintings interpret the world around him, usually without moral or literary allusions, his candid eye recording things normally considered improper to transform into art. Manet's objectivity helped establish the artist's judgement above restrictive moral and social conventions.

OTHER WORKS in the Musee d'Orsay, Paris

The Birth of Venus, 1879, WILLIAM BOUGUEREAU

Woman with Coffee Pot, 1890–5, PAUL CÉZANNE

Self-Portrait, 1889, VINCENT VAN GOGH

The Angelus, 1857, JEAN-FRANÇOIS MILLET

Orpheus, 1865, GUSTAVE MOREAU

Woman with Black Boa, 1892, HENRI DE TOULOUSE-LAUTREC

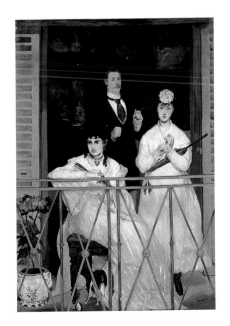

Romanticism

Romanticism was a very broad movement which developed as a reaction against Neo-Classicism. Romanticism valued human emotions, instincts and intuitions over a rational, rule-based approach to questions of value and meaning in the arts, society and politics.

WILLIAM BLAKE (1757–1827); EUGÈNE DELACROIX (1798–1863); CASPER DAVID FRIEDRICH (1774–1840); THÉODORE GÉRICAULT (1791–1824); JOSEPH MALLORD WILLIAM TURNER (1775–1881)

rebellion; freedom; symbol; intuition; emotion; the individual; truth

In its broadest use, 'Romantic' refers to any art work in which subjective states of mind, such as feelings, moods and intuitions, dominate. In the art of every era it is possible to distinguish between 'Romantic' art, in this general sense, and 'Classical' art, in which form, structure or rules of composition have greater importance. Both, however, are concerned

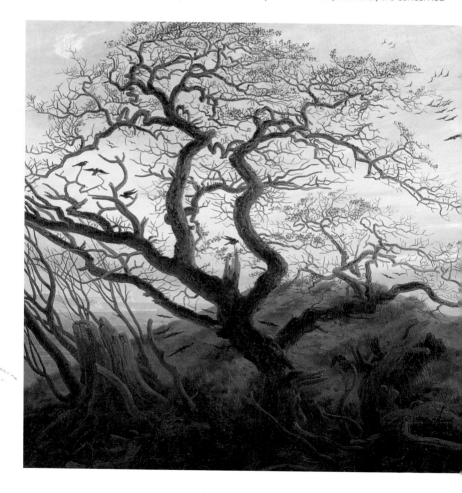

Romanticism

with the ideal. In the case of 19th century Romanticism 'the ideal' was authentic individual expression of experiences which could not be evaluated or assessed in purely rational or materialistic terms.

Definitions of Romanticism usually emphasise its rejection of rationalism but overlook its loathing of materialism – in particular the utilitarian attitudes which played so important a role in the Enlightenment's attack on the Church. Romanticism must also be understood as an attempt to salvage art from the utilitarian emphasis on art's 'usefulness' to society, bourgeois society in particular.

Romanticism rejected the Neo-Classical belief that man could be perfected through reason. It criticised the Enlightenment for its failure to accept the importance of the subjective – the irrational, the emotional, the spiritual. Romanticism embraced all these facets of experience and laid great emphasis on the sublime: usually an encounter with the immensity of nature in which man recognised both his own transience and his true moral character. Landscape painting developed extensively because of the Romantic fascination with nature.

Horror and the supernatural also played a role in Romanticism, partly as a result of the suffering caused by the Napoleonic Wars, partly because of the significance accorded to private worlds of myth and fantasy. Medieval, fantastical and contemporary historical subjects were prominent in Romantic painting.

KEY WORKS in The Louvre, Paris

◄ _Tree with Crows_, c.1822, **CASPER DAVID FRIEDRICH**
The tree looks dead but it is set against a sunset or sunrise, reminding us that death is inevitable, part of the cycle of nature and not to be feared. However, the painting invites a melancholy response in the viewer rather than a philosophical indifference. Romanticism privileged nature as a source of truths about human experience which could be most effectively expressed in art and best understood intuitively or emotionally.

OTHER WORKS in The Louvre, Paris

Liberty Leading the People (July 28, 1830), 1830, **EUGÈNE DELACROIX**

Lady Macbeth, 1784, **HENRY FUSELI**

Portrait of a Compulsive Gambler, c.1822, **THÉODORE GÉRICAULT**

The Raft of the Medusa, 1819, **THÉODORE GÉRICAULT**

Reading the Breviary, c.1854, **CARL SPITZWEG**

Landscape with Distant River and Bay, c.1845, **JOSEPH MALLORD WILLIAM TURNER**

 Medievalism; Orientalism; Primitivism; Expressionism; Neo-Expressionism

 Academicism; Classicism; Neo-Classicism; Realism; Materialism; Impressionism; Neo-Impressionism; Post-Impressionism; Dadaism; Surrealism; Conceptualism; Neo-Conceptualism; Sensationalism

Orientalism

Orientalism describes a tendency to portray the Near and Middle East in ways which appealed to the assumptions, tastes, fantasies, politics and prejudices of Western audiences.

EUGÈNE DELACROIX (1798–1863); WILLIAM HOLMAN HUNT (1827–1910); CHARLES GLEYRE (1806–1874); ANTOINE-JEAN GROS (1771–1835); JEAN-AUGUST-DOMINIQUE INGRES (1780–1867); FREDERIC LEIGHTON (1830–1896)

empire; fantasy; cruelty; opulence; eroticism; West depicts East; prejudice

British and French imperial expansion in the 19th century provided artists with more information about the Near and Middle East. The paintings which resulted were 'Orientalist' in the sense that they appeared to accurately represent the landscape, architecture and customs of this region. Despite their new-found accuracy of detail Orientalist paintings were often informed or motivated by assumptions about the Orient which arose, not from observation, but from preconceptions or prejudice. Accurate topographical detail was the perfect foil for works which indulged the imagination of Western audiences.

Orientalist works generally presented the Orient as backward and primitive, thereby justifying Imperialism as a 'civilizing' process. Whether they emphasised barbarism or nobility, images of the Orient were often arguments about the morality of the West.

Orientalist paintings also revelled in the supposed opulence and extravagance of the Orient. From harems to slave markets, the Orient was credited with a genius for pleasure and cruelty. The Orient could be luxurious or barbaric, the home of every hot-blooded passion, but it could not, like the West, be rational.

The Near East was believed to be largely unchanged since the times of the Old Testament patriarchs. Biblical paintings made use of ethnographic information about everything from architecture to jewellery to create, what appeared to Western audiences, 'authentic' images of Biblical history.

KEY WORKS in the Louvre, Paris

→ *The Massacre at Chios*, 1824, EUGÈNE DELACROIX
This scene illustrates a brutal episode during the Greek War of Independence from Turkey. The Greek cause was taken up by many Romantics, most notably Lord Byron. In *The Massacre at Chios* the Turks are shown to be ruthless killers of men, women and children. The head of the Turkish soldier on horseback is isolated against the sky to reinforce the apparent cruelty of his features.

↓ *The Turkish Bath*, 1862,
JEAN-AUGUST-DOMINIQUE INGRES
This is a classic Orientalist work in which Turkey is shown to be a land of enslaved females, naked, heavy-limbed and restless for love. The shape of the painting suggests that the scene is being glimpsed through a hole in a wall or door, adding to its erotic charge. This is a stolen glimpse of women kept under lock and key for the pleasure of men.

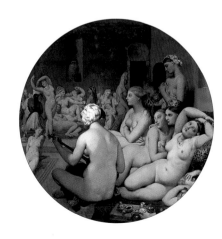

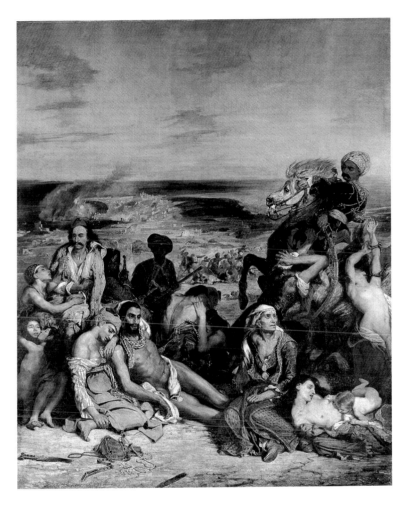

OTHER WORKS in the Louvre, Paris

Un Bain au Serial, 1849, THÉODORE CHASSÉRIAU

Women of Algiers in Their Apartment, 1834, **EUGÈNE DELACROIX**

Mort de Sardanapale, 1826–7, **EUGÈNE DELACROIX**

Grand Odalisque, 1819, **JEAN-AUGUSTE-DOMINIQUE INGRES**

Le Petite Baigneuse. Intérieur de harem, 1828, **JEAN-AUGUSTE-DOMINIQUE INGRES**

Ruines de la mosquée du khalife Hakem au Caire, c.1840–1846, **PROSPER MARILHAT**

Romanticism; Medievalism; Pre-Raphaelitism; Secessionism; Aestheticism; Symbolism; Primitivism; Expressionism

Academicism; Realism; Impressionism; Neo-Impressionism; Post-Impressionism; Classicism; Post-Modernism

Medievalism

Medievalism was a movement within the 19th century's broader Romantic reaction against both Neo-Classicism and Industrialisation. It looked back to the art and culture of the period leading up to the Renaissance as a time of greater spiritual and imaginative purity.

EDWARD BURNE-JONES (1833–98); PETER VON CORNELIUS (1783–1867); WILLIAM HOLMAN HUNT (1827–1910); JOHN EVERETT MILLAIS (1829–96); FRIEDRICH JOHANN OVERBECK (1789–1869); DANTE GABRIEL ROSSETTI (1828–82)

purity; craftsmanship; tradition; national character; chivalry; faith; industrialisation

Artists who were inclined towards Medievalism explored subjects drawn from literature and history. They were reacting against the disfiguring and dislocating effects of industrialisation, and against the artistic and commercial dominance of Neo-Classicism. For many of them, 'the Medieval' was synonymous with artistic sincerity, and stood in opposition to commercial Academic art produced in various Classical styles. When looking at Medievalist art, however, it is important to try and distinguish between the artists who were simply painting medieval scenes in contemporary Naturalistic styles, and those who were more deeply affected by it.

The medieval world provided an escape route for artists' imaginations. It also formed part of a cultural preoccupation with distinctive traits of national character and culture which might withstand the upheavals of revolution, reform and industrialisation. Like Orientalism, Medievalism was often a vehicle for exploring contemporary social and political issues.

an overall design, the Pre-Raphaelites preferred to concentrate on the naturalistic detail of the subject in its setting. They were supported in this by the critic John Ruskin who believed that the close observation of nature enabled artists to perceive God's presence in the world.

By the mid 1850s the three original founders of Pre-Raphaelitism were working less closely together. A second generation of Pre-Raphaelites formed around Rossetti towards the end of the decade. This group included William Morris and Edward Burne-Jones. The latter played a significant role in shifting Pre-Raphaelitism towards a more eclectic and mannered style which gave it strong affinities with Aestheticism.

KEY WORKS in Tate Britain, London

◄ *Ophelia*, 1851–2, JOHN EVERETT MILLAIS
Pre-Raphaelites often painted scenes derived from literature and, here, Millais depicts Ophelia's suicide in Shakespeare's *Hamlet*. Typically, the detail in the natural setting is as closely observed as that in the figure of Ophelia. Millais also invites the viewer to identify emotionally with this female character so traditionally symbolic of tragic grief, loss and madness.

OTHER WORKS in Tate Britain, London

Christ in the House of His Parents, 1849-50,
JOHN EVERETT MILLAIS

Proserpine, 1874, DANTE GABRIEL ROSSETTI

The Awakening Conscience, 1853,
WILLIAM HOLMAN HUNT

La Belle Iseult, 1858, WILLIAM MORRIS

Love and the Pilgrim, 1896-7, EDWARD BURNE-JONES

Rossetti. All three were students at the Royal Academy of Arts and rejected the Academic tradition in which they were trained. Raphael was the Renaissance painter most closely associated with the Academic tradition. The three artists chose the name 'Pre-Raphaelite' because they wanted to return to what they considered to be the painterly and spiritual 'purity' of art prior to Raphael. Instead of idealising the natural form and incorporating it within

Romanticism; Medievelism; Aestheticism; Naturalism; Symbolism; International Gothicism

Academicism; Realism; Materialism; Baroque; Rococo; Modernism; Post-Modernism

A mid to late 19th century movement, Realism claimed that the artist should represent the world as it is, even if this meant breaking artistic and social conventions. The subjects of many Realist paintings were considered immoral in their day because they broke with accepted standards of 'good taste'. Realism was at its strongest in France and its most important painter-advocates were Gustave Courbet and Edouard Manet.

GUSTAVE COURBET (1819–77); **HONORÉ DAUMIER** (1808–79); **EDGAR DEGAS** (1834–1917); **HENRI FANTIN LATOUR** (1836–1904); **EDOUARD MANET** (1832–1883); **ALFRED MENZEL** (1815–1905); **JAMES TISSOT** (1836–1902)

anti-bourgeois defiance; labourer; the real; social critique; contemporary nude; outrage

Realists attempted to record the world as they saw it and, as a result, their work was solidly focused on its subject matter and its emotional and social significance. In times of great disparity between social classes the results were always likely to be provocative. Realists were interested in freeing art from social conventions and exploring how society shapes people's lives.

Courbet's manifesto *La Réalisme* claimed that art should be an objective record of the world and that it should be guided by the artist's vision at the expense of hallowed notions about 'appropriate' and 'inappropriate' subject matter. Realism was a concerted attempt to liberate art and the artist from bourgeois taste. It drew inspiration from Romanticism but rejected Romanticism's emphasis on the individual artist's feelings. Courbet painted workers in 'real' nature, not in an idealised natural landscape, and they had the appearance of recognisable men and women – genuine labourers. He also rejected many of the painterly techniques associated

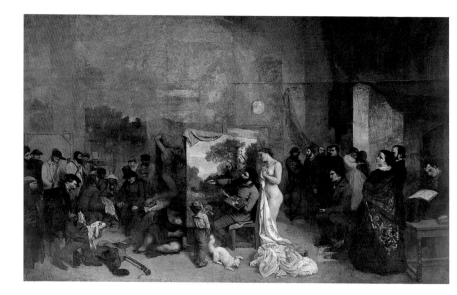

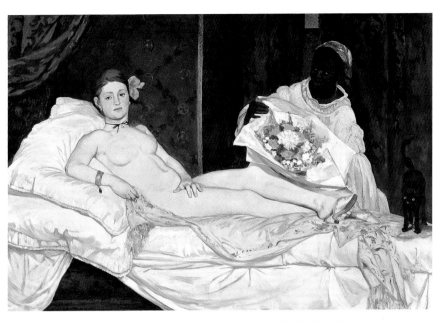

with fine art: his paintings began to look as rough as his subjects.

Other artists did not see their own versions of Realism as part of a broader programme of social and political change. Manet's realism was distinctly bourgeois and no less shocking – despite the lack of any political motivation or ideological commitment – simply by virtue of painting what he saw.

KEY WORKS in the Musée d'Orsay

The Artist's Studio, 1855, GUSTAVE COURBET
Realists aspired to paint what they saw, even what was dirty and unpleasant. *The Artist's Studio* can be read as Courbet's critique of this failure to engage with the real world as he saw it: the artist's studio is grimy and crowded, but the painting on his canvas shows a beautiful landscape which bears no relation to the world in which the artist lives. Courbet was also showing himself to be both a master of Realist painting and of the style of painting he was rejecting.

↑ *Olympia*, 1863, ÉDOUARD MANET
Manet's *Olympia* caused a scandal when it was exhibited at the 1865 Salon in Paris. Visitors to the Salon were used to nudity in painting – but they were used to seeing it in a Classical context. A nude was Venus, or a nymph, and usually alluded to a well–known myth or a passage in Classical history. In *Olympia* they saw a 'real' nude presented without reference to the Classical world, a prostitute who evoked the Parisian street rather than the Classical past.

OTHER WORKS in the Musée d'Orsay

The Floor Planers, 1875, GUSTAVE CAILLEBOTTE

Large Peasant, 1897–1902, AIMÉ-JULES DALOU

The Charge, 1902–3, ANDRÉ DEVAMBEZ

A Studio of the Batignolles Quarter, 1870, HENRI FANTIN-LATOUR

The Gleaners, 1857, JEAN-FRANCOIS MILLET

 Materialism; Naturalism; Caravaggism; Social Realism; Neo-Conceptualism; Sensationalism

 Idealism; Mannerism; Allegoricism; Absolutism; Romanticism; Medievalism; Orientalism; Aestheticism; Symbolism; Impressionism; Post-Impressionism; Modernism

Materialism

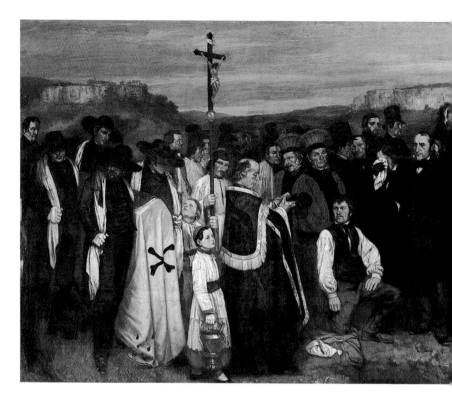

Materialist values were particularly evident in Realism and Social Realism, both of which explored the realities of people's lives. The term is used for a range of philosophies and attitudes which share a common belief that a person's moral, intellectual and emotional being is moulded by his environment. Materialism rejected Idealism and Romanticism.

GUSTAVE COURBET (1819–77); HONORÉ DAUMIER (1808–79); EDGAR DEGAS (1834–1917); HENRI FANTIN LATOUR (1836–1904); JEAN-FRANCOIS MILLET (1814–75); JAMES TISSOT (1836–1902)

the body; historical context; environment; socialism; social conscience; forces; processes; vision

Materialism has been a constant feature of western thought for as long as Idealism. It claims that the physical world shapes human identity, ideas and experiences, primarily through conditioning factors such as class, gender and nationality, in complete contradiction to Idealism which claims that we are the product, or expression, of inner forces such as a soul.

Courbet, the leading French Realist painter, rejected Romanticism and its emphasis on emotions. He considered emotions to be self-indulgent distractions from the realities of life and claimed that he could never paint an angel because he had never seen one. For committed Materialists any art which claims to be 'independent' of society is deeply suspect,

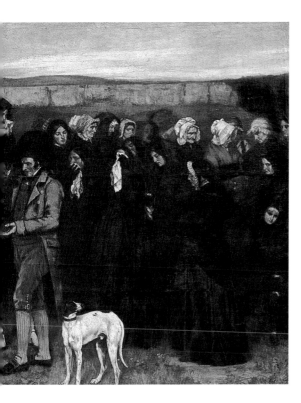

including movements as seemingly diverse as Impressionism, Aestheticism and Neo-Plasticism.

In contemporary art, Neo-Conceptualists are part of the Materialist tradition because they critique the way art and personal identity are shaped by economic and cultural forces.

OTHER WORKS in the Musée d'Orsay, Paris

Portrait of Mlle L. L., or Young Woman in a Red Jacket, 1864, **JAMES TISSOT**,

Luncheon on the Grass, 1863, Edouard Manet *Olympia*, 1863, **EDOUARD MANET**

Young Boy with a Cat, 1868-9, **PIERRE AUGUST RENOIR**

The Orchestra of the Opéra, c. 1870, **EDGAR DEGAS**

KEY WORKS in the Musée d'Orsay, Paris

The Burial at Ornans, 1849–50, **GUSTAVE COURBET**
Courbet presents an ordinary burial in his home region of Ornans. The work records the event as a real social ritual and has no overtly religious message. The painting's emotional impact rests on Courbet's observation of the physical stillness of a group of unknown people attending a funeral. The dead person is not the subject of the work and is not identified.

 Realism; Social Realism; Naturalism; Perspectivism; Gesturalism; Emotionalism

 Impressionism; Aestheticism; Symbolism; International Gothicism; Idealism; Humanism; Classicism; Baroque Classicism; Medievalism; Pre-Raphaelitism

Impressionism

Impressionism originated in France between 1860 and 1900 and local variants soon developed in most other western countries. The Impressionists rejected Academic traditions of representing the world. Their paintings evoke strong, but often subtle, perceptual impressions of sunlight, colour and shadow.

PAUL CÉZANNE (1839–1906); EDGAR DEGAS (1834–1917); CLAUDE MONET (1840–1926); CAMILLE PISSARRO (1830–1903); PIERRE-AUGUSTE RENOIR (1841–1919); ALFRED SISLEY (1839–99)

physical sensation; effects of light; movement; *en plein air*; bright colour

The term Impressionist was first used by hostile critics to describe a work which they considered 'unfinished' by the Academic standards of the day. The term was quickly taken up by the artists themselves. The subject matter of Impressionism is deceptively unsubversive. However, Impressionism rejected a number of Academic conventions and conservative critics were correct to see it as an assault on tradition.

The Impressionists were not interested in telling stories and painting morals. They left that to the Academic painters. Instead, they preferred to explore how paint could capture their sensory impressions. Above all, they wanted to evoke the sensations of light, colour and movement. They applied colour in looser, more distinct brush strokes rather than blending it into even shades and tones and they used lighter, brighter colours than the Academic painters. This serious-minded but playful pursuit of momentary

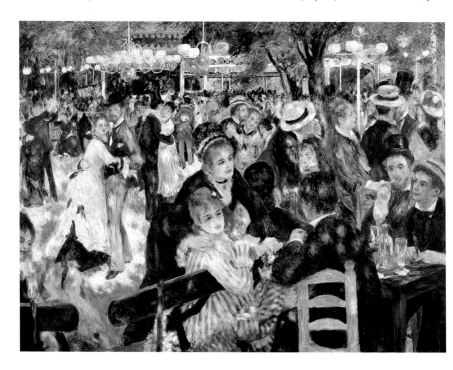

effect and sensation drew them away from traditional perspective and modelling. It also led them outdoors to paint *en plein air* (in the open air), where they could more directly engage with nature.

Many Impressionists became dissatisfied with the informal spontaneity of their work. From the 1880s onwards the movement's leading painters worked more independently of each other in an attempt to press beyond the techniques they had developed for capturing momentary effects.

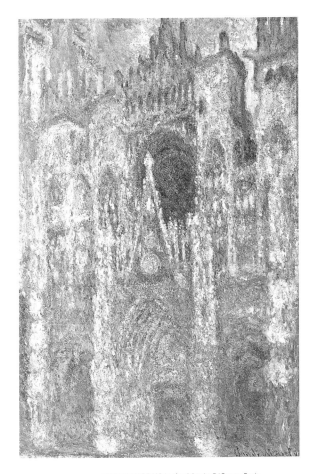

Key Works in the
Musée d'Orsay, Paris

Rouen Cathedral. Harmony in Blue, 1893, CLAUDE MONET
Monet painted Rouen Cathedral thirty times in an effort to capture the varied impressions of light on its gothic façade. In this version, the cathedral has been reduced to a pale filigree form. By painting it so many times Monet was implying that we can only know something properly through experiencing the full range of impressions and sensations it induces.

Dance at le Moulin de la Galette, Montmartre, 1876, AUGUSTE RENOIR
Renoir has used patches of paler colour to convey the impression of flickering light falling through leaves. This effect, combined with loose, blurred brushwork, also gives an impression of constant movement appropriate to a dance.

OTHER WORKS In the Musée D'Orsay, Paris

Saint-Lazare Station, 1877, **CLAUDE MONET**

Wind Effect, Series of the Poplars, 1891, **CLAUDE MONET**

The Swing, 1876, **PIERRE-AUGUST RENOIR**

Algerian Landscape. The Ravine of the Wild Woman, 1881, **PIERRE-AUGUST RENOIR**

 Neo-Impressionism; Post-Impressionism; Naturalism; Illusionism; Idealism; Fauvism

 Romanticism; Realism; Medievalism; Orientalism; Aestheticism; Symbolism; Classicism; Perspectivism; Academicism; Neo-Classicism; Modernism; Post-Modernism

Neo-Impressionism

 The Neo-Impressionists were a distinct group within the Impressionist movement. They formed a connecting corridor between the two larger movements of Impressionism and Post-Impressionism. The Neo-Impressionists were less concerned with painting spontaneously and more interested in the preparatory and technical aspects of design and colour forms.

 CAMILLE PISSARRO (1830–1903); LUCIEN PISSARRO (1863–1944); PAUL SIGNAC (1863–1935); GEORGES SEURAT (1859–91)

colour theory; pointillism; divisionism; dots; strokes; monumental stillness

This term was first used to describe the work of a group of Impressionist artists who requested that their work be shown together in a single room at the last Impressionist exhibition in 1886.

Unlike the Impressionists, the Neo-Impressionists were less interested in evoking spontaneity and movement. Seurat laboured intensively on preparatory studies for up to a year before beginning to work on the final painting. He also talked about 'organising' the colour on his canvas. This emphasis on design accounts for the static, unmoving quality of many Neo-Impressionist paintings, some of which are characterised by an almost monumental sense of stillness.

All Impressionists valued colour, but the Neo-Impressionists were the only artists to develop working methods where theories about colour, and how our eyes register it, were combined with theories of paint application. Pointillism and Divisionism are the two most significant of these theory-based methods. Pointillism refers to the tiny dots of colour which were applied to canvases to build an effect of shimmering

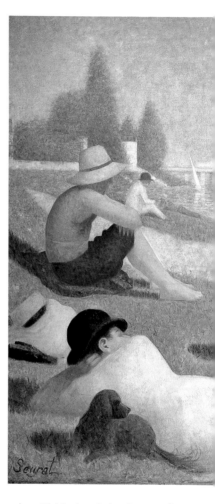

colour. Divisionism derives its name from the method of using different colours in distinct dots or strokes.

KEY WORKS in the National Gallery, London

↑ *Bathers at Asnières*, 1884, GEORGES SEURAT
Seurat completed at least fourteen oil sketches and ten drawings before painting *Bathers at Asnières*. For the bathers, and for Seurat himself, this simple moment of leisure captured in shimmering paint disguises the enormous amount of labour that made it possible.

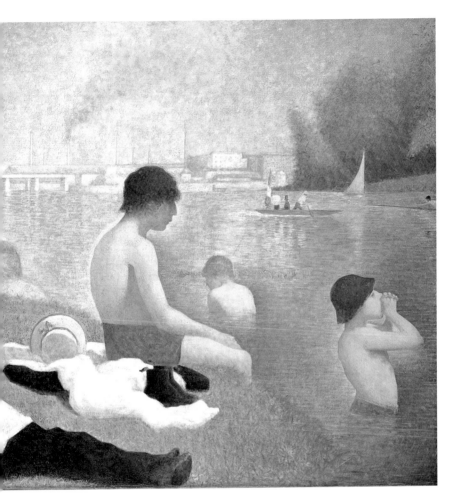

Asnières was an industrial area and factories can be seen in the distance. Great care was taken with the painting's design and colour and the result is a complete sense of stillness, of a moment in time captured forever, as though etched in stone.

Bathers at Asnières predated Seurat's development of Pointillism. Later, he returned to this work and repainted the hat worn by the boy in the river using the dots of paint which are definitive of pointillist technique.

OTHER WORKS in the National Gallery, London

The Little Country Maid, 1882, **CAMILLE PISSARRO**

The Pork Butcher, 1883, **CAMILLE PISSARRO**

Le Bec du Hoc, 1885, **GEORGES SEURAT**

The Seine seen from La Grande Jatte, 1888,
GEORGES SEURAT

The Channel of Gravelines, Grand Fort Philippe, 1890,
GEORGES SEURAT

 Impressionism; Post-Impressionism;
Naturalism; Illusionism; Idealism

 Romanticism; Realism; Medievalism;
Orientalism; Aestheticism; Symbolism;
Classicism; Perspectivism; Academicism;
Neo-Classicism; Modernism; Post-Modernism

Secessionism

This term was used by German and Austrian artists who broke with the traditions of the art Academies at the end of the 19th century. Secession artists wanted independent exhibitions, which would enable artistic experimentation. The three most significant Secessions were those of Munich, Berlin and Vienna.

LOVIS CORINTH (1858–1925); FERDINAND HODLER (1853–1918); GUSTAV KLIMT (1862–1918); OSKAR KOKOSCHKA (1886–1980); MAX LIEBERMANN (1847–1935); MAX SLEVOGT (1862–1932); EGON SCHIELE (1890–1918); FRANZ VON STUCK (1862–1928); FRITZ VON UHDE (1848–1911)

decorative style; flatness; ritual sophistication; suggestiveness

The Munich Secession arose out of disputes within the Munich art world in 1892. Of the three Secessions explored here, the Munich Secession was least shaped by a repressive Academic tradition. Although the Munich Secession showed

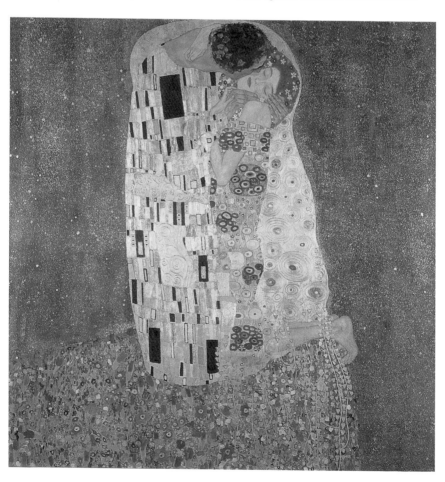

some avant-garde work it also included a large amount of Naturalistic and Impressionistic painting and was not strongly associated with the period's most experimental artists.

The Berlin Secession was formed in 1898 and quickly established itself as the voice of opposition to the conservatism of Berlin's tradition of Academic painting. Impressionism, and later Post-Impressionism, were welcomed by the Berlin Secession, but mixed responses to Expressionism caused the group to break up in 1913.

The Vienna Secession was founded by Gustav Klimt in 1897. The most distinctive work of this group of painters combined a flat, decorative style with subtle, often strong, use of colour. Their works are often suggestiveness of ambiguous emotional states and attitudes that invite the viewer to make sophisticated readings of the works. The Vienna Secession can be seen as a bridge between 19th century Aestheticism and 20th century Modernism. By 1905 the Vienna Secession was divided into two groups: on one side, those who supported Klimt and wanted to establish links between art and commerce; on the other, Naturalists who wanted to re-assert the primacy of the arts.

↑ *Mother with Two Children*, 1917, EGON SCHIELE
Schiele was a young artist in the last days of Viennese Secessionism and this work reveals the lasting influence of Gustav Klimt. Schiele's emotionally intense work developed into Expressionism and helped bring Viennese Secessionism to an end. But his stylisation of the human figure where it becomes part of a flattened, decorative pattern – both features of *Mother with Two Children* – remained characteristic of his work until his early death in 1918.

OTHER WORKS in the Österreichische Galerie Belvedere, Vienna

Judith, 1901, **GUSTAV KLIMT**

Water Serpents I, 1904–7, **GUSTAV KLIMT**

Farmhouse in Upper Austria, 1911, **GUSTAV KLIMT**

Avenue in the Park at Schloss Kammer, 1912, **GUSTAV KLIMT**

Portrait of Eduard Kosmack, 1910, **EGON SCHIELE**

KEY WORKS in the Österreichische Galerie Belvedere, Vienna

◄ *The Kiss*, 1907–8, GUSTAV KLIMT
Klimt's painting evokes an idealised world rendered in decorative colour, shimmering gold and abstract patterns. A couple kiss on a carpet of flowers and the woman kneels before the man suggesting a ritual of presentation and offering. The ideal, the decorative and the ritualistic are key features which distinguish Vienese Secessionism from the other main Secessionist groups.

 Romanticism; Medievalism; Aestheticism; Symbolism; Impressionism; Neo-Impressionism; Post-Impressionism; Expressionism

 Realism; Materialism; Academicism; Social Realism

Initially a 19th century literary movement led by writers like Oscar Wilde and Joris Karl Huysmans, Aestheticism soon found advocates among artists who wanted to liberate art from morality, politics and social purpose. Aestheticism was the more general Movement from which Symbolism developed.

EDWARD BURNE-JONES (1833–98); ALBERT MOORE (1841–93); GUSTAVE MOREAU (1826–98); ODILON REDON (1840–1916); JAMES ABBOTT MCNEILL WHISTLER (1834–1903)

'art for art's sake'; harmonies; suggestion; detached emotion

As a general cultural trend, viewer. Aestheticism was characterised by an interest in Japanese art, the evocation of subtle moods, the exploration of sophisticated colour combinations, an emphasis on the artifice of art, the occasional description of one art form in terms of another, and a delight in paradox and epigrammatic wit.

Inspired by the Aesthetes of the literary movement, Aesthetic artists tried to provoke a complex and highly nuanced assortment of sensuous and intellectual responses in the viewer. Subtle and complex colour harmony was more important than illustrating a story or moral viewpoint. The

work as art object was more important than the subject of the painting.

Aesthetes demanded that the viewer have sufficient 'disinterest', or detachment, to distinguish between feelings provoked by a painting's subject matter, and, in their view, its more important qualities as a work of beauty in itself. This 'responsiveness' to art is the connecting thread between Aestheticism's insistence on art's independence from life and their scorn for the bourgeoisie. Artists and writers associated with this movement had a lasting impact on the art of the 20th century.

◄ *Nocturne: Black and Gold – The Fire Wheel*, 1875, JAMES ABBOTT MCNEILL WHISTLER

When he named this work Whistler subordinated his subject matter – the fire wheel – to an evocative title. He wanted to draw attention to the dominance of black and gold in the painting. Other night studies of the same period were also called 'nocturnes', which alludes to the nocturnes for piano composed by Chopin. Whistler's purpose was to evoke moods and emotions associated with colour and music. This would enhance our appreciation of the painting as an art object, rather than as a picture of a fire wheel.

OTHER WORKS in Tate Britain, London

Blossoms, 1881, **ALBERT MOORE**

The Toilette, 1886, **ALBERT MOORE**

Three Figures: Pink and Grey, 1868–78, **JAMES ABBOTT MCNEILL WHISTLER**

Nocturne: Blue and Silver – Chelsea, 1871, **JAMES ABBOTT MCNEILL WHISTLER**

Harmony in Grey and Green: Miss Cicely Alexander, 1872–4, **JAMES ABBOTT MCNEILL WHISTLER**

 Medievalism; Pre-Raphaelitism; Orientalism; Symbolism; Romanticism; Impressionism; Neo-Impressionism; Post-Impressionism; Modernism

 Materialism; Naturalism; Realism

Britain, London

75, ALBERT MOORE

ies and a decorative emphasis
se this Aesthetic painting.
al elements with Japanese fans
f the artist's studio rather than the
tic suggestion of nakedness
s the sleeping girl with the vase
the foreground, suggesting that
ects for the spectator to

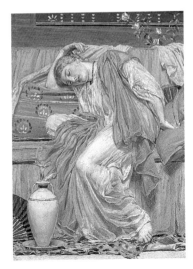

Symbolism

Symbolism emerged in the 1880s and was eclipsed by the rise of Modernism. Symbolist art subverted bourgeois conventions and emphasised disturbing and disturbed states of mind. It was often influenced by spiritualism, anarchism and socialism – all systems of belief alien to the bourgeois world.

AUBREY BEARDSLEY (1872–1898); **ARNOLD BÖCKLIN** (1827–1901); PUVIS DE CHAVANNES (1824–1898); **PAUL GAUGUIN** (1848–1903); **JAMES ENSOR** (1860–1949); **GUSTAV KLIMT** (1862–1918); **GUSTAVE MOREAU** (1826–1898); **EDVARD MUNCH** (1863–1944); **ODILON REDON** (1840–1916); HENRI ROUSSEAU (1844–1910)

disturbance; emotion; the uncanny; anarchy; spiritualism; esoteric; perversity

In many respects the Symbolist movement was a reaction against the 19th century's belief in the advance of science and technology – variously referred to as materialism and positivism. Symbolism explored what these left out: the life of the spirit, the mysterious, uncanny, the unknown or the unspeakable.

Symbolists such as Gauguin emphasised that the emotional response to art is more important than the intellectual and that the artist must paint on the basis of his intuition and imagination rather than observation and description. His own style utilised plain, unmixed colours and simplified forms outlined in black. It was very influential.

Symbolist paintings are suggestive of another reality rather than descriptive of the physical world. Melancholy, sexuality and disturbance are central to Symbolism. Its images make use of dreams, nightmares and altered states in a manner which prefigures Surrealism, Dadaism and Expressionism.

Where nature appears it is often threatening or deranged. Symbolists tried to reveal its dark inner meaning rather than its familiar appearance. The dandy with his esoteric pursuits, strange clothes, epigrams and scandalous pleasures was a central Symbolist figure. Another important Symbolist figure is the androgyne displaying an ambivalent sexuality through a body that evokes disconcerting and contradictory fears and desires.

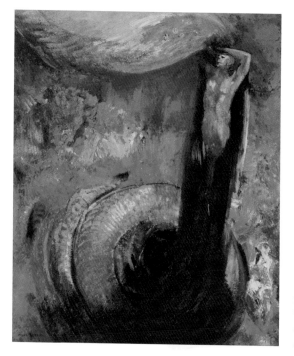

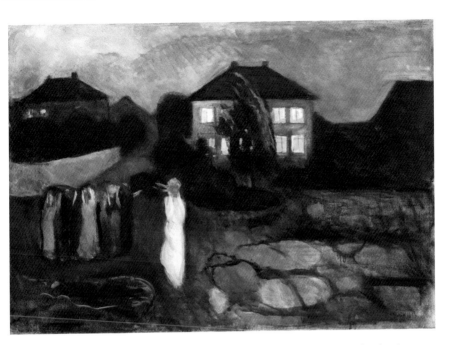

KEY WORKS in the Museum of Modern Art, New York

The Storm, 1893, EDVARD MUNCH

The storm is not only a physical event but an emotional one, too. The figures are simplified to the point of anonymity, only their gender is indicated. The isolated female figure in the foreground is dressed in white, the traditional colour of innocence, suggesting that the storm is in some way connected with this figure's virginity or youthfulness. Most of the painting's emotional impact is derived from the implication of lost innocence and the unsettling contrast between the painting's silence, the noise suggested by the storm and the young woman's anguish.

Green Death, c.1905, ODILON REDON

A green figure seems to rise up from a coiled snake. Contemporary viewers would have recognised the lurid green as an allusion to the drink Absinthe which was associated with inspiration, excess and fantastical mental states – all of which Symbolism valued and explored. Here, the 'green death' could be the death of reason under the influence of intoxication, or the suspension of conventional patterns of thinking and feeling during visionary, artistic experiences.

OTHER WORKS in the Museum of Modern Art, New York

Iron Bridges at Asnieres, 1887, ÉMILE BERNARD

Tribulations of St Anthony, 1887, **JAMES ENSOR**

Masks Confronting Death, 1888, **JAMES ENSOR**

Hope II, 1907–8, **GUSTAV KLIMT**

Brooding Woman, 1904, **PICASSO**

 Pre-Raphaelitism; Aestheticism; Primitivism; Post-Impressionism; Expressionism

 Romanticism; Orientalism; Naturalism; Perspectivism; Pietism; Post-Modernism

Post-Impressionism

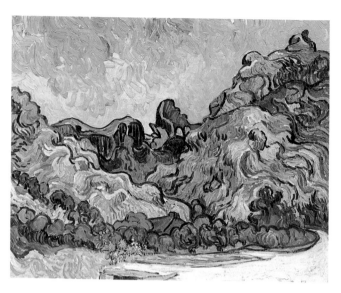

🌓 This is a very broad term used to cover much art produced between the 1880s and the early 20th century. Gauguin, Cézanne and Van Gogh are the most significant artists associated with the movement. 'Post-Impressionism' was coined by the English critic Roger Fry for his exhibition *Manet and the Post-Impressionists* in London (1910–11).

�']

🌑 PAUL CÉZANNE (1839–1906); PAUL GAUGUIN (1848–1903); VINCENT VAN GOGH (1853–90); ODILON REDON (1840–1916); MAURICE DE VLAMINCK (1876–1958)

🌘 communicate emotion; structure; design; symbolic meaning; significant form; early modernism; social vision

🌑 The Post-Impressionists had no common artistic goal. Roger Fry chose to show their work alongside paintings by Manet to indicate where they were coming from and what they were leaving behind. With his *Déjeuner sur l'herbe* Manet asserted his freedom to break with tradition in pursuit of his own vision. The Post-Impressionists identified with this goal but wished to take it further, completely rejecting most bourgeois standards of taste. Like Manet, they were also dissatisfied with Impressionism's insistent pre-occupation with nature, light and momentary impressions.

Characteristic of this broad, anti-bourgeois movement is a focus on design and structure and a refusal to imitate nature or moralise through narrative subjects. This emphasis on form recovered the significance of art's symbolic, spiritual and emotional meaning.

Cézanne was a central figure for the Post-Impressionists and features of his work cast light on the rest of the group. Cézanne approached his painting as something which had to be designed and given a shape. Likewise, Gauguin structured his works to convey what he thought was the spiritual truth of his subject matter. He focused on design too, painting in flat areas of colour and abandoning traditional, naturalistic preoccupations with modelling, spatial depth and effects of light in favour of symbolic and emotional meaning.

KEY WORKS in the Solomon R. Guggenheim Museum, New York

Mountains at Saint-Rémy, 1889,
VINCENT VAN GOGH
Brightly coloured and painted with heavy brush strokes, this is typical of Van Gogh's later work and of Post-Impressionism's preference for strong colour and simplified forms. Van Gogh's painting was informed by his emotional response to the mountains of Saint-Rémy. This exemplifies the Post-Impressionist aim to communicate emotion in ways which subvert social constraints on communication.

Still Life: Flask, Glass and Jug, c.1877,
PAUL CÉZANNE
This work is typical of Post-Impressionism's preoccupation with the structure of painting. Cézanne was less interested in capturing a convincing likeness of a flask, glass and jug than in exploring their volume and the space they inhabited. The rim of the glass is seen at the wrong angle and seems to be higher than

it would be if it was actually sitting on the same surface as the flask and jug. This liberation from conventional methods greatly influenced Cubism.

OTHER WORKS in the Solomon R. Guggenheim Museum

Man with Crossed Arms, 1889, **PAUL CÉZANNE**

Haere Mai, 1891, **PAUL GAUGUIN**

Le Moulin de la Galette, 1900, **PABLO PICASSO**

Artillerymen, c 1893–95, **HENRY ROUSSEAU**

Farm Women at Work, 1882–3, GEORGES SEURAT

 Impressionism; Neo-Impressionism; Secessionism; Modernism

 Romanticism; Realism; Medievalism; Orientalism; Classicism; Academicism; Neo-Classicism; Post-Modernism

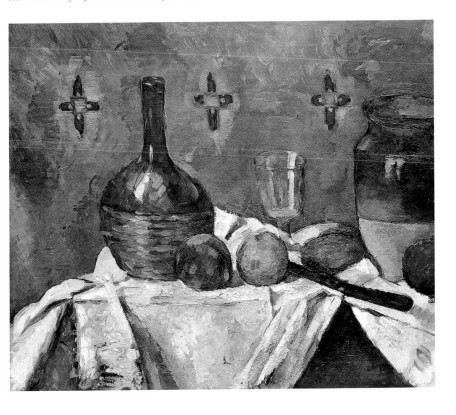

4

MODERNISM

Modernism was a broad movement encompassing all the avant-garde isms of the first half of the 20th century. Although different modern-isms were often incompatible (and occasionally antagonistic) they all rejected the dominance of Naturalism and Academicism in favour of experimental art.

The common trend was to seek answers to fundamental questions about the nature of art and human experience.

experimental; radical; ready made; primitive; the unconscious; spiritual order; expressive truth; art and industry; internationalism

All modern-isms shared a common feeling that the modern world was fundamentally different from what had passed before and that art needed to renew itself by confronting and exploring its own modernity. For some this meant rejecting the industrial in favour of the primitive (Primitivism), for others a celebration of technology and machinery (Futurism).

In Modernism generally, the artist's exploration of his or her vision was paramount. Although this trend was already evident in the 19th century, it became an orthodoxy for Modernists.

Certain modern-isms began to question what art is, what it is for and what it supports. Through this process artistic activity and cultural critique became more closely identified with each other. The Dadaists displaced the individual entirely, replacing him with the unconscious.

Modern-isms contested between themselves whether art should explore emotions and states of mind (Expressionism), spiritual order (Neo-Plasticism), social function (Constructivism), the unconscious (Surrealism), the nature of representation (Cubism) or the social role of art in a capitalist, bourgeois society (Dadaism). Many of these trends overlapped with one another.

Art increasingly became a means of discovering truth, whether a peculiarly modern truth (Futurism) or a universal truth (Suprematism).

KEY WORKS in the Solomon R. Guggenheim Museum, New York

→ *Carafe, Jug, and Fruit Bowl*, 1909, PABLO PICASSO
Cubism, of which this painting is an example, is regarded as the most important modern-ism. Like many modern-isms, it makes intellect central to art. It systematically explores the relation between art and what it represents, thereby completely abandoning the Naturalistic aim to paint things 'simply' as they appear to the observer. Instead, Cubists sought to convey an object's existence in time and space, representing the object from different vantages. They explored how paintings are constructed, and how they function as works of art, making explicit the questions: what is art? And: what does art represent?

↙ *Overturned Blue Shoe with Two Heels Under a Black Vault*, c.1925, JEAN ARP
The unconscious, valued for its creative powers, became central to many modern-isms, not least for the Dadaists and Surrealists who tapped into it as the source of authentic, irrational creativity. The title of Arp's work is intended to be humorous and make us pay more attention to the work itself. Arp compared his creativity to natural forces of growth. The shapes in *Overturned* evoke the change and movement of living organisms and are meant to refute the rationalising preference for fixed forms and definite meanings in favour of the uncertain and the undefined.

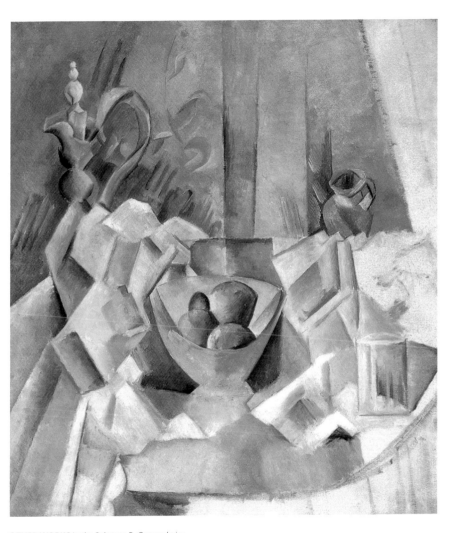

OTHER WORKS in the Solomon R. Guggenheim
Museum, New York

Dynamism of a Speeding Horse + Houses, 1914–15,
UMBERTO BOCCIONI

The Soldier Drinks, 1911–12, **MARC CHAGALL**

Knight Errant, 1915, **OSKAR KOKOSCHKA**

In the Black Square, June 1923, **WASSILY KANDINSKY**

Composition No. 1, 1930, **PIET MONDRIAN**

Anchored Cross, 1933, **ANTOINE PEVSNER**

Fauvism

The term 'Fauve', meaning 'wild beasts', was originally used disparagingly in 1905 by conservative art critic Louis Vauxalles. The artists he was criticising appropriated his term to celebrate their own sense of creative freedom. Many modern artists have used 'wild' colour but the term 'Fauve' is only applied to a small group of artists, mostly friends, working in France between 1898 and 1908.

ANDRE DERAIN (1880–1954); **KEES VAN DONGEN** (1877–1968); **HENRI MATISSE** (1869–1954); **GEORGES ROUAULT** (1871–1958); **MAURICE DE VLAMINCK** (1876–1958)

patterns of colour, simplified scenes, flatness; intensity; non-naturalistic

The Fauves were influenced by Van Gogh and Gauguin and the central Fauve artists were Henri Matisse, André Derain and Maurice de Vlaminck. The group first exhibited together at the Salon d'Automne of 1905 where their work caused a sensation. And it was here that the appellation 'Fauve' originated.

Derain and de Vlaminck in particular often applied their intense colours with thick, heavy brush strokes reminiscent of Van Gogh's work. The Fauves used these strong colours straight from the tube and applied them directly to the canvas without mixing or shading. Fauvist paintings show the world simplified into vivid shapes where much detail is omitted. As a result, the paintings often look like brightly patterned flat surfaces.

In a Fauvist landscape distant hills don't look distant, they are simply one part of an overall pattern of colour. Derain reduced London's bridges to simple shapes rendered in solid colours and the human figure was frequently depicted in the same way.

The Fauves were unconstrained by the actual colour of their subject matter, so trees could be painted orange, the sky pink, a face green. Shadows were usually represented by another colour rather than a darker version of the same, so that a shadow on grass might be navy or red rather than dark green.

A retrospective exhibition of Cezanne's work at the Salon d'Automne encouraged the Fauves to explore different aspects of their individual styles and helped bring about the dissolution of Fauvism.

KEY WORKS In the Museum of Modern Art, New York

◄ *Modjesko, Soprano Singer*, 1908,
KEES VAN DONGEN
Van Dongen's soprano is reduced to a flat yellow shape with little attempt to create the impression of a three-dimensional human body. She casts a red and orange shadow on a solid pink background. The stark brilliance of the yellow amidst the other blocks of colour help express a dynamicism and energy befitting the painting's subject.

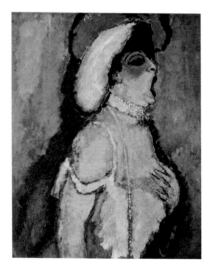

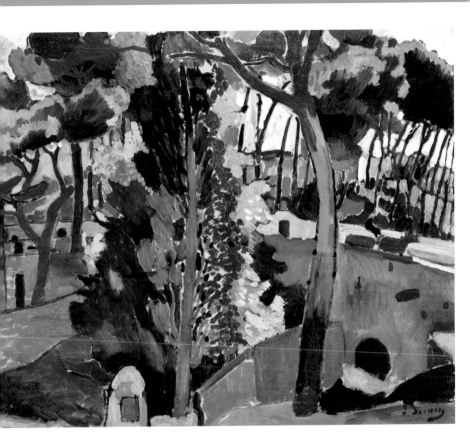

Bridge over the Riou, 1906,
ANDRÉ DERAIN
Derain may have painted this during the summer of
1906 when he met and struck up an important
friendship with Picasso. Derain has simplified his
landscape subject matter into a colourful pattern that
flattens the landscape almost entirely. It's difficult to
work out what is in the foreground and what is in
the distance. Shadow and light are shown as different
(though related) colours rather than as darker and
lighter shades of the same colour. Derain uses a
characteristic intensity of colour to capture the
vividness and heat of the Cote d'Azur landscape
and climate.

OTHER WORKS In the Museum of Modern Art,
New York

London Bridge, 1906, **ANDRÉ DERAIN**

Study for Luxe, Calme et Volupté, 1904,
HENRI MATISSE

Landscape at Collioure, 1905, **HENRI MATISSE**

Autumn Landscape, c.1905, **MAURICE DE VLAMINCK**

Primitivism; Expressionism;
Post-Impressionism; Cubism

Constructivism; Suprematism; Neo-Plasticism;
Social Realism; Classicism; Academicism;
Neo-Classicism; Realism

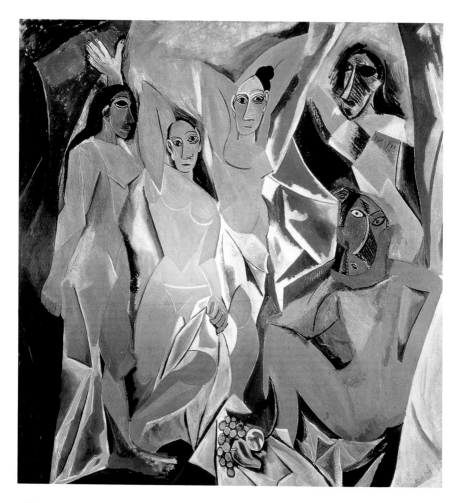

Primitivism was a widespread trend in modern art, but not a distinct movement like Futurism or Cubism. Modern artists explored the ethnographic collections of major museums, and the art of non-western cultures, in search of 'primitive' art works which would inspire them to rejuvenate western art.

CONSTANTIN BRANCUSI (1876–1957); **MAX ERNST** (1891–1976); **PAUL GAUGUIN** (1848–1903); **ERNST LUDWIG KIRCHNER** (1880–1938); **HENRY MOORE** (1898–1986); **EMILE NOLDE** (1867–1956); **PABLO PICASSO** (1881–1973)

ethnographic; expressive force; intuitive emotion; vigour; insanity; reproductive nature; wholeness; truth

To modern artists 'the primitive' represented the antithesis of the

Academic art they reviled. 'Primitive' works, by contrast, were celebrated for their forceful expressiveness. Modern artists celebrated 'the primitive' as an unconscious creative impulse which had not been tamed and gelded for the drawing room. To call a work 'primitive', was to recognise a formal simplicity and vigour, or a strong emotional presence, which had been lost from Western art.

Unfortunately, when modern artists celebrated 'the primitive' they didn't always distinguish between African art of 2000 years ago and African art produced in 1900. This implied that 'primitive' art came from an unconscious source of creativity rather than from artistic traditions, an idea which suited many modern artists, but which denied so-called 'primitive' peoples any form of art history, or history in general.

Modern artists' reverence for the primitive can be seen as part of a European tradition of idealising non-Western cultures as happier, more natural and less sophisticated and corrupt. Flattering though this may sound it is also an insulting simplification – especially when modern artists also praised the 'primitivism' of art produced by children, the insane and untrained, 'naïve' adults. At its broadest 'primitivism' also included expressive, non-academic art created within the Western tradition – medieval woodcuts and Gothic carving in particular.

KEY WORKS in the Museum of Modern Art, New York

 Les Demoiselles d'Avignon, **1907, PABLO PICASSO**
Picasso explored the collections of the Museé d'Ethnographie du Trocadéro while working on *Les Demoiselles d'Avignon*. The distorted features of the two demoiselles on the right are often attributed to his study of Dan, Fang and Kota masks and Iberian art. Picasso has integrated 'the primitive' into his response to the Western tradition of the nude – he has even incorporated a still-life into the foreground.

 The Moon and the Earth, **1893, PAUL GAUGUIN**
Gauguin produced his greatest works in Tahiti where he sought to escape from civilization and 'return to nature'. At first glance, his paintings are 'primitive' in the sense that they contain images of a native culture which was considered uncivilized. The more significant primitivism of *The Moon and the Earth* arises from its identification of the uncivilised, naked female body with the cycles of the moon and the regenerative powers of the earth. Often, the Western nude is idealised: its beauty is allegorical of a quality of mind or spirit, or derives meaning from an ancient myth. By contrast, the nudity in *The Moon and the Earth* is rooted in the sexual physicality of the body and nature as a whole.

OTHER WORKS in the Museum of Modern Art, New York

The Seed of the Areoi (Te aa no areois), 1892, **PAUL GAUGUIN**

The Bather, c.1885, **PAUL CÉZANNE**

Spoon Woman, 1926–7, **ALBERTO GIACOMETTI**

Blond Negress, II, 1933, **CONSTANTIN BRANCUSI**

Fauvism; Expressionism; Cubism; Post-Impressionism; Dada; Surrealism; Abstract Expressionism; Orientalism; Romanticism

Constructivism; Suprematism; Neo-Plasticism; Social Realism; Classicism; Academicism; Neo-Classicism; Realism; Post-Modernism

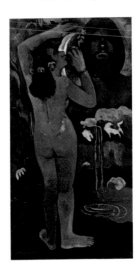

Expressionism

Expressionism emerged in different artistic circles across Europe, its highpoint being the period 1905 to 1920. It was not a distinct, self-contained movement but used strong colour, distorted figures, and sometimes abstraction to explore themes of belonging and alienation. Art from other eras, for instance the work of Francis Bacon, can be referred to, quite correctly, as 'expressionistic' in a more general sense.

In *Die Brücke* group: **KEES VAN DONGEN** (1887–1968); **ERICH HECKEL** (1883–1970); **ERNST LUDWIG KIRCHNER** (1880–1938); **PAULA MODERSOHN-BECKER** (1876–1907); **OTTO MÜLLER** (1874–1913); **EMILE NOLDE** (1867–1956); **MAX PECHSTEIN** (1881–1955); **KARL SCHMIDT-ROTLUFF** (1884–1976). In *Der Blaue Reiter* group: **ALEXEI VON JAWLENSKY** (1864–1941); **WASSILY KANDINSKY** (1866–1944); **FRANZ MARC** (1880–1916). Other artists: **MAX BECKMAN** (1884–1950); **GEORGE GROSZ** (1893–1959); **KÄTHE KOLLWITZ** (1867–1945)

strong colour; distortion; abstraction; community; alienation; social critique; masquerade; purification

Expressionism is a Northern European phenomenon characterised by emotional extremes which can be traced back to the work of Van Gogh, Edvard Munch and James Ensor.

Expressionism is the art of unrest and the search for truth. In Germany its leading artists were loosely gathered in two groups called Die Brücke (The Bridge) and Der Blaue Reiter (The Blue Rider). Both explored the destruction of genuine feelings by a society which, they felt, needed to be 'cleansed' or 'purified'. The artists often visualised this process through depictions of natural disasters, lightning striking a forest for example, or through reference to Biblical scenes such as the Apocalypse in which the world is destroyed and remade by a wrathful God.

Die Brücke rejected the classical inheritance and turned to nature and the primitive to rejuvenate German art. Most of its members moved to Berlin between 1910 and 1914 .They came to be seen as harbingers of destruction and loss. Their Expressionism was intimately bound up in an exploration of German identity and traditions.

Der Blaue Reiter was more overtly mystical and aimed to reveal the spiritual truth hidden within the world. It was strongly influenced by the Russians Kandinsky and Jawlensky and used a subtler, more diverse range of colours than Die Brücke artists. What both groups shared with other Expressionists was the conviction that art could express an intrinsic human truth and restore meaning to people's lives.

KEY WORKS in the Solomon R. Guggenheim Museum, New York

↓ *Improvisation 28 (second version)*, 1912, **WASSILY KANDINSKY**
Vivid colour and loose, aggressive brushwork distinguish *Improvisation 28*. Like most other Expressionists Kandinsky was highly critical of the society in which he lived and welcomed its transformation. Waves, boats and mountains can be seen on the left, suggesting the elemental destruction by storms and floods, while on the right, an embracing couple evoke the creation of a new society shaped by pure honesty and loving spirituality.

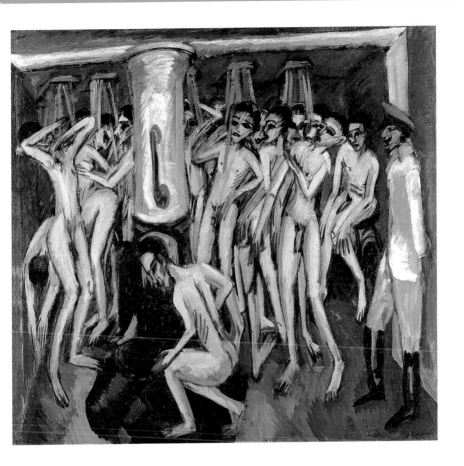

↑ *Artillerymen*, 1915, **ERNST LUDWIG KIRCHNER**
Crude colours, rough brushwork and distorted figures
makes *Artillerymen* typically Expressionist. It has a
charged, emotional impact which combines the artist's
personal feelings with social criticism. Kirchner shows
naked men crowded into a shower room under the
gaze of a military officer. He conveys his own sense of
vulnerability during the war. He was drafted but later
discharged on grounds of mental illness. At the the
same time, he expresses his loathing of the conformist,
brutalising society in which he felt he lived.

OTHER WORKS in the Solomon R. Guggenheim
Museum, New York

Paris Society, 1931, **MAX BECKMANN**

Red Balloon, 1922, **PAUL KLEE**

Knight Errant, 1915, **OSKAR KOKOSCHKA**

The Unfortunate Land of Tyrol, 1913, **FRANZ MARC**

Portrait of Johann Harms, 1916, **EGON SCHIELE**

 Fauvism; Abstract Expressionism; Primitivism;
Post-Impressionism; Romanticism; Orientalism;
Neo-Plasticism; Neo-Expressionism

 Constructivism; Suprematism; Social Realism;
Classicism; Academicism; Neo-Classicism;
Realism; Conceptualism; Neo-Conceptualism

Cubism

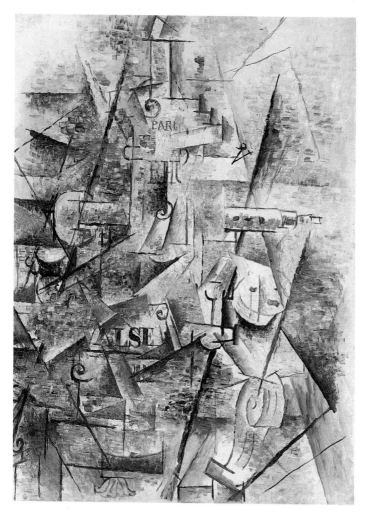

The first Cubist exhibition took place in 1911 at the Salon des Indépendants, Paris and its origins have been traced back as far as 1901. Cubism was pioneered by Picasso and Braque and was initially indebted to Cezanne's use of multiple viewpoints in a single painting. The way Cubists represented objects was considered to be radical. Their subject matter was often highly conventional and usually drawn from the still life tradition.

GEORGES BRAQUE (1882–1963); PABLO PICASSO (1881–1973); RAYMOND DUCHAMP-VILLON (1876–1918); JUAN GRIS (1887–1927); FERNAND LÉGER (1881–1955)

flattened volume; confused perspective; collage; multiple viewpoint; still life; analytic; synthetic

Cubism made use of shifting viewpoints. For example, we can look at a table from different angles: from above while standing over it, from the side when we sit down, then from underneath when we pick a pen up off the floor. Cubists attempted to capture this on canvas and, consequently, Cubism has been described as a conceptual approach to painting. Development of the 'conceptual' can be seen in Cézanne's later work where tables, and objects sitting on them, are painted from mutually incompatible angles. An exhibition of Cézanne's work at the Salon d'Automne in 1907 was a major influence on both Picasso and Braque.

Cubists made no distinction between three-dimensional forms that ought to curve towards the viewer and ones that ought to curve away. They simply flattened them into shapes which they multiplied across the canvas. The results were often flat, highly patterned surfaces painted in subdued colours, in which it can be difficult to distinguish objects from each other and

from the space they inhabit. By painting objects from different angles Cubists also explored their movement through time as well as space.

The terms 'analytic' and 'synthetic' Cubism are used to distinguish between Cubism based primarily on observation of a subject and Cubism based on its artistic techniques such as collage.

KEY WORKS in Tate Modern, London

←*Clarinet and Bottle of Rum on a Mantelpiece*, 1911, GEORGES BRAQUE

Cubists often used words or syllables in their paintings and collages, sometimes incorporating or painting text from real newspapers. In this work the word 'Valse', which means 'waltz', reinforces the work's musical theme. 'RHU' are the first three letters in the French word for rum. The scroll shape in the right hand corner could be the head of a violin or cello, or it could be part of the mantelpiece on which the clarinet and bottle of rum are sitting. It looks as if Braque's subject matter has exploded and then been flattened.

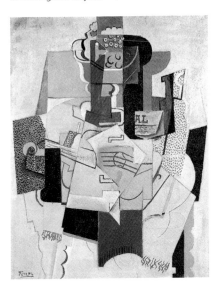

↙*Bowl of Fruit, Violin and Bottle*, 1914, PABLO PICASSO

The violin at the centre of this Cubist still life has been fragmented. It is impossible to say where it 'really' is in relation to the table top: lying down or propped up on something? This ambiguity is typical of Cubist painting. So, too, is the way the paint has been applied to resemble a collage of differently coloured pieces of paper.

OTHER WORKS in Tate Modern, London

Mandora, 1909–10, **GEORGES BRAQUE**

Glass on Table, 1909–10, **GEORGES BRAQUE**

Bottle and Fishes, c.1910–12, **GEORGES BRAQUE**

The Sunblind, 1914, **JUAN GRIS**

Bottle of Rum and Newspaper, 1914, **JUAN GRIS**

Nature Morte, 1914, **PABLO PICASSO**

 Constructivism; Neo-Plasticism; Suprematism; Conceptualism

 Dada; Surrealism; Expressionism; Primitivism; Renaissance; Baroque; Rococo; Academicism; Neo-Classicism

Futurism was an Italian movement, launched with the publication of Filippo Tommaso Marinetti's *Le Futurisme* in a French newspaper in 1909. It was characterised by its aggressive celebration of modern technology, speed, and city life, and by the vigour with which it poured scorn on the traditions of Western art.

GIACOMO BALLA (1871–1958); **CARLO CARRÀ** (1881–1966); **LUIGI RUSSOLO** (1885–1947); **GINO SEVERINI** (1883–1966)

speed; energy; aggression; force lines; crowds; urban; new technology; progress; weapon

Marinetti articulated the frustration of a generation which felt itself crushed under the weight of Western artistic tradition. Futurists rejected the art and culture of the past: they wanted to destroy everything old and venerated to make way for everything new and vital.

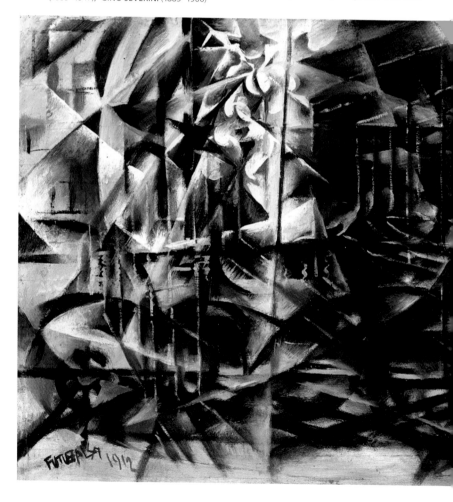

The movement of the car, for example, and the experience of its acceleration, were more significant to Futurists than its shape or appearance when stationary. Likewise, the crowd was a more significant political force in their imagination than institutions of Government. Futurists were highly adept at promoting their work. Everything from lectures to publicity stunts made Futurism a highly visible movement.

Futurists often used strident colours, but they never developed a coherent theory of colour which could distinguish them from other artistic movements of the period. Their initial interest in Neo-Impressionism gave way to a more sustained interest in Cubism.

Futurism lost its impetus by World War Two. A second generation of less subversive Futurists emerged by the early 1920s and sustained the movement into the 1930s. Related movements in England and Russia were known as Vorticism and Rayonism respectively.

KEY WORKS in the Museum of Modern Art, New York

↑ *Armoured Train in Action*, 1915, GINO SEVERINI
This work displays all of Futurisms preoccupations on one canvas: modern technology, aggression and movement. The train is reduced to a speeding arrow crammed with armed men as it bursts through the top of the canvas. Even the steam coming from the front of the train looks menacing, almost armour-plated, because of Severini's use of force lines.

◄ *Speeding Automobile*, 1912, GIACOMO BALLA
Rather than the recognisable form of a car, Balla painted its distinguishing *function* and *experience*, namely its ability to accelerate at high speeds. Balla's car has disappeared among a bewildering array of 'force lines' – an important stylistic device used by the Futurists to convey the sensations of forceful movement.

OTHER WORKS In the Museum of Modern Art, New York

Swifts: Paths of Movement + Dynamic Sequences, 1913, **GIACOMO BALLA**

States of Mind 1: The Farewells, 1911; *States of Mind II: Those Who Go*, 1911; *States of Mind III: Those Who Stay*, 1911, **UMBERTO BOCCIONI**

Dynamic Hieroglyphic of the Bal Tarbin, 1912, **GINO SEVERINI**

 Dadaism; Surrealism; Cubism; Suprematism

 Primitivism; Expressionism; Neo-Plasticism; Abstract Expressionism; Renaissance; Baroque; Rococo; Academicism; Neo-Classicism; Neo-Expressionism

Dadaism emerged during the First World War. Allegedly taken at random from a dictionary, the word 'dada' means 'hobby-horse' in French. The Dadaists proclaimed that all received moral, political and aesthetic beliefs had been destroyed by the war. They advocated a destructive, irreverent and liberating approach to art. Dadaism gave way to Surrealism in the mid 1920s.

JEAN (OR HANS) ARP (1886–1966); MARCEL DUCHAMP (1887–1968); HANNAH HÖCH (1889–1978); **FRANCIS PICABIA** (1879–1953); **MAN RAY** (1890–1976)

destruction; liberation; the unconscious; chance; nonsense; ready-mades; anti-bourgeois; nihilistic; witty

The first Dada manifesto, published in 1918, claimed that Dadaism was 'a new reality' and accused the Expressionists, 'of sentimental resistance to the times'. Shock was a key tactic for Dadaists who hoped to shake society out of the nationalism and materialism which had led to the carnage of World War One. Dadaism was a literary movement as well as a visual one and there were independent groups of Dadaists in Zurich, New York, Berlin and Paris.

Chance and the nonsensical were key elements in Dadaism. It expressed a new awareness of the role of the unconscious in everyday life, and constituted a refusal to develop a coherent theory of art which would simply be committed to a lifeless confinement in an art library.

Arp, for instance, made collages in which he glued the paper wherever it happened to fall. Duchamp planted an aesthetic time-bomb with his 'ready-mades' – industrial or everyday objects which he signed as though he had made them himself and then exhibited in art galleries. The most famous of these, *Fountain*, was a urinal which he signed 'R Mutt'. Through ready-mades Duchamp rejected traditional craftsmanship and categories of art. His intention was to make people aware that the definitions and standards by which we label and judge works of art are possibly secondary to art and not definitive of it.

KEY WORKS in the Solomon R. Guggenheim Museum, New York

Merz 163, with Woman Sweating, 1920, KURT SCHWITTERS
'Merz' is the name Schwitters gave to his own method of assembling works out of the detritus of daily life such as tram tickets, stamps and wrappers. He wanted to develop a method of creating art which was free from the conventions and norms imposed by society and artistic traditions.

The Child Carburettor, 1919, FRANCIS PICABIA
This work is based on a diagram for a racing car's carburettor, but it has been relabelled so that the various components of the carburettor represent male and female genitals. Dadaist art, while often witty, can be seen as nihilistic, denying life any intrinsic value, meaning or purpose. *The Child Carburettor* suggests a world which functions thoughtlessly, like a machine, and in which children are created from mindless, mechanical sexual acts.

OTHER WORKS in the Solomon R. Guggenheim Museum, New York

Study for Chess Players, 1911, MARCEL DUCHAMP

Little Machine Constructed by Minimax Dadamax in Person, 1919–20, MAX ERNST

Very Rare Picture on the Earth, 1915, FRANCIS PICABIA

Merz 199, 1921, KURT SCHWITTERS

 Surrealism; Primitivism; Futurism; Suprematism; Primitivism; Conceptualism; Neo-Conceptualism; Sensationalism

 Expressionism; Abstract Expressionism; Renaissance; Baroque; Rococo; Academicism; Neo-Classicism; Neo-Expressionism;

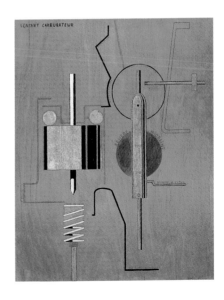

Suprematism

This movement was developed and led by Russian artist Kasimir Malevich. His art was geometric, and often colourless. Suprematism rejected all conventional definitions of art, in favour of an artistic exploration of a spiritual reality which Suprematists believed they could express through geometric abstraction.

EL LISSITZKY (1890–1947); KASIMIR MALEVICH (1878–1935)

geometric abstraction; monochrome; assault; spiritual purity; spatial movement

While working on collaborative theatre and opera projects Malevich met experimental writers who were exploring the connections between sound and meaning. Malevich made similar experiments with painting and developed an art of basic geometric shapes often painted in monochrome. Suprematism, as he called it, was highly influential among Russia's avant-gardes. Malevich opposed the claim that the distinctions between 'art' and 'industry' would, and should, become obsolete in a Communist society. He was convinced that Suprematism had spiritual value.

The first Suprematist exhibition took place in Moscow in 1915. *Black Square* – a large black square painted against a white background – was hung across the corner of the exhibition space mimicking the display of religious icons. Suprematist paintings contained neither narrative nor social comment, nor did the Suprematists respect any of the traditional genres of painting, such as landscape or still life. Malevich celebrated this emancipation as the 'new realism', believing that his work was as true to the spirit of art as it was offensive to artistic traditions.

The reduction of painting to a 'pure language' of basic shapes might have resulted in Suprematism's quick demise as an art movement. But Malevich's belief in the mystical or religious nature of his work was a key stimulant to the movement's development. Suprematist paintings became increasingly complex in their colour and composition while their artists continued to resist the subordination of 'pure' art to industry or politics. The movement influenced art and design in the west throughout the 1920s and '30s.

KEY WORKS in the Museum of Modern Art, New York

→ *Suprematist Composition: White on White*, 1918, KASIMIR MALEVICH
Malevich's *Suprematist Composition* combines both the basic geometry and monochrome which characterise Suprematism. It also suggests movement, the tilt of one square against another creating a dynamic impression of movement which became more explicit in later Suprematism.

→ *Proun 19D*, 1922, EL LISSITZKY
El Lissitzky's *Proun 19D* exemplifies Suprematism's later, more complex, exploration of geometric forms which no longer seem to be set *on* an abstract background but move *in* an abstract environment. The blurring of 'real' and 'abstract' space was deliberate, as was the impression of movement. El Lissitzky called this complex space 'the interchange station between painting and architecture'.

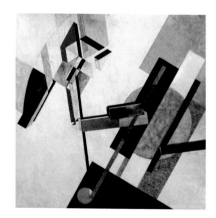

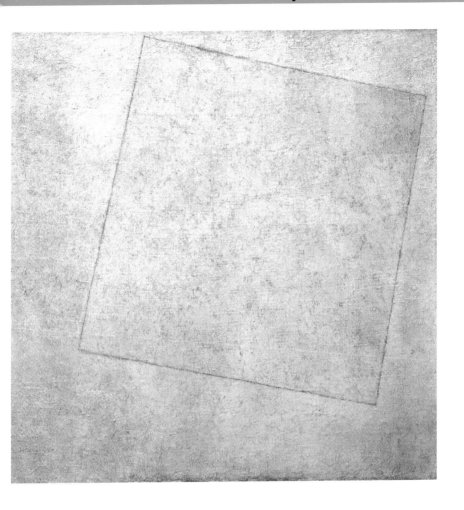

OTHER WORKS in the Museum of Modern Art, New York

Composition, 1922, **EL LISSITZKY**

Airplane Flying, 1914–15, **KASIMIR MALEVICH**

Suprematist Composition: Painterly Realism. Boy with Knapsack – Colour Masses in the Fourth Dimension, 1915, **KASIMIR MALEVICH**

Suprematist Painting, 1917, **KASIMIR MALEVICH**

Constructivism; Neo-Plasticism; Cubism; Conceptualism

Dadaism; Surrealism; Expressionism; Primitivism; Renaissance; Baroque; Rococo; Academicism; Neo-Classicism

Constructivism Russian and International

This term was first used by Russian artists in 1921. It is also an umbrella term under which other constructivists, mainly working in Western Europe, are also included. 'Constructivism' in the more general sense describes abstract, geometric works of art which are constructed, or organized, from distinct components and contemporary materials, such as plastic.

Russian Constructivists:
ALEKSANDR RODCHENKO (1891–1956);
VARVARA STEPANOVA (1894–1958);
VLADIMIR TATLIN (1885–1953).
International Constructivists: **THEO VAN DOESBURG** (1883–1931); **NAUM GABO** (1890–1977);
LÁSZLÓ MOHOLY-NAGY (1895–1946);
KURT SCHWITTERS (1887–1948);
GEORGES VANTONGERLOO (1886–1965)

geometric abstraction; kinetics; technology; social utility; social progress; non-spiritual

Russian Constructivism was a Utopian movement within the ongoing social revolution that followed the Communist coup of 1917. Constructivists rejected the idea that art works are 'composed', and are, therefore, 'compositions'. They adopted the term 'construction' to break down the barriers between the artistic and the industrial. Tatlin was the leading sculptor of the movement. He was influenced by Cubism and tried to develop a sculptural technique which could convey movement through time. Like the Futurists, he and other Constructivists were also convinced that art and technology could transform society for the better. Many Constructivists welcomed the disappearance of 'art' altogether, seeing it as socially useful production, like manufacturing.

Russian Constructivism was suppressed for being 'bourgeois', in other words, for concentrating on artistic issues rather than

socialist ideology. Many of its leading members emigrated to the west, encouraging the development of International Constructivism. Similarly Utopian, this movement promoted art as a means of achieving social progress, but didn't envisage its disappearance within industry. It differed in significant ways from other avant-garde movements in its rejection of 'subjectivity'. It denied that the individual artist's emotions were central to art. Moholy Nagy dictated an art work down the telephone to a professional sign painter in what can be seen as an early example of Conceptualism. International Constructivism underlay the Bauhaus movement which helped revolutionise modern furniture design and architecture.

KEY WORKS in Tate Modern, London

← *Kinetic Construction (Standing Wave)*, 1919–20, NAUM GABO

Kinetic Construction is a moving sculpture. As the metal turns it gives the impression of a solid, curving shape. Gabo used this sculpture to teach his students about kinetics, gracing it with a poetic sub-title, *Standing Wave*. Constructivists were intent on developing sculptures in which movement, or the suggestion of movement, was integral. As a sculpture, *Kinetic Construction* only exists when it is moving.

↑ *Interrelation of Volumes*, 1919, GEORGES VANTONGERLOO

Vantongerloo's sculpture looks as though many different blocks have been sunk into each other. He was exploring the way our mind perceives shape and volume. When we look at this work, our mind breaks it down into distinct blocks which make competing claims on a limited amount of space. This sculpture constantly changes as the viewer explores its composition.

OTHER WORKS in Tate Modern and Tate Britain

Antennae with Red and Blue Dots, 1960, ALEXANDER CALDER

Ile de France, 1935, JEAN HELION

Ball, Plane and Hole, 1936, BARBARA HEPWORTH

Head No. 2, 1916, NAUM GABO

1935 (White Relief), 1935, BEN NICHOLSON

June 1937 (painting), 1937, BEN NICHOLSON

 Cubism; Neo-Plasticism; Suprematism; Conceptualism

 Dadaism; Surrealism; Expressionism; Primitivism; Renaissance; Baroque; Rococo; Academicism; Neo-Classicism

Neo-Plasticism is inseparably connected with the work of Piet Mondrian. His distinctively grid-shaped paintings were meant to reveal the timeless, spiritual order underlying the endlessly changing appearance of the world. Mondrian's theories were explored and expounded by artists associated with the Dutch art magazine *De Stijl*.

THEO VAN DOESBURG (1883–1931); VILMOS HUSZÁR (1884–1960); J.J.P. OUD (1890–1963); PIET MONDRIAN (1872–1944); GERRIT RIETVELD (1888–1964); GEORGES VANTONGERLOO (1886–1965); JAN WILS (1891–1972)

grids; primary colour; black and white; spiritual order; decentralised; peripheric; elementarism

In relation to Mondrian's geometrical, abstract paintings Neo-Plasticism refers to black horizontal and vertical lines, on an off-white background, to which he added blocks of primary colours (blue, red and yellow). Mondrian advocated paintings without a centre and many of his works have no obvious point on which the eye can rest. The edges of his painting are as important as the middle. The horizontal and vertical lines often suggest a stillness and suspension which arises from two mutually opposed forces holding each other in balance. Mondrian was motivated by the belief that his art revealed the essential spiritual structure which supports the world as we experience it.

Mondrian's impact extended well beyond the fine arts. His work and theories influenced artists who contributed to the Dutch magazine *De Stijl*, and the Constructivists, all of whom were looking for new art forms for the modern world. These groups included architects, especially those associated with Bauhaus, and designers.

When Mondrian moved to the United States in 1940 he influenced the Abstract Expressionists who held similar beliefs about a psycho-spiritual order underpinning human existence.

KEY WORKS in the Solomon R. Guggenheim Museum, New York

Tableau 2, 1922, PIET MONDRIAN
A black grid is painted on an off-white background to which has been added solid blocks of primary colour. Mondrian believed it described the spiritual structure supporting the world of experience. *Tableau 2* has no central point of focus. Mondrian termed this 'peripheric', meaning that the painting has been decentralised – it is like a grid-based city without a distinct centre or downtown.

 Counter-Composition VIII, 1925–6, THEO VAN DOESBURG
Doesburg's *Counter-Composition VIII* deviates from Mondrian's strict grid. Van Doesburg called this deviation 'elementarism'. (Mondrian called it heresy and resigned from *De Stijl*). Although *Counter-Composition VIII* retains the colour schemes and geometric shapes typical of Neo-Plasticism, van Doesburg's work has a sense of movement which is lacking from Mondrian's static, perfectly balanced paintings.

OTHER WORKS in the Solomon R. Guggenheim Museum, New York

Composition No. 1, 1930, **PIET MONDRIAN**

Composition, 1938–39, **PIET MONDRIAN**

Composition in Grey, 1919, **THEO VAN DOESBURG**

Construction of Volumetric Interrelationships Derived from the Inscribed Square and the Square, 1924, **GEORGES VANTONGERLOO**

 Constructivism; Cubism; Suprematism; Conceptualism

Dadaism; Surrealism; Expressionism; Primitivism; Renaissance; Baroque; Rococo; Academicism; Neo-Classicism

Surrealism

Surrealism was founded in Paris, in 1924, by the poet André Breton and continued Dadaism's exploration of everything irrational and subversive in art. Surrealism was more explicitly preoccupied with spiritualism, Freudian psychoanalysis and Marxism than Dadaism was. It aimed to create art which was 'automatic', meaning that it had emerged directly from the unconscious without being shaped by reason, morality or aesthetic judgements.

HANS ARP (1886–1966); **SALVADOR DALÍ** (1904–89); **MAX ERNST** (1891–1976); **FRIDA KAHLO** (1907–54); **PAUL KLEE** (1879–1940); **RENÉ MAGRITTE** (1898–1967); ANDRÉ MASSON (1896–1987); JOAN MIRÓ (1893–1983); **YVES TANGUY** (1900–55)

the unconscious; irrational; dreams; automatism; juxtaposition; destruction; eroticism

The unconscious was central to Surrealists. To them it resembled a vast storehouse full of astonishing, hitherto repressed artistic creativity. Heavily influenced by the psychoanalyst Sigmund Freud, they came to see reason as a guard barring entry to this storehouse. They adopted various techniques to unlock the unconscious. Automatic writing (also called *automatism*) is perhaps the most famous of their techniques for evading conscious control of the artistic process. They strove to undermine most accepted truths and conventions, rejecting them as essentially uncreative. Surrealists characterised Naturalism and Realism as fundamentally bourgeois, claiming that both artistic movements confused truth with objects and treated both life and art as though they were old furniture: solid, ugly and dusty.

The Surrealists also explored dream imagery which Ernst and Dalí introduced into their painting with all the attention to detail of Realist painters. Miro's paintings, on the other hand, contain bio-morphic shapes which could be amoeba, viruses, or thoughts glimpsed in the psyche's uncharted synaptic spaces.

It is not particularly subversive to say that dreams often seem real and bizarre at the same time, but Surrealists sought out these disruptive qualities in everyday life, as part of their artistic process, even opening an office in Paris where people could report 'surreal' experiences.

KEY WORKS In the Solomon R. Guggenheim Museum, New York

→ *Attirement of the Bride*, 1940, MAX ERNST
This work subverts the naturalism of Western art by realistically representing a fantastical, nightmarish subject. Dalí often used the same technique. The classical architecture alludes to reason and the rational, but it has become a setting for a disturbing, erotic rite in which a masked and cloaked woman is led to her wedding by a bird-man. Surrealists delighted in revealing primitive, often sexually aggressive impulses, beneath the rational surface of everyday life.

↓ *Woman with Her Throat Cut*, 1932,
ALBERTO GIACOMETTI
This sculpture shows a woman as an insect-like creature. The spikes along the spine are reminiscent of a trap, suggesting that the woman is an aggressor as well as a victim, and the spine is arched, suggesting death or orgasm. Surrealists conflated and juxtaposed different elements in one sculpture as a means of evoking subconscious fears and fantasies. Surrealist attitudes to women were often ambivalent, and occasionally very negative

OTHER WORKS In the Solomon R. Guggenheim
Museum, New York

The Red Tower, 1913, **GIORGIO DE CHIRICO**

*Overturned Blue Shoe with Two Heels Under a Black
Vault*, c.1925, **JEAN ARP**

Birth of the Liquid Desires, 1931–32, **SALVADOR DALÍ**

Voice of the Space, 1931, **RENÉ MAGRITTE**

Promontory Palace, 1931, **YVES TANGUY**

 Dadaism; Primitivism;
Futurism

 Expressionism; Abstract Expressionism;
Renaissance; Baroque; Rococo;
Academicism; Neo-Classicism;
Neo-Expressionism

Spatialism

Spatialism was an Italian movement pioneered by the artist Lucio Fontana in the years immediately following the Second World War. He wanted to use art to create new physical environments and abandoned artists' traditional reliance on painting and the illusion of spatial depth. Although shortlived, Spatialism had considerable influence on later artistic movements, including performance art and environmental art.

ROBERTO CRIPPA (1921–1972); GIANNI DOVA (1925–1991); LUCIO FONTANA (1899–1968)

art as environment; slashed; process; roughness

Fontana advocated a new art for the era following on from World War Two. He wanted to use new technologies, such as neon lighting and television, in art works which would encompass sight, sound, movement and time. In practical terms, this resulted in works which encompassed the entire exhibition space, with walls painted uniform colours and filled with sound and colour projections. This prefigured environmental art.

Fontana also slashed the surfaces of his canvases. Again, this was highly influential, because it gave greater importance to the process of making art than to the final art object. (This was paralleled by a similar development in Abstract Expressionism where the energetic creation of the work acquired greater importance.) The slashed canvases were radical statements of departure from artistic tradition but, ironically, they have often been admired for their beauty as art objects.

KEY WORKS Tate Modern, London

Spatial Concept 'Waiting', 1960, LUCIO FONTANA
By slashing the canvas with a knife and leaving it unpainted, Fontana was criticizing the conventional sensuousness of the Western tradition. He also exposed what he criticised as the insubstantial or illusory nature of Western art which uses the painted canvas as a window through which we look 'into' another world. The slash subverts this by creating a literal space in the canvas itself which we do indeed look 'into'. This act also tries to draw our attention to the material reality which supports our ideas.

Nature, 1959–60, LUCIO FONTANA
Fontana slashed a lump of clay and then cast it in bronze. He deliberately left the clay as unshaped as possible to draw attention to the all-pervading density – the pure 'stuff' – of nature. Fontana believed that this type of art work revealed nature more effectively than art which imitates nature's many appearances.

OTHER WORKS Tate Modern, London; Tate Liverpool

Aurora Borealis, 1952, **ROBERTO CRIPPA**

Explosion, 1953, **GIANNI DOVA**

Spatial Concept 49–50 B4, 1949–50, **LUCIO FONTANA**

Spatial Concept, 1958, **LUCIO FONTANA**

Primitivism; Expressionism; Dadaism; Conceptualism

Cubism; Neo-Plasticism; Suprematism; Futurism; Renaissance; Baroque; Rococo; Academicism; Neo-Classicism

This movement developed in New York during the decades immediately following the World War Two. It is also referred to as the New York School or, less accurately, as 'Action Painting' and it is characterised by an attempt to depict universal emotions. It was the first exclusively American movement to gain international recognition.

HELEN FRANKENTHALER (b.1928); ARSHILE GORKY (1904–48); ADOLPH GOTTLIEB (1903–74); PHILIP GUSTON (1913–80); ELLSWORTH KELLY (b.1923); WILLEM DE KOONING (1904–97); LEE KRASNER (1908–84); ROBERT MOTHERWELL (1915–91); BARNETT NEWMAN (1905–70); JACKSON POLLOCK (1912–56); MARK ROTHKO (1903–70); FRANK STELLA (b.1936); CLYFFORD STILL (1904–80)

universal order; physical gesture; dance; psychic energy; unconscious symbols; contemplation; iconic; stillness

Abstract expressionists concentrated on the physical process of painting, from which the narrower term 'Action Painting' was derived, often throwing paint at their canvases in an expressive and highly physical subversion of traditional methods of painting. Breton, Ernst and Masson, all leading Surrealists, moved to New York during World War Two and were influential in its initial development. However, whereas the Surrealists explored the unconscious for means of disrupting society's cherished conventions, the Abstract Expressionists turned to the unconscious for symbols of universal meaning which could restore both art and society after World War Two.

The psychologist Carl Gustav Jung was an important influence on them. He maintained that archetypal, symbol-generating emotions and behaviour can be found in every psyche and culture. The Abstract Expressionists believed that their paintings expressed these universal symbols. Colour Field Painting looks like the exact opposite of Action painting, but, like the latter, it is simply another variant within Abstract Expressionism. The rhythmic vitality of Action Painting has disappeared. Instead, luminous and brooding colours saturate the canvas with contemplative stillness. If Action Painting captures the physical energy of dance, Colour Field Painting evokes the psychic energy of contemplation.

By the 1960s, artist Philip Guston was one of a growing number who criticised Abstract Expressionism for having become a sterile, and decorative orthodoxy which was stifling creativity.

KEY WORKS in the Solomon R. Guggenheim Museum, New York

→ *Untitled (Violet, Black, Orange, Yellow on White and Red)*, 1949, MARK ROTHKO
Rothko's *Untitled* is characterised by luminous colours. Looked at directly, it has an iconic quality typical of many Abstract Expressionist, or Colour Field, paintings. The suggestion of a dark horizon in the centre of the painting evokes universal feelings about distance and proximity, travel and arrival, containment and freedom. *Untitled* is meant to liberate us from the burden of our individuality, our class, nationality and gender, and restore our sense of common humanity.

OTHER WORKS in the Solomon R. Guggenheim Museum, New York

Painting no. 7, 1952, **FRANZ KLINE**

Composition, 1955, **WILLEM DE KOONING**

Personage (Autoportrait), 1943, **ROBERT MOTHERWELL**

Circumcision, 1946, **JACKSON POLLOCK**

Sacrifice, 1946, **MARK ROTHKO**

1948, 1948, **CLYFFORD STILL**

Fauvism; Primitivism; Expressionism; Neo-Expressionism

Cubism; Neo-Plasticism; Suprematism; Futurism; Renaissance; Baroque; Rococo; Academicism; Neo-Classicism; Conceptualism; Neo-Conceptualism

↑ *Alchemy*, 1947, JACKSON POLLOCK
Pollock poured commercial paint directly onto his
canvas with the help of a stick. This revolutionary act
dispensed with the traditional brush and easel and
involved his entire body in the act of painting. The work
has a physicality and energy typical of much Abstract
Expressionism, Action Painting in particular. 'Alchemy'
refers to the ancient search for a means of transforming
base matter into gold which Jung saw as symbolic of
psychological transformation.

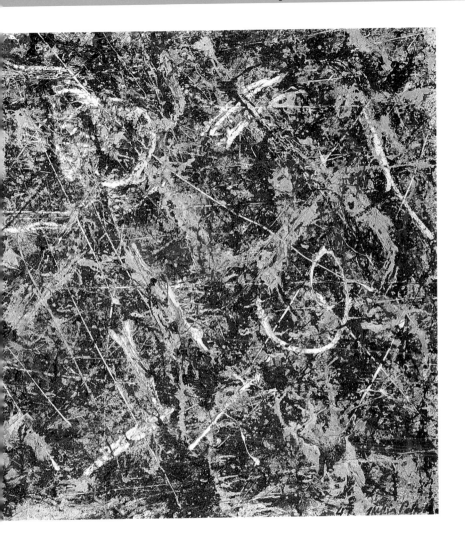

Social Realism

A tendency rather than a movement, Social Realism is a term used to describe art which is Realist in style and in which there is usually explicit reference to, or critiques of, prevailing social conditions. It has achieved most in film and photography. Social Realism is often Left wing but should not be confused with Socialist Realism, the official art of the former Soviet Union.

JOHN BRATBY (1928–92); GILBERT AND GEORGE (b.1943, b.1942); NAN GOLDIN (b.1953); DEREK GREAVES (b.1927); WILLIAM MAW EGLEY (1826–1916); EDWARD MIDDLEDITCH (1923–87); JACK SMITH (b.1928)

social critique; social justice; political struggle; ugliness; uncomfortable truths

Social Realism developed in tandem with a growing consciousness of the poverty experienced in some urban and rural communities. It emerged in the 19th century, though it varied from nation to nation, either sentimentalising the plight of the poor or preferring to focus more on political struggle. The work of the 19th century Realist Gustave Courbet is an important origin of Social Realism. His depictions of working people were shaped by his political views. In general, Social Realism utilises Realism for political purposes and often subordinates questions about artistic value and method to questions about social justice.

Specific Social Realist movements include the Kitchen Sink School in Britain. Kitchen Sink artists painted drab, cluttered works showing what they felt to be the miseries of British life during the period of austerity following World War Two. Kitchen Sink art was political. It confronted the viewer with images of 'real life', demanding change and improvement.

Social Realism has no defined theory of the State. It often appeals against the use of State power, but just as often calls for more State intervention to solve social problems.

KEY WORKS in Tate Modern, London

↓ *Nan One Month After Being Battered*, 1984, NAN GOLDIN
This work documents Nan Goldin's experience of domestic violence. Goldin is wearing high-gloss lipstick and jewellery and has not tried to disguise her ugly bruising. The work explores the pressure women are under to look beautiful in order to attract partners who sometimes leave them bruised and scarred.

↑ *The Toilet*, 1955, JOHN BRATBY

Bratby was referred to as a Kitchen Sink School artist because of his interest in domestic settings. Social Realism is characterised by its refusal to idealise or flatter its subject matter and by a determination to find the real in the mundane, the dirty and the depressing. Here, Bratby shows a typical scene from British life in the '50s, giving the viewer a look at a working class, outside toilet from the perspective of someone about to use it or clean it. Most art buyers in the '50s would have enjoyed inside toilets. This work might have reminded them that, on the physical level, if not on the social, we are all equal.

OTHER WORKS in Tate Modern, London and Tate Britain, London

Still Life with Chip Fryer, 1954, **JOHN BRATBY**

Omnibus Life in London, 1859, **WILLIAM MAW EGLEY**

Demolished, 1996, **RACHEL WHITEREAD**

 Constructivism; Realism; Materialism; Neo-Conceptualism

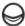 Primitivism; Expressionism; Cubism; Suprematism; Neo-Plasticism; Dadaism; Surrealism; Futurism; Abstract Expressionism; Renaissance; Baroque; Rococo; Academicism; Neo-Classicism; Conceptualism; Neo-Expressionism

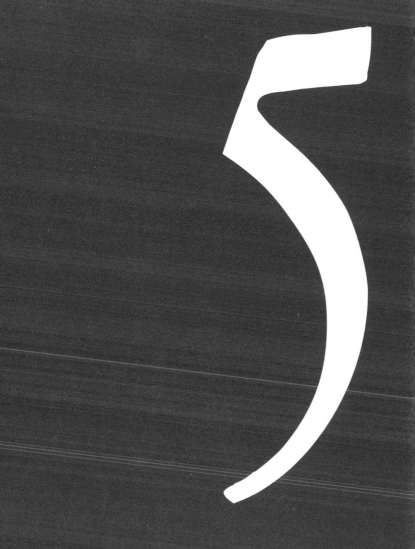

POST-MODERNISM

Post-Modernism developed from critiques of architectural modernism in the 1970s. By the 1980s, visual art which criticised society was also being referred to as 'post-modern'. Post-Modernism is effectively a late Modernism many of whose critiques can be traced back to Modernism itself.

eclecticism; anti-corporate; critique of institutions; deconstruction; relativism; mass media

Architects took the lead in the development of Post-Modernism. They criticised the International Style of Modernist architecture for being too

formal, austere and functional. Post-Modern architects felt that International style had become a repressive orthodoxy. It had been adopted by the corporate world and exploited at the expense of its social vision.

Post-Modernist architecture uses more eclectic materials and styles with greater playfulness. Parody of earlier styles is a dominant Post-Modern trait. Another is the refusal to develop comprehensive theories about architecture and social progress.

Post-Modernism in the visual arts is associated with Neo-Conceptualism in particular. The ethical touchstone of Post-Modernism is relativism – the belief that no society or culture is more important than any other. Although few Post-Modern artists are pure relativists, they often use their art to explore and undermine the way society constructs and imposes a traditional hierarchy of cultural values and meanings. Post-Modernism also explores power and the way economic and social forces exert that power by shaping the identities of individuals and entire cultures.

Unlike Modernists, Post-Modernists place little or no faith in the unconscious as a source of creative and personal authenticity. They value art not for its universality and timelessness but for being imperfect, low-brow, accessible, disposable, local and temporary.

While it questions the nature and extent of our freedom and challenges our acquiescence to authority, Post-Modernism has been criticised for its pessimism: it often critiques but equally often fails to provide a positive vision or redefinition of what it attacks.

KEY WORKS in Tate Modern, London

◄ *Three Ball Total Equilibrium Tank (Two Dr J Silver Series, Spalding NBA Tip-Off)*, 1985, JEFF KOONS
Koons takes mass produced objects from everyday life and exhibits them in art galleries. This thwarts our expectation of art's authenticity and uniqueness. Koons' work deliberately provokes us to consider how art institutions impose cultural and economic value on objects, and challenges our acceptance of their definitions of 'art'. These consumer items are exhibited as art to make us reflect on how our most private dreams of success (as a basketball player for instance) are shaped by the culture and economy in which we live.

↙ *Marilyn Diptych*, 1962, ANDY WARHOL
Pop Art, with its interest in mass media, marketing and advertising, can be seen as an early form of Post-Modernism. Warhol's work explores the cult of celebrity and the way an individual can be consumed by, or lost behind, their own image. The loss of an original and its displacement copies is a central preoccupation of the Post-Modern art of which Pop was a forerunner. Warhol's diptych was produced in the months following Monroe's suicide. It is an exploration of the way individuals, after death, can achieve 'immortality' through endlessly replicated images in magazines and advertising.

OTHER WORKS in Tate Modern, London

Unitled (We Will No Longer Be Seen and Not Heard), 1985, BARBARA KRUGER

Vest with Aqualung, 1985, JEFF KOONS

Brillo, 1964, ANDY WARHOL

You are driving a Volvo, 1996, JULIAN OPIE

Interior with Waterlilies, 1991, ROY LICHTENSTEIN

Five Open Geometric Structures, 1979, SOL LEWITT,

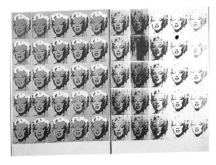

Conceptualism emerged in the 1960s and was first defined and promoted as an ism by Sol LeWitt in 1967. Its central claim is that art is a 'concept', rather than a material object. There are strong precedents for Conceptualism in the work of the Dadaist artist Marcel Duchamp.

JOHN BALDESSARI (b.1931); JOSEPH BEUYS (1921–86); JAN DIBBETS (b.1941); MARCEL DUCHAMP (1887–1968); JOSEPH KOSUTH (b.1945); BARBARA KRUGER (b.1945); JEAN TINGUELY (1925–1991); LAWRENCE WEINER (b.1940); SOL LEWITT (b.1928)

idea, concept, intention, critique, language

Conceptualism is shaped by four basic tenets. The first is that the art work is an idea, or concept, rather than a material object. To understand the idea that shapes an art work is to understand the work itself – so it is possible to understand an art work without ever having seen it.

Conceptualists deliberately blur the distinction between language and art when they define the art work as an idea or concept. Regardless of whether a Conceptualist art work employs wood or canvas, the real work is the idea and the language used to construct, manipulate and explore it. The artist's intention and the spectator's response are an integral part of the art work itself. This has radically affected the materials used in Conceptualist art, and the way such works are made.

Conceptualism also criticises the commercialisation of art. In a capitalist economy commercial value is attached to tradeable objects, especially those which

support and endorse current social arrangements. Designating an object as 'art' can be a sure means of increasing its material value, so it can be bought, sold and insured for enormous sums. When Conceptualists assert that the art work is the idea, not the material object, they hope to disrupt this trade, or at least problematise it.

Finally, by emphasising the concept over the art work Conceptualists attempt to disrupt the process by which ownership translates into social status and cultural authority. Individuals become important collectors because of their wealth, not because of what they know about art. However, institutions such as museums and galleries can shape and influence our experience of art through their powers of selection and omission.

KEY WORKS in Tate Modern, London

↑ *Two Open Modular Cubes/Half Off, 1972,* SOL LEWITT
LeWitt has assembled aluminium beams covered with enamel to obtain a simple cubic form. The artist intends the work to be 'created' through the perception of the spectator. The 'creation' will change according to how the object is viewed.

The opportunity for multifarious objective interpretations to validate the work defies the conventional belief that art objects express or explore the artist's personal experiences. A further challenge to preconceptions forces us to judge the work as a concept not as an object made by LeWitt.

↙ *Clock (one and five), English/Latin version (Exhibition Version), 1965, 1997,* JOSEPH KOSUTH
This work is composed of five elements: a photograph of a clock, a clock and entries from an English/Latin dictionary for the words 'time', 'machine' and 'object.' By placing a real clock beside a photograph of one, Kosuth questions why we consider a photograph but not the object itself to be art. This juxtaposition also challenges the idea that art is beautiful and/or functionless.

OTHER WORKS in Tate Modern, London

Fountain, 1917, replica 1964, **MARCEL DUCHAMP**

The Bride Stripped Bare by Her Bachelors Even (The Green Box), 1934, **MARCEL DUCHAMP**

A Wall Divided Vertically into Fifteen Equal Parts, Each with a Different Line Direction and Colour, and All Combinations, 1970, **SOL LEWITT**

Eleven Colour Photographs, 1966–7, 1970, **BRUCE NAUMAN**

 Neo-Conceptualism; Minimalism; Perspectivism; Idealism; Dadaism; Cubism

 Neo-Expressionism; Baroque; Rococo; Academicism; Neo-Classicism

object, I. n. 1, = something presented to the mind by the senses, *res*; the —s around us, *res externae*; to be the — of is variously rendered; by *esse* and dat. (e.g. to be an — of care, hatred, contempt to anyone, *alci esse curae, odio, contemptui*), by *esse* and *in* (e.g. to be an — of hatred with anyone, *in odio esse apud algm*; to become an — of hatred, *in odium venire, pervenire*), by nouns already involving the idea (e.g. — of love, *amor*, *deliciae*; — of desire, *desiderium*), by circumloc. with verbs (e.g. to be the — of anyone's love, *ab algo amari, diligi*);

malicious de-; to make —a, thing through algd. ma-machinamenti, f. (= frame-an body, com-a. machinatio,

Neo-Conceptualism includes a variety of artistic tendencies and critiques which emerged in the 1970s. It criticises artistic and cultural norms (e.g. originality and gender). It also explores the relation between capitalism and art and between mass media and individual identity. Neo-Conceptualism is often cited as the best example of the broader cultural trend called Post-Modernism.

ROSS BLECKNER (b.1949); PETER HALLEY (b.1953); JENNY HOLZER (b.1950); JEFF KOONS (b.1955); BARBARA KRUGER (b.1945); LOUISE LAWLER (b.1947); SHERRIE LEVINE (b.1947); RICHARD PRINCE (b.1949); CINDY SHERMAN (b.1954); HAIM STEINBACH (b.1944); PHILIP TAAFFE (b.1955)

deconstruction; critique of power; ethnicity; sexual identity; subversive

Neo-Conceptual art attacks many of the cultural values through which the importance or significance of art is articulated. In particular, Neo-Conceptualists have explored the ways in which the concepts of authority, originality and creation have been used to say what is and is not art and who is and who is not an artist. Neo-Conceptualism includes work influenced by feminist theory, queer theory and ethnic rights movements, all of which critique the use of cultural values to exclude certain groups from the production and evaluation of art. The most obvious examples include the widespread use of the female body in art created by and for men, the tendency to avoid any overt eroticism in depictions of the white, male body, and the association of ethnic minorities with 'primitive' motifs such as bright colours, sensuality, and superstition.

Duchamp has been an important influence on Neo-Conceptualists, many of whom have explored his concept of 'the ready-made'. Poststructuralism has provided Neo-Conceptualists with an intellectual armoury with which to challenge the cultural assumptions of art establishments. The most widespread poststructuralist concept adopted by Neo-Conceptualists is 'deconstruction'. This describes a process of 'taking apart' that will 'undo' the very concepts utilised in that process. Victim and victimiser will trade places endlessly, as the meanings of

those terms will become radically and progressively unstable. The implication for what we can know about the world, and on what basis any authority can ever be claimed is profoundly subversive and disturbing. The best Neo-Conceptualist work is informed by this awareness that deconstruction leads to an endless flux of understanding and not to definition or certainty.

KEY WORKS in the Solomon R. Guggenheim Museum, New York

Two Cells with Conduit, 1987, PETER HALLEY
Halley's work looks like Minimalism but is actually a critique of Minimalism and other forms of abstract art based on geometry, which claim to be 'neutral', 'pure' and dissociated from any social context. Halley identifies a similarity between the geometry of abstract art and the rigid pattern of grid-shaped cities and high rise buildings typical of the modern world.

Untitled Film Still, #15, 1978, CINDY SHERMAN
Sherman's series of untitled film stills shows the artist disguised as a range of female characters from B-movies of the 1950s and '60s. The photographs explore stereotypes of women promoted by cinema. Sherman undermines the conventional film still which tries to look 'real' and 'ordinary'. She uses odd angles and props to draw attention to the fact that photographs, like all art and stereotypes, are deliberately constructed

OTHER WORKS in the Solomon R. Guggenheim Museum, New York

Throbbing Hearts, 1994, **ROSS BLECKNER**

Untitled (Public Opinion), 1991 **FELIX GONZALEZ-TORRES**

Two cells with conduit, 1987, **PETER HALLEY**

Untitled, 1989, **JENNY HOLZER**

Untitled, #112, 1982, **CINDY SHERMAN**

 Conceptualism; Dadaism

 Renaissance; Baroque; Rococo; Academicism; Neo-Classicism; Modernism; Neo-Expressionism; Minimalism

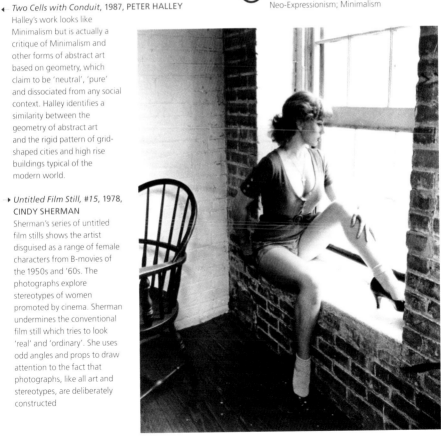

This movement emerged in the 1970s and is usually associated with painting, although some sculpture is also considered Neo-Expressionist. It is characterised by strong, emotional content and a deliberate crudeness in its use of artistic materials which has prompted an attack labelling it 'Bad Painting'.

GEORG BASELITZ (b.1938); SANDRO CHIA (b.1946); FRANCESCO CLEMENTE (b.1952); PHILIP GUSTON (1913–80); ANSELM KIEFER (b.1945); DAVID SALLE (b.1952); JULIAN SCHNABEL (b.1951)

crudeness; anti-abstract; primitive; rough; figurative; emotional

Neo-Expressionism grew out of a rebellion against the dominance of abstraction in modern painting. The avant-garde protest against the abstract began in the 1960s and reached its fullest expression in the late 1970s. Its leading figures advocated a figurative art that reflected the artist's often violent feelings. Their aim was to reconnect art with the psyche. Like the Abstract Expressionists, the Neo-Expressionists were influenced by Jung. Anselm Kiefer has described his work as an attempt to approach the psychological 'centre from which events are controlled', and has worked extensively on an artistic exploration of the psychological forces underlying German history.

Neo-Expressionists were influenced by *art brut* ('rough art') and, like the Expressionists before them, were fascinated by the role 'primitive' emotions play in shaping art and society. They were particularly interested in the 'primitive' or 'rough' art produced by the mentally unstable.

Other trends in Neo-Expressionism have provoked negative reactions. Work which does not have the same emotional force as Baselitz's or Kiefer's, is sometimes dismissed as messy and opportunistic. Julian Schnabel's works, which often utilise broken pottery and tarpaulin, have been criticised for embodying the worst traits of Neo-Expressionism.

KEY WORKS in Tate Modern, London

→ *Parsifal I*, 1973, ANSELM KIEFER
Parsifal is a central figure in Germanic mythology. He was the subject of one of Wagner's greatest music-dramas in which he goes in pursuit of the Holy Grail. Kiefer's *Parsifal I* shows the hero's cot and contrasts the heroic associations of the name with a canvas dominated by floorboards. Parsifal will strive towards the light (represented by the window) but Kiefer's emphasis on the floorboards reminds us that Parsifal's energy comes from hidden, unconscious forces which work in darkness.

→ *Rebel*, 1965, GEORG BASELITZ
This rebel is characteristically Neo-Expressionist because of his physical awkwardness and the absence of any connection with a specific, historical event. Instead, *Rebel* epitomises the possibility of rebellion as a state of mind, or as part of the human condition. Baselitz's rebel has neither shoes nor weapons and seems to be wounded in the leg. The artist implies that hierarchy, authority and rebellion are all part of an unchanging 'human condition'.

OTHER WORKS in Tate Modern, London

Large Head, 1966, **GEORG BASELITZ**

Water Bearer, 1981, **SANDRO CHIA**

Lilith, 1987–9, **ANSELM KIEFER**

Humanity Asleep, 1982, **JULIAN SCHNABEL**

Expressionism; Primitivism; Abstract Expressionism

Conceptualism; Neo-Conceptualism; Minimalism; Baroque; Rococo; Academicism; Neo-Classicism; Constructivism; Neo-Plasticism; Suprematism; Cubism

This term came into general use in the 1960s to describe sculpture which is highly simplified or austere. It was influenced by Abstract Expressionism, in particular the Colour Field paintings of Barnett Newman and Mark Rothko.

Minimalist works are often composed of multiple, uniform elements (e.g. bricks, or sections of tubular lighting) and tend to favour industrial materials.

CARL ANDRÉ (b.1935); DAN FLAVIN (1933–96); EVA HESSE (1936–70); DONALD JUDD (1928–94); YVES KLEIN (1928–62); SOL LEWITT (b.1928); ROBERT MORRIS (b.1931); ROBERT RAUSCHENBERG (b.1925); AD REINHARDT (1913–67); FRANK STELLA (b.1936)

simplicity; austerity; repetition; specific object; non-traditional material; sterile; impersonal

Minimalists often favour the repetitive use of an element which has its own formal simplicity or wholeness. Each part of the sculpture is a self-contained unit or whole, and the construction of the art work is a multiplication of this basic constitutive unit.

Minimalists believe that basic forms of a square, rectangle or circle inevitably arouse certain emotions in the viewer. They wanted to develop a form of sculpture which would take the wholeness they found in certain Abstract Expressionist paintings and explore it in the three dimensions of sculpture. Donald Judd coined the phrase 'specific object' meaning an art work which was neither painting nor sculpture but composed of self-sufficient elements, each of which could exist independently.

Minimalist sculpture is part of the general tendency towards conceptualism in contemporary art. It has been criticised for eliminating complexity and nuance from sculpture, for denying the sensuousness of its materials, and for intellectual sterility.

KEY WORKS in Tate Modern, London

↵ *Steel Zinc Plain*, 1969, by CARL ANDRÉ
The 'minimalism' of this chess-board pattern is rendered through a simple repetition of zinc and steel plates. Visitors to the Tate are allowed to walk on *Steel Zinc Plain* because it is an environment as well as an art work. This subverts the traditional relationship between viewer and sculpture and invites us to question what rules shape our usual interaction with art and each other, and what kind of social games structure our sense of reward and failure in relation to art and human relationships.

▸ *Monument for V. Tatlin*, 1966–9, DAN FLAVIN
Flavin admired the work of Constructivist artist Vladimir
Tatlin and this small work is an ironic tribute to a work
of Tatlin's which, if constructed, would have been taller
than the Eiffel Tower. Flavin's *Monument* is made from
identical, non-traditional materials (pre-fabricated
fluorescent tubing) arranged in a strict pattern.

OTHER WORKS in Tate Modern, London

Venus Forge, 1980, **CARL ANDRE**

Equivalent VIII, 1968, **CARL ANDRE**

Addendum, 1967, **EVA HESSE**

Untitled, 1972, **DONALD JUDD**

Five Forms Derived from a Cube, 1982, **SOL LEWITT**

 Conceptualism; Idealism; Perspectivism;
Constructivism; Neo-Plasticism; Suprematism;
Cubism; Abstract Expressionism

 Neo-Expressionism; Neo-Conceptualism;
Baroque; Rococo; Academicism;
Neo-Classicism

Sensationalism

This term refers to the 'Young British Artists', or YBAs, who first rose to prominence in the late 1980s. Influenced by conceptualism, their work is characterised by its irony, diverse materials and its exploration of contemporary experience. The artists themselves are recognised as expert exploiters of mass media and are closely identified with the collector and advertising mogul, Charles Saatchi.

RICHARD BILLINGHAM (b.1970); JAKE AND DINOS CHAPMAN (b.1966, b.1962); MAT COLLISHAW (1966); TRACEY EMIN (b.1963); MONA HATOUM (b.1952); DAMIEN HIRST (b.1965); GARY HUME (b.1962); LANGLANDS AND BELL (b.1955, b.1959); SARAH LUCAS (b.1962); RON MUECK (b.1958); CHRIS OFILI (b.1968); SIMON PATTERSON (b.1967); MARC QUINN (b.1964); FIONA RAE (b.1963); JENNY SAVILLE (b.1970); SAM TAYLOR WOOD (b.1967); GAVIN TURK (b.1967); MARK WALLINGER (b.1959); GILLIAN WEARING (b.1963); RACHEL WHITEREAD (b.1963); CERITH WYN EVANS (b.1958)

contemporary experience; dark humour; diverse media; insincerity; irony; obscurity; shock tactics; Saatchi

Most of the Young British Artists met at Goldsmiths College, London in the late 1980s. Freeze, their first group exhibition, established their reputation and began to draw attention to London as a vibrant centre of artistic innovation. The YBAs' work has been praised for its dark humour and determination to explore contemporary experience as well as the traditional 'big themes' of art, such as mortality and human identity. It is characterised by a maverick playfulness which utilises any genre and any material – a working practice deliberately encouraged at Goldsmiths College which abolished the traditional distinctions between departments to enable students to take possession of their own creative

development. Although influenced by Conceptualism, the YBAs never abandoned painting in favour of ready-mades: both are prominent in their work. And, despite their reputation for self-promotion and media-savvy, images from contemporary media and advertising have not played a significant role in their work. Critics have attacked them for 'insincerity' and 'obscurity', but these charges cannot detract from the fact that many works by YBA have entered the popular imagination, weathered the hype and remained there.

↑ **KEY WORKS** in Tate Modern, London

Forms Without Life, 1991, **DAMIEN HIRST**
Hirst's work often explores death and dying in an ironic context. In *Forms Without Life* he presents shells in a glass case, which is reminiscent of a museum display. The work reminds us that the acquisition of knowledge often requires us to kill the things we wish to know more about. Hirst points to the danger of privileging categorised knowledge over living experience, an issue also explored in Dadaism and Surrealism.

OTHER WORKS in Tate Modern, London

Untitled (Air Bed II), 1992, **RACHEL WHITEREAD**

The Great Bear, 1992, **SIMON PATTERSON** (b.1967)

Ghost, 1998, **RON MUECK**

Pauline Bunny, 1997, **SARAH LUCAS**

Disasters of War, 1993, **JAKE AND DINOS CHAPMAN**

 Conceptualism; Neo-Conceptualism; Neo-Expressionism; Dadaism; Surrealism; Expressionism

 Idealism; Classicism; Perspectivism; Pietism; Sectarianism; Neo-Classicism; Naturalism; Neo– Plasticism; Suprematism

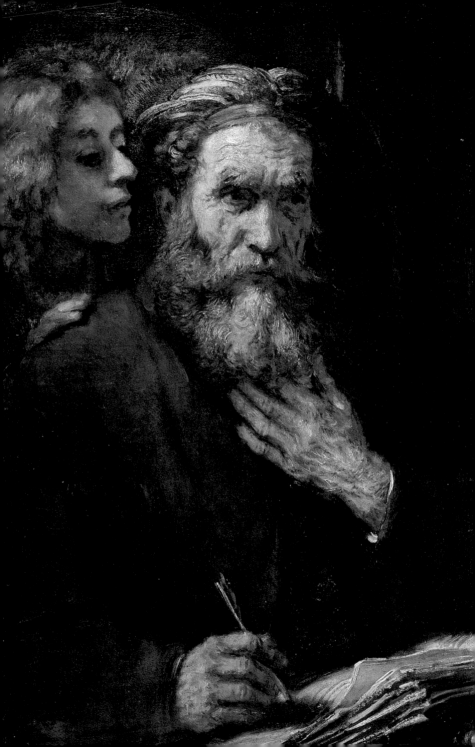

REFERENCE
SECTION

A

ABATE, Niccolò dell' (c. 1510–71)
Mannerism

ALBERTI, Leon Battista
(1404–72)
Renaissance Classicism

ALLORI, Alessandro (1535–1607)
Mannerism

ALMA-TADEMA, Lawrence
(1836–1912)
Medievalism; Aestheticism;
Classicism

ALTDORFER, Albrecht
(c. 1480–1538)
Renaissance; Naturalism

ALVEREZ CUBERO, José
(1768–1827)
Neo-Classicism

AMMANATI, Bartolommeo
(1511–92)
Mannerism

ANDRE, Carl (b. 1935)
Minimalism

ANGELICO, FRA (c. 1395–1455)
International Gothicism;
Renaissance; Perspectivism;
Naturalism

APPEL, Karel (b. 1921)
Modernism; Expressionism;
Neo-Expressionism

APPIANI, Andrea (1754–1817)
Neo-Classicism

ARCIMBOLDO, Giuseppi
(1527–93)
Mannerism

ARP, Jean (or Hans) (1886–1966)
Modernism; Expressionism;
Dadaism; Surrealism

ASPERTINI, Amico (c. 1475–1552)
Mannerism

AUERBACH, Frank (b. 1931)
Modernism; Expressionism;
Neo-Expressionism

B

BABUREN, Dirck van
(c. 1595?–1624)
Baroque; Caravaggism

BACON, Francis (1909–92)
Modernism; Expressionism;
Surrealism; Neo-Expressionism

BALDESSARI, John (b. 1931)
Post-Modernism; Conceptualism

BALLA, Giacomo (1871–1958)
Modernism; Futurism

BANKS, Thomas (1735–1805)
Neo-Classicism

BARLACH, Ernst (1870–1938)
Modernism; Expressionism

BARTOLOMMEO, FRA
(1472–1517)
Renaissance; Idealism; Naturalism

BASELITZ, Georg (b. 1938)
Modernism; Neo-Expressionism

BASSANO, Jacopo (c. 1515–92)
Renaissance; Naturalism; Realism

BASTIEN-LEPAGE, Jules
(1848–84)
Impressionism

BAZILLE, Frédéric (1841–70)
Impressionism

BEARDLSEY, Aubrey (1872–98)
Aestheticism

BECKMANN, Max (1884–1950)
Modernism; Expressionism

BELL, Vanessa (1879–1961)
Modernism; Post-Impressionism

BELLANY, John (b. 1942)
Modernism; Expressionism

BELLINI, Giovanni (c. 1433–1516)
Renaissance; Perspectivism;
Naturalism

BERCHEM, Nicolaes (1620–83)
Baroque Classicism

BERNARD, Émile (1868–1941)
Symbolism; Modernism; Post-
Impressionism

BERNINI, Gianlorenzo
(1598–1680)
Baroque; Pietism; Sectarianism;
Gesturalism; Emotionalism;
Absolutism

BEUYS, Joseph (1921–86)
Postmodernism; Conceptualism

BLAKE, Peter (b. 1932)
Postmodernism

BLAKE, William (1757–1827)
Romanticism

BLOEMART, Abraham
(1566–1651)
Mannerism; Caravaggism;
Naturalism; Neo-Classicism

BOCCIONI, Umberto (1882–1916)
Modernism; Futurism

BÖCKLIN, Arnold (1827–1901)
Symbolism

BOLTRAFFIO, Giovanni Antonio
(c. 1467–1516)
Secularism

BOMBERG, David (1890–1957)
Modernism; Futurism; Cubism;
Expressionism

BONNARD, Pierre (1867–1947)
Impressionism

BOSCH, Hieronymus
(c. 1450–1516)
Renaissance

BOSCHAERT, Ambrosius
(1573–1621)
Baroque

BOTH, Jan (c. 1618–52)
Baroque Classicism

BOTTICELLI, Sandro
(c. 1445–1510)
Renaissance; Secularism;
Classicism

BOUCHER, Francois (1703–70)
Rococo

BOUGUEREAU, William
(1825–1905)
Academicism

BOURGEOIS, Louise (b. 1911)
Modernism; Post-Modernism;
Conceptualism

BRAMANTE, Donato
(c. 1444–1514)
Renaissance; Classicism;
Monumentalism; Illusionism

BRANCUSI, Constantin
(1876–1957)
Idealism; Modernism

BRAQUES, Georges (1882–1963)
Modernism; Fauvism; Cubism

BRATBY, John (1928–92)
Realism; Social Realism

BRONZINO, Agnolo (1503–72)
Mannerism

BROWN, Ford Madox (1821–93)
Medievalism; Realism

BRUEGEL, Pieter the Elder
(c. 1525–69)
Renaissance; Naturalism

BRUNELLESCHI, Filippo
(1377–1446)
Renaissance; Perspectivism;
Classicism; Secularism

BURNE-JONES, Edward
(1833–98)
Aestheticism

C

CAILLEBOTTE, Gustave
(1848–94)
Naturalism; Realism;
Impressionism

CALDER, Alexander (1898–1976)
Modernism; Surrealism

CANALETTO, Giovanni Antonio
Canal called (1697–1768)
Academicism

CANO, Alonso (1610–67)
Baroque; Pietism; Sectarianism;
Baroque Classicism

CANOVA, Antonio (1757–1822)
Neo-Classicism; Naturalism

CARACCIOLO, Giovanni Battista
(1578–1635)
Mannerism; Baroque;
Carravagism; Baroque Classicism

CARAVAGGIO, Michelangelo
Merisi da (1571/2–1610)
Baroque; Pietism; Realism;
Caravaggism

CARL, Jacon van (c. 1705–65)
Academicism; Rococo

CARPACCIO, Vittore
(c. 1460–c. 1526)
Secularism

CARRÀ, Carlo (1881–1966)
Modernism; Futurism; Realism

CARRACCI
Agostino (1557–1602)
Annibale (1560–1609)
Lodovico (1555–1619)
Academicism; Classicism

CARREÑO DE MIRANDA, Juan
(1614–85)
Baroque; Absolutism

CASSATT, Mary (1844–1926)
Impressionism

CASTAGNO, Andrea del
(c. 1418–57)
Renaissance; Monumentalism;
Perspectivism

CELLINI, Benvenuto (1500–71)
Mannerism

CÉZANNE, Paul (1839–1906)
Modernism; Post-Impressionism

CHAGALL, Marc (1887–1985)
Modernism; Expressionism

CHAMPAIGNE, Philippe de
(1602–74)
Baroque; Absolutism; Pietism;
Sectarianism

CHARDIN, Jean-Siméon
(1699–1779)
Rococo

CHIA, Sandro (b. 1946)
Neo-Expressionism

CHIRICO, Giorgio de
(1888–1978)
Modernism; Dadaism; Surrealism

CHRISTO (b. 1935)
Postmodernism; Conceptualism

CIONE, Jacopo di
(c. 1362–c. 1398)
International Gothicism

CLOSE, Chuck (b. 1940)
Modernism; Abstract
Expressionism; Realism

COELLO, Claudio (1642–93)
Pietism

CONSTABLE, John (1776–1837)
Naturalism; Romanticism

COPLEY, John Singleton
(1738–1815)
Rococo; Academicism

COROT, Jean-Baptiste-Camille
(1796–1875)
Naturalism; Classicism

CORREGGIO, Antonio Allegri
called (c. 1494–1534)
Renaissance; Illusionism;
Monumentalism

COURBET, Gustave (1819–77)
Realism; Social Realism

CRANACH, Lucas the Elder
(1472–1553)
Renaissance; Naturalism;
Secularism

CRIPPA, Roberto (1921–1972)
Spatialism

D

DA VINCI, Leonardo (1452–1519)
Renaissance; Naturalism;
Idealism; Secularism

DALÍ, Salvador (1904–89)
Modernism; Surrealism

DAUMIER, Honoré (1798–1879)
Realism

DAVID, Jacques-Louis
(1748–1825)
Neo-Classicism; Realism

DEGAS, Edgar (1834–1917)
Impressionism;
Post-Impressionism; Modernism

DE KOONING, Willem (1904–97)
Modernism;
Abstract Expressionism

DEL SARTO, Andrea (1486–1530)
Mannerism

JOUVENET, Jean (1644–1717)
Baroque; Emotionalism; Pietism;
Sectarianism

JUDD, Donald (1928–1994)
Post-Modernism; Minimalism

K

KAHLO, Frida (1907–54)
Modernism; Surrealism

KANDINSKY, Wassily
(1866–1944)
Symbolism; Modernism;
Expressionism; Surrealism

KAPOOR, Anish (b.1954)
Post-Modernism

KAUFMANN, Angelica
(1741–1807)
Neo-Classicism

KELLY, Ellsworth (b.1923)
Abstract Expressionism

KIEFER, Anselm (b.1945)
Post-Modernism;
Neo-Expressionism

KING, Philip (b.1934)
Post-Modernism

KIRCHNER, Ernst Ludwig
(1880–1938)
Primitivsim

KITAJ, R.B. (b.1932)
Post-Modernism

KLEE, Paul (1879–1940)
Modernism

KLEIN, Yves (1928–62)
Conceptualism

KLIMT, Gustav (1862–1918)
Secessionism; Symbolism

KOKOSCHKA, Oskar
(1886–1980)
Modernism; Expressionism

KOLLWITZ, Käthe (1867–1945)
Modernism; Social Realism

KOONS, Jeff (b.1955)
Post-Modernism; Conceptualism

KOSUTH, Joseph (b.1945)
Post-Modernism; Conceptualism

KRASNER, Lee (1908–84)
Abstract Expressionism

KRUGER, Barbara (b.1945)
Post-Modernism; Conceptualism

L

LABRADOR, EL, Juan Fernandez
called, (1630s)
Baroque; Illusionism

LANDSEER, Edwin (1802–73)
Academicism

LANFRANCO, Giovanni
(1582–1647)
Baroque; Illusionism

LA TOUR, Georges de
(1593–1652)
Baroque; Caravaggism;
Gesturalism

LATOUR, Maurice-Quentin de
(1704–88)
Rococo

LAWLER, Louise (b.1947)
Neo-Conceptualism

LAWRENCE, Thomas
(1769–1830)
Academicism

LE BRUN, Charles (1619–90)
Baroque Classicism; Academicism

LE CORBUSIER, Charles-Edouard
Jeanneret called (1887–1965)
Modernism

LÉGER, Fernand (1881–1955)
Modernism; Fauvism; Futurism;
Neo-Classicism; Cubism

LEIGHTON, Lord Frederic
(1830–96)
Medievalism; Academicism

LELY, Sir Peter (1618–80)
Baroque

LEMOYNE, François (1688–1737)
Rococo

LEMOYNE, Jean-Baptiste
(1704–78)
Rococo

LE NAIN Brothers
Antoine (c.1600–48)
Louis (c.1600–48)
Mathieu (c.1607–77)
Baroque; Academicism

LEVINE, Sherrie (b.1947)
Neo-Conceptualism

LEWITT, Sol (b.1928)
Post-Modernism; Conceptualism

LICHTENSTEIN, Roy (1923–97)
Post-Modernism

LIMBOURG Brothers
(all dead by c.1416)
International Gothicism

LIPCHITZ, Jacques (1891–1973)
Modernism; Cubism

LIPPI, Fra Filippo (1406/7–69)
Renaissance

LISSITZKY, EL (1890–1947)
Modernism; Neo-Plasticism;
Constructivism

LONG, Richard (b.1945)
Post-Modernism; Conceptualism

LORRAIN, Claude Gelée called
(1600–82)
Baroque Classicism

LOTTO, Lorenzo (c.1480–1556/7)
Renaissance; Naturalism

M

MACKE, August (1887–1914)
Impressionism; Modernism;
Fauvism; Expressionism

MAGRITTE, René (1898–1967)
Modernism; Surrealism

MAILLOL, Aristide (1861–1944)
Modernism; Primitivism;
Classicism

MALEVICH, Kasimir (1878–1935)
Modernism; Suprematism

MANET, Édouard (1832–83)
Realism

MANFREDI, Bartolommeo
(1582–1622)
Baroque; Caravaggism

MAN RAY (1890–1976)
Modernism; Surrealism

MANTEGNA, Andrea
(c.1431–1506)
Renaissance; Perspectivism;
Classicism

MARC, Franz (1880–1916)
Modernism; Expressionism

MASACCIO, Tommaso Guidi called (1401–28)
Renaissance; Perspectivism; Classicism

MASSON, André (1896–1987)
Modernism; Cubism; Surrealism

MATISSE, Henri (1869–1954)
Impressionism;
Neo-Impressionism; Modernism;
Post-Impressionism

MEULEN, Adam Frans van der (1632–90)
Absolutism

MICHELANGELO BUONARROTI (1475–1564)
Renaissance; Idealism; Classicism;
Monumentalism; Humanism

MIDDLEDITCH, Edward (1923–87)
Social Realism

MILLAIS, John Everett (1829–96)
Medievalism; Naturalism;
Academicism

MILLET, Jean-François (1814–75)
Realism

MIRÓ, Joan (1893–1983)
Modernism; Surrealism;
Cubism; Primitivism

MODERSOHN-BECKER, Paula (1876–1907)
Modernism; Post-Impressionism;
Primitivism

MODIGLIANI, Amadeo (1884–1920)
Modernism

MOHOLY-NAGY, László (1895–1946)
Modernism; Constructivism

MONDRIAN, Piet (1872–1944)
Modernism; Neo-Plasticism

MONACO, Lorenzo (c. 1370–c. 1425)
International Gothicism

MONET, Claude (1840–1926)
Impressionism

MOORE, Henry (1898–1986)
Modernism; Primitivism

MORANDI, Giorgio (1890–1964)
Modernism

MOREAU, Gustave (1826–98)
Aestheticism, Symbolism

MORISOT, Berthe (c. 1841–95)
Impressionism

MORRIS, William (1834–96)
Medievalism; Aestheticism

MOTHERWELL, Robert (1915–91)
Modernism; Abstract
Expressionism

MUNCH, Edvard (1863–1944)
Symbolism

MURILLO, Bartolomé Esteban (c. 1617–82)
Baroque; Pietism; Sectarianism

N

NEWMAN, Barnett (1905–70)
Modernism; Abstract
Expressionism

NICHOLSON, Ben (1894–1982)
Modernism; Primitivism;
Constructivism

NOLDE, Emil (1867–1956)
Modernism; Expressionism

O

O'KEEFE, Georgia (1887–1986)
Modernism

OLDENBURG, Claes (b. 1929)
Post-Modernism

OUD, J. J. P. (1890–1963)
Neo-Plasticism

OPIE, Julian (b. 1958)
Post-Modernism; Conceptualism

OUDRY, Jean-Baptiste (1686–1755)
Rococo

P

PALMER, Samuel (1805–81)
Naturalism

PAOLOZZI, Eduardo (b. 1924)
Post-Modernism

PARET Y ALCÁZAR, Luis (1746–99)
Rococo

PARMIGIANINO, Girolamo
Francesco Maria Mazzola called (1503–40)
Mannerism

PARROCEL, Joseph (1646–1704)
Absolutism

PASMORE, Victor (1908–98)
Modernism; Constructivism

PATINIR or **PAINIER** or **PATENIER**, Joachim (c. 1475–1524)
Renaissance

PECHSTEIN, Max (1881–1955)
Expressionism

PELLEGRINI, Giovanni Antonio (1675–1741)
Rococo

PERINO DEL VAGO, Piero
Buonaccorsi called (c. 1500–47)
Renaissance

PERUGINO, Pietro Vanucci called (c. 1450–1523)
Renaissance

PERRIER, Francois (c. 1590–1650)
Baroque Classicism

PEVSNER, Antoine (1886–1962)
Modernism

PHILLIPS, Tom (b. 1937)
Post-Modernism

PICABIA, Francis (1879–1953)
Dadaism

PIAZZETTA, Giovanni Battista (1683–1754)
Baroque; Caravaggism

PICASSO, Pablo (1881–1973)
Modernism; Cubism; Surrealism;
Classicism

PIERO DELLA FRANCESCA (c. 1415–92)
Renaissance; Classicism;
Perspectivism

PIETRO DA CORTONA, Pietro Berrettini called (1596–1669)
Baroque; Illusionism; Baroque Classicism

PIGALLE, Jean-Baptiste (1714–85)
Naturalism

PINTORICCHIO, Bernardino di Betto called (c.1454–1513)
Renaissance

PIRANESI, Giovanni Battista (1720–78)
Classicism; Romanticism

PISANELLO, Antonio Pisano called (c.1395–1455)
International Gothicism

PISSARRO, Camille (1839–1903)
Impressionism; Neo-Impressionism

PISSARRO, Lucien (1863–1944)
Impressionism; Neo-Impressionism

POLLAIULO
Antonio (c.1432–98)
Piero (c.1441–96)
Renaissance; Classicism

POLLOCK, Jackson (1912–56)
Modernism; Abstract Expressionism

PONTE, Giovanni dal (1385–1437)
International Gothicism

PONTORMO, Jacopo Carucci called (1494–1557)
Mannerism

POUSSIN, Nicolas (1594–1665)
Baroque Classicism

POZZO, Andrea (1642–1709)
Sectarianism

PRIMATICCIO, Francesco (1504–70)
Mannerism

PRUD'HON, Pierre-Paul (1758–1823)
Neo-Classicism

PUVIS DE CHAVANNES, Pierre (1824–98)
Symbolism

R

RAEBURN, Henry (1756–1823)
Academicism; Naturalism

RAPHAEL, Raffaello Sanzio called (1483–1520)
Renaissance; Idealism; Classicism

RAUSCHENBERG, Robert (b.1925)
Post-Modernism

REDON, Odilon (1840–1916)
Symbolism; Aestheticism

VAN RIJN, Rembrandt Hermensz (1606–69)
Baroque; Pietism; Sectarianism; Gesturalism; Emotionalism

REPIN, Ilya (1844–1930)
Realism

REYNOLDS, Joshua (1723–92)
Academicism

RIBERA, Jusepe de (1591–1652)
Baroque; Pietism; Baroque

RICCI, Sebastiano (1659–1734)
Rococo

RIETVELD, Gerrit (1888–1964)
Neo-Plasticism

RIGAUD, Hyacinth (1659–1743)
Baroque; Absolutism

RIVERA, Diego (1886–1957)
Cubism; Realism

RODCHENKO, Alexander (1891–1956)
Modernism; Suprematism; Constructivism

RODIN, Auguste (1840–1917)
Naturalism; Realism

ROMNEY, George (1734–1802)
Academicism; Classicism

ROSA, Salvator (1615–73)
Baroque

ROSSETTI, Dante Gabriel (1828–82)
Naturalism; Medievalism

ROSSO FIORENTINO, Giovanni Battista di Jacopo called (1494–1540)
Mannerism

ROTHKO, Mark (1903–70)
Modernism; Abstract Expressionism

ROUAULT, Georges (1871–1958)
Expressionism

ROUSSEAU, Henri (1844–1910)
Primitivism

RUBENS, Peter Paul (1577–1640)
Baroque; Allegoricism; Absolutism; Emotionalism; Gesturalism

RUISDAEL, Jacob van (1628–82)
Baroque; Naturalism; Romanticism

RUSSOLO, Luigi (1885–1947)
Futurism

S

SARGENT, John Singer (1856–1924)
Academicism; Impressionism

SCHMIDT-ROTLUFF, Karl (1884–1976)
Expressionism

SCHNABEL, Julian (b.1951)
Post-Modernism; Neo-Expressionism

SCHWITTERS, Kurt (1887–1948)
Modernism; Dadaism

SCOREL, Jan van (1495–1562)
Renaissance; Classicism

SEURAT, Georges (1859–91)
Impressionism; Neo-Impressionism

SEVERINI, Gino (1883–1966)
Modernism; Futurism

SHERMAN, Cindy (b.1954)
Post-Modernism; Neo-Conceptualism

SIBERECHTS, Jan (1627–c.1701)
Baroque

SICKERT, Walter Richard (1860–1947)
Impressionism; Realism

SISLEY, Alfred (1839–99)
Impressionism

SMITH, Jack (b. 1928)
Social Realism

SOUTINE, Chaim (1894–1943)
Modernism

SPENCER, Stanley (1891–1959)
Modernism; Realism

SPRANGER, Bartolomeus
(1546–1611)
Mannerism

STEINBACH, Haim (b. 1944)
Neo-Conceptualism

STELLA, Frank (b. 1936)
Post-Modernism; Abstract
Expressionism; Minimalism

STEPANOVA, Varvara
(1894–1958)
Constructivism

STILL, Clyfford (1904–80)
Modernism;
Abstract Expressionism

STUART, Gilbert (1755–1828)
Academicism

STUBBS, George (1724–1806)
Academicism; Naturalism

T

TAAFFE, Philip (b. 1955)
Neo-Conceptualism

TANGUY, Yves (1900–55)
Modernism; Surrealism

TÀPIES, Antonio (b. 1932)
Modernism; Surrealism

TATLIN, Vladimir (1885–1953)
Modernism; Constructivism

TERBRUGGHEN, Henrick
(1588–1629)
Baroque; Caravaggism

THULDEN, Theodoor van
(1606–69)
Absolutism

TIBALDI, Pellegrino (1527–96)
Baroque

TIEPOLO, Giovanni Battista
(1696–1770)
Rococo

TINGUELY, Jean (1925–1991)
Post-Modernism; Conceptualism

TINTORETTO, Jacopo Robusti
called (1518–94)
Renaissance; Naturalism

TISSOT, James or Jacques
(1836–1902)
Impressionism; Realism

TITIAN, Tiziano Vecellio called
(c. 1485–1576)
Renaissance; Naturalism;
Classicism; Secularism

TOULOUSE-LAUTREC, Henri de
(1864–1901)
Impressionism; Naturalism;
Realism

TOURNIER, Nicolas
(1590–1638/9)
Caravaggism

TURNER, Joseph Mallord William
(1775–1851)
Romanticism; Classicism;
Impressionism

TWOMBLY, Cy (b. 1929)
Post-Modernism;
Neo-Expressionism

U

UCCELLO, Paolo (1397–1475)
Renaissance; Perspectivism;
Classicism

V

DE VALENCIENNES, Pierre-Henri
(1750–1819)
Classicism

VANTONGERLOO, Georges
(1886–1965)
Modernism; Constructivism

VASARI, Giorgio (1511–74)
Renaissance; Classicism;
Humanism

VELÁZQUEZ, Diego (1599–1660)
Baroque; Realism; Absolutism;
Pietism; Gesturalism;
Emotionalism; Sectarianism

VERMEER, Jan (1632–75)
Baroque; Allegoricism

VERONESE, Paolo (c. 1528–88)
Renaissance; Naturalism;
Illusionism

VERROCHIO, Andrea del
(c. 1435–88)
Renaissance

VLAMINCK, Maurice de
(1876–1958)
Modernism; Fauvism

VOUET, Simon (1590–1649)
Baroque; Absolutism

W

WARHOL, Andy (1928–87)
Post-Modernism

WATTEAU, Jean-Antoine
(1684–1721)
Rococo

WEST, Benjamin (1738–1820)
Academicism

WEYDEN, Rogier van der
(c. 1399–1464)
Renaissance; Naturalism

WHISTLER, James Abbott McNeill
(1834–1903)
Aestheticism

WHITEREAD, Rachel (b. 1963)
Post-Modernism; Conceptualism

WILS, Jan (1891–1972)
Neo-Plasticism

WIT, Jacob de (1695–1754)
Baroque; Illusionism; Sectarianism

WOUWERMAN, Philips
(1619–68)
Baroque; Naturalism

Z

ZOFFANY, Johann (1733–1810)
Academicism, Neo-Classicism

ZURBARÁN, Francisco de
(1598–1664)
Baroque; Pietism; Sectarianism

ABSTRACTION
Art which does not imitate, or refer directly, to the appearance of objects in the world.

ART BRUT
Meaning, literally, 'raw art' and devised by French artist Jean Dubuffet (1901–85). Used to describe art created by people working outside the art world and/or the 'normal' adult world e.g. children, the insane, criminals.

ART POVERA
Or 'poor art'. A form of minimal or conceptual art. Uses banal materials such as soil and newspaper and rejects the commodification of art into marketable art objects.

BLOT DRAWING
An art work in which an accidental blot is used as the basis of landscape or figure.

BODY ART
Art in which the artist uses his or her own body as the medium. Closely associated with performance art.

BOZZETTO
A small wax or clay model made in preparation for a larger sculpture.

BYZANTINE ART
The art of the Eastern Roman empire (AD 330 – 1453). Sometimes used to describe art which is hieratic, formal and highly decorative.

CABINET PICTURE
Small easel paintings for domestic settings.

CAMERA LUCIDA
A device used for projecting and copying images. It usually consists of a prism on a metal arm. When the artist looks into the prism he or she can see an image projected onto the page and can copy it. (See also Camera Obscura.)

CAMERA OBSCURA
A device for projecting and copying images. Traditionally, a small box with mirrors inside it which project an image onto the artist's paper or canvas to facilitate copying. (See also Camera Lucida.)

CARICATURE
Images which exaggerate or distort figures' physical features for comic, satirical or other purposes.

CARTOON
A preliminary drawing used to transfer the outline of an image onto a canvas prior to painting.

CHIAROSCURO
The contrast between areas of darkness and areas of light in a painting or drawing, often used for dramatic effect, and associated with certain Baroque artists in particular, notably Caravaggio (1571–1610) and Rembrandt (1606–69).

CLAUDE GLASS
A small mirror which reflects entire landscapes in miniature so that the artist can judge the landscape's tonal range. Used by Claude Lorrain (c.1600–82) from which it derives its name.

COLOURIST
At its broadest, this term is used to describe an artist whose work is highly colourful, or obviously pre-occupied by certain ranges or qualities of colour. Used more narrowly, it describes an artist who builds images from colour rather than sketching outlines within which colour is added. (See also Venetian School, Disegno.)

COLLAGE
The term refers both to an artistic technique and to the art works which result from the technique. Collage involves applying different materials such as newspaper, tickets, or cloth to a flat surface such as paper or canvas, often alongside painted or drawn sections. In art history, collage is most closely associated with Cubism.

COMPOSITION
The arrangement of forms from which the art work is composed. Hence 'a balanced composition' or 'an ugly composition in which the forms seem entirely unrelated to each other'.

CONCRETE ART
Abstract, often geometric art, without any representational or symbolic content or significance other than that of the artwork itself.

CONTRAPPOSTO
Describes the twists or turns of a human figure or figures in either sculpture or painting. Renaissance artists frequently make use of it.

DISEGNO
The design of an art work (usually in preparatory drawings) where the form and outline are carefully arranged to achieve the best possible composition. Colour is added later and is of secondary importance in the process of Disegno. (See also Venetian School, Colourist, **Renaissance, Idealism**.)

DONOR PORTRAITS
Religious art in which, from the Renaissance onwards, the person, or family, who commissioned the artwork are shown participating in appropriately devotional activities, such as worship or prayer.

DRY POINT
A method of Intaglio printmaking. The image is marked or scratched directly into a copper plate with a sharp tool. (See Intaglio)

ENGRAVING
A method of Intaglio printmaking. A tool is used to gouge into the surface of the metal plate. (See Intaglio.)

ENVIRONMENT ART
A movement in later 20th-century art. Characterised by distinct environments which are deliberately created by artists and which the viewer must enter in order to

experience it. Not to be confused with Land Art in which artists make use of elements from natural or urban environments.

ETCHING

A method of Intaglio printmaking. A copper plate is covered in wax and the artist then scratches a design or image into the wax, exposing the copper. The plate is then treated with acid. Exposed areas are bitten by the acid and can then be inked. The longer the exposed areas are exposed to the acid, the darker they print. (See Intaglio)

FANCY PICTURE

An 18th-century term used to describe paintings showing conventional, often sentimental scenes, such as children playing with pets. Intended for domestic display.

FIGURATIVE

A term used to describe art which realistically represents nature and the human form.

FORESHORTENING

A method of depicting objects according to the rules of linear perspective. The length of an object is shortened to give the impression that it is being viewed from one end, thereby heightening the viewer's impression that the work contains spatial depth into which he or she looks. (See Renaissance Perspectivism.)

FOUND OBJECT

(See Objet Trouvé.)

FRESCO

A method of painting on walls. The pigment is applied directly to wet plaster. When the plaster dries the painting is fixed into the wall itself. The technique has been used most successfully in countries with dry climates, such as Italy.

GENRE

Genre is French for 'type' or 'category' and is a method of classifying different 'types' of art.

Traditionally, the hierarchy of genres are now associated with the Academicism of the 17th to 19th centuries. The hierarchy of genre ranged from history painting at the top, to landscape at the bottom, via portraiture, so-called 'genre scenes' (pictures of everyday subjects) and still life. There is no longer an established hierarchy of genres. (See **Academicism**)

GOLDEN SECTION

A proportion devised by the Greek mathematician Euclid and used in art from the Renaissance onwards, this is a division of pictorial space where the smaller section has the same proportional relationship to the larger section as the larger section has to the total pictorial space.

GRAFFITI ART

Art which utilises the styles and/or methods of graffiti but which is usually exhibited in galleries. Amongst the best-known exponents are Jean-Michel Basquiat (1960–88) and Keith Haring (1958–90).

GRAND MANNER

18th century English term for the genre of history painting. (See Genre.)

GRAND TOUR

Primarily an 18th century British phenomenon in which wealthy or aristocratic people, usually men, toured Italy to complete their education in art and culture.

HAPPENING

An art event in which visitors must actively participate in order for art to 'happen'. (See also Performance Art.)

HISTORY PAINTING

(See Genre.)

ICON

A religious image intended to be viewed and revered as part of religious devotion. Usually

associated with the art and culture of Byzantium.

ICONOGRAPHY

The study of the particular meaning of images or parts of images, including their symbolic meaning e.g. the study of the iconography of thorns would explore how artists have used thorns to convey different sorts of symbolic, theoretical or philosophical meaning.

INSTALLATION ART

Installation art emerged in the 1960s. It is characterised by art works which are made for particular environments and only exist for as long as they remain installed. Collectable installations can be re-installed in different locations. Installation art was a means of challenging conventional definitions of art and side-stepping the commercial galleries.

INTAGLIO

Umbrella term for methods of printing which involve marking the surface of a metal plate (usually copper). Ink is then applied to the metal plate. It gathers in the marks and remains there after the unmarked areas of the plate have been wiped clean. Damp paper is then laid on the plate and pressed against it so that the paper lifts the inked image from the plate. (See Drypoint, Engraving, Etching.)

INTIMISME

A style of art associated with French artists Pierre Bonnard (1867–1947) and Edouard Vuillard (1868–1940) characterised by intimate, domestic scenes of daily life such as mending clothes, preparing meals and reading books.

JUNK ART

Art made from rubbish. The movement was strongest during the 1950s and '60s and made explicit criticism of the art world's dominant commercial and cultural pre-occupations. (See also Installation Art.)

KINETIC ART
Art which moves, or appears to move, and which often only 'properly' exists when in movement. (See **Constructivism**.)

LAND ART
Sculptural movement of the 1960s and '70s. Used or reshaped natural or rural landscapes to create art. Also includes the use of natural elements, such as mud, branches and ice, to create temporary art works in specific spaces ranging from galleries to streets and public parks. Related to **Conceptualism**.

LANDSCAPE
(See Genre.)

LITHOGRAPH
A method of printing in which the design or image is drawn directly onto stone or other panel materials with a greasy crayon. The panel is wetted before being rolled with ink. The ink sticks to the greasy image but not to the wet panel. Prints can then be made by pressing or rolling paper on the panel.

MAGIC REALISM
Any style of painting in which naturalistic or photographic style is used in paintings with odd or fantastical subject matter.

METAPHYSICAL PAINTING
A style of art associated with Italian artist de Chirico (1888–1978) characterised by odd perspectives, strange imagery and a strong feeling for Italian Renaissance architecture.

MEZZOTINT
A method of printmaking. A steel-wool tool is used to work a design into a metal plate. Ink holds where the plate has been roughened, the rougher areas print darker, the less roughened areas print lighter. This method of printmaking is valued for its tonal range. Virtually eclipsed by photography in the 19th century.

MODELLO
A preparatory drawing for a larger work. Usually finished to a high standard to impress potential clients.

MONOTYPE
A method of printmaking. The design or image is painted or drawn directly onto a panel and then printed onto paper. Usually only a single print is made from the panel, hence 'monotype'.

MULTIPLES
This term is used of identical or similar art works produced in large quantities, sometimes without the artist's direct involvement. Multiples were popular in the 1960s and were intended to bypass commercial art galleries. The term does not apply to series of prints or series of sculptures made by artists. Multiples are often produced according to the artist's instructions but without his or her direct involvement.

NABIS
A group of French painters active in Paris at the end of the 19th century. Influenced by Paul Gauguin (1848–1903) and associated with Symbolism. Key artists include: Pierre Bonnard (1867–1947); Maurice Denis (1870–1943); Aristide Maillol (1861–1944); Paul Sérusier (1864–1927); Félix Vallotton (1865–1925); Édouard Vuillard (1868–1940).

NAZARENES
A group of German artists of the early 19th century who aspired to create morally purposeful art. They admired the Middle Ages and, like the Pre-Raphaelites in England, they were characteristic of 19th century Medievalism. Key artists include: Julius Schnorr von Carolsfeld (1794–1872); Peter von Cornelius (1783–1867); Friedrich Johann Overbeck (1789–1869); Wilhelm von Schadow (1788–1862).

NEUE SACHLICHKEIT
The German name means 'New Objectivity'. A movement in German art of the 1920s and '30s characterised by great attention to detail and violent social satire, giving it a strong relationship with Expressionism, despite its lack of a coherent style. Key artists include: Otto Dix (1891–1969); George Grosz (1893–1959).

NEW IMAGE PAINTING
A term used of art since 1970 which is characterised by rough, cartoon-like imagery. Key artist: Philip Guston (1913–80).

NON OBJECTIVE ART
Non-Objective art is abstract and non-representational. The term is usually confined to highly geometric art and was first used by Alexander Rodchenko (1891–1956), the leading artist of Suprematism.

OBJET TROUVÉ (FOUND OBJECT)
An object which has been found by an artist and then exhibited so that others can appreciate its aesthetic qualities. Found objects were first exhibited by the Dadaists who were keen to break down the distinctions between art and everyday life. (See also Ready Made.)

OP ART
From 'Optical Art'. An art movement which was at its strongest in the 1960s. The movement's name is derived from Op artists' preference for painterly techniques which make their works seem to move or flicker. Op art is usually produced to create specific effects on the eye, requiring artists to pay great attention to their use of colour and form. Key artists include: Bridget Riley (b. 1941); Victor Vasarely (1908–97).

PASTEL
Pigment mixed with resin or gum to make solid sticks of colour which can be applied to paper. The medium enables artists to work directly in colour without the line and tone preparation of pencil.

PERFORMANCE ART

Related to Happenings (see above). The event or performance constitutes the art work. Usually, Performance Art is more extreme than the theatre or drama with which it shares basic affinities, namely that art lives in a performance observed by an audience.

PHOTOREALISM

An art movement which developed in America in the late 1960s in reaction against Minimalism and Abstraction. Photorealism is an extreme form of Realism. Photorealists rely heavily, and obviously, on photography, often projecting photographs onto canvas and then painting a replica of the photograph onto the canvas. Key artists include: Chuck Close (b. 1940); Richard Estes (b. 1936).

PIETÀ

From the Italian meaning 'pity ', this applies to a painting or sculpture which shows the Virgin Mary supporting the body of the dead Christ on her lap. Other key figures may also be included.

POST-PAINTERLY ABSTRACTION

A term developed by American critic Clement Greenberg to describe abstract art which was calmer and more controlled than Abstract Expressionism. Key artists include: Helen Frankenthaler (b. 1928); Morris Louis (1912–62); Kenneth Noland (b. 1924).

QUATTROCENTO

The 15th century (1400s). Usually used in relation to Italian art e.g. The 16th century (1500s) is referred to as the cinquecento.

READY MADE

A term developed by Marcel Duchamp (1887–1968) and used to describe an industrial or mass-produced object exhibited in an art gallery e.g. a stool or bicycle.

REPRESENTATIONAL ART

Art which we recognise as imitating or referring to the appearance of objects in the world. Representational art ranges from Naturalism to Realism through to Impressionism and Post-Impressionism. All Representational Art invites comparison between itself and its subject matter as it exists in the world. (See also Abstraction)

ROMANESQUE

Primarily an architectural term denoting Roman influence on European architecture but also used more broadly to indicate the effect of the same influence on art and culture in the same period. Romanesque style was dominant in Medieval Europe between 1100 and 1200.

SERIAL ART

A term which is sometimes used to refer to Minimalism or to contemporary art works made from a series of component parts or made as part of a larger series of works.

SFUMATO

This term describes the way one colour or tone changes into another colour or tone in the same painting.

STILL LIFE

Paintings of objects ranging from fruit and flowers through to cups and violins, usually arranged on table-tops or window sills. Still life never contains a human figure, though it often plays with the absence of a suggested person or presence as a means of contemplating loss or death. An intimate genre suited to meditative themes and subtle displays of painterly virtuosity. (See also Genre and Vanitas.)

TEMPERA

A type of paint made from pigment mixed with egg white. From 1300 to 1500, egg tempera was the most commonly used medium for painting on panels and was gradually replaced by oil paints.

VANITAS

From the Latin meaning 'vanity' or 'emptiness', this is a still-life painting in which a collection of objects symbolizes man's mortality, and the transience of all earthly pleasures and achievements. Especially popular in Dutch and Spanish art of the 17th century.

VENETIAN SCHOOL

Venice was a centre of the Italian Renaissance. Unlike Florentine artists, Venetian artists emphasised colour and effects of atmosphere over line and form. The high point of the Venetian School was c. 1510–1580. Key Artists include: Giovanni Bellini (c. 1431–1516); Giorgione (c. 1476–1510); Tintoretto (1518–94); Titian (c. 1480–1576); Veronese (1528–88).

VERISM

An extreme form of Realism in which the artist aims to replicate appearance exactly and without allowing any 'artistic' considerations – about composition, colour or meaning for instance – to influence the creation of the art work.

WOODCUT

The oldest technique for creating prints. The term is often used very generally to describe any print from wood. The term applies both to the wood block from which the print is made and to the print itself, and should only be used to describe a block, or print from a block, on which the grain runs lengthways up and down, and not across, from left to right.

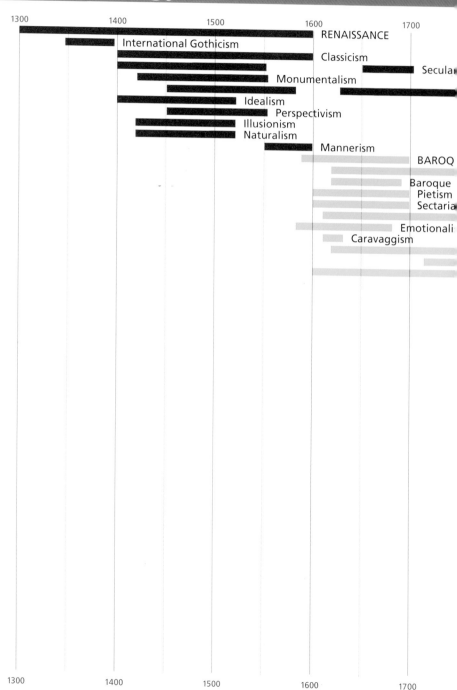

RENAISSANCE

International Gothicism

Classicism

Secular

Monumentalism

Idealism

Perspectivism

Illusionism

Naturalism

Mannerism

BAROQ

Baroque
Pietism
Sectaria

Emotionali

Caravaggism

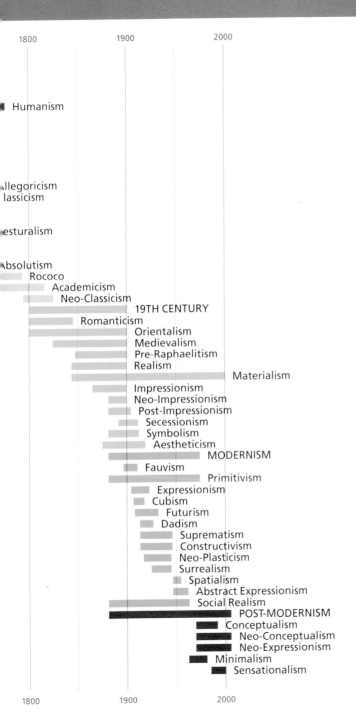

NATIONAL GALLERY
London
International Gothicism; Idealism;
Naturalism; Mannerism; Caravaggism;
Academicism; Neo-Impressionism

TATE GALLERY
(Tate Britain and **Tate Modern, London**;
Tate Liverpool)
Medievalism; Pre-Raphaelitism;
Aestheticism; Constructivism;
Social Realism; Cubism;
Spatialism; Social Realism;
Post-Modernism; Conceptualism;
Neo-Expressionism; Minimalism;
Sensationalism; Spatialism

UFFIZI, Florence:
Renaissance; Secularism; Perspectivism

VATICAN, Rome:
Classicism; Monumentalism;
Illusionism

LOUVRE, Paris:
Humanism; Allegoricism; Sectarianism;
Gesturalism; Absolutism; Rococo;
Neo-Classicism; Romanticism; Orientalism

MUSÉE D'ORSAY, Paris:
Realism; Materialism; Impressionism

PRADO, Madrid:
Baroque; Baroque Classicism; Pietism;
Emotionalism

ÖSTERREICHISCHE GALERIE BELVEDERE,
Vienna
Secessionism

MUSEUM OF MODERN ART,
New York
Symbolism; Fauvism; Primitivism; Futurism;
Suprematism

SOLOMON R. GUGGENHEIM MUSEUM,
New York
Post-Impressionism; Modernism;
Expressionism; Dadaism; New-Plasticism;
Surrealism; Abstract Expressionism;
Neo-Conceptualism

IMPORTANT NOTE FOR READERS:
This listing is not, of course, exhaustive –
it is a simple guide. The collections in each
museum and gallery above will also include
examples of other isms.

All numbers refer to page numbers

The publishers would like to thank the following contributors:

LOUVRE
Paris
photos © RMN 26, 49;
photos © RMN–J.G. Berizzi 10 (detail of 27), 27, 47, 62;
photos © RMN–R.G. Ojeda 46, 48;
photo © RMN–Jean Schormans 52;
photo © RMN–Hervé Lewandowski 53, 55, 72–73, 142 (detail of 53);
photo © RMN–Gérard Blot 54, 60, 68 (detail of 74), 74;
photo © RMN–Ojeda/Le Mage 61, 63;
photo © RMN– G. Blot/C. Jean 66–67;
photo © RMN–Le Mage: 75

MUSÉE D'ORSAY
Paris
photo © RMN 84;
photo © RMN–Gérard Blot cover detail & 70;
photo © RMN–Hervé Lewandowski 71, 80, cover detail & 81, 82–83, 85

GALERIA DEGLI UFFIZI
Florence
© photo SCALA, Florence 13 (Galeria degli Uffizi © 1990, courtesy of the Ministero Beni e Att. Culturali)
© photo Bridgeman Art Library, London cover (details of 22–23 & 32–33), 14, 20–21, 22–23, 30–31, 32–33

MUSEI VATICANI,
The Vatican, Rome
© photo Bridgeman Art Library, London cover detail & 19;
photo © Musei Vaticani 25

NATIONAL GALLERY,
London
© National Gallery, London cover (details of 17, 59 & 86–87), Endpapers (detail of 29), 4 (detail of 38), 16, 17, 28, 29, 36, 37, 38, 39, 40 (detail of 59), 58, 59, 64, 65, 86–87, 107

DUCAL PALACE OF THE GONZAGA FAMILY
Mantua
© photo Bridgeman Art Library, London cover detail & 35

MUSEO NACIONAL DEL PRADO, Madrid
All rights reserved © Museo Nacional del Prado-Madrid cover detail & 43, 44–45, 50, 51, 56, 57

CAMPIDOGLIO
Rome
Photo © Esko Koskimies 24

TATE GALLERIES
London and Liverpool
© Tate, London cover (detail of 137), 76, 77, 78–79, 90, 91, 106, 115, 120, 121, 126, 127, 128 (detail of 131), 130, 131, 132, 133, 136, 137, 138, 139, 140–1
The works of Naum Gabo © Nina Williams 114

ÖSTERREICHISCHE GALERIE BELVEDERE
Vienna
© photo Bridgeman Art Library, London cover detail & 88, 89

MUSEUM OF MODERN ART (MoMA)
New York
© Photo SCALA 2003, Florence/MoMA, New York 92 (Lillie P. Bliss Collection), 93 (Gift of Mr and Mrs H. Irgens Larsen and acquired through the Lillie P. Bliss and Abby Aldrich Rockefeller Funds), 96 (detail of 102), 100 (Gift of Mr and Mrs Peter A. Rübel), Cover detail & 101 (The William S. Paley Collection), 103 (Lillie P. Bliss Collection), 108, 109 (Gift of Richard S. Zeisler), cover detail & 112 (Katherine S. Dreier Bequest), 113 (Acquisition confirmed in 1999 by agreement with the Estate of Kasimir Malevich and made possible with funds from the Mrs John Hay Whitney Bequest)
MoMA, New York/© photo Bridgeman Art Library, London 102

SOLOMON R. GUGGENHEIM MUSEUM
New York
© The Solomon R. Guggenheim Foundation, New York 94 (Thannhauser Collection, Gift, Justin K. Thannhauser, 1978), 95 & cover detail (Thannhauser Collection, Gift, Justin K. Thannhauser, 1978), 98 (Peggy Guggenheim Collection, Venice, 1976), 99 (Gift, Solomon R. Guggenheim, 1937), 104 (Gift, Solomon R. Guggenheim, 1937), 105 (Acquired by exchange, 1988), 110 (Gift, Estate of Katherine S. Dreier, 1953), 111, 116, 117 (Peggy Guggenheim Collection, Venice, 1976), 118 (Peggy Guggenheim Collection, Venice, 1976), 119 (Peggy Guggenheim Collection, Venice, 1976), 123 (Gift, Elaine and Werner Dannheisser and The Dannheisser Foundation, 1978), 124–5 (Peggy Guggenheim Collection, Venice, 1976), 134 (Purchased with funds contributed by Denise and Andrew Saul and Ellyn and Saul Dennison, 1987), 135 (Thannhauser Collection, Gift, Justin K. Thannhauser, 1978)

The following images are still in copyright (copyright clearance has been obtained and the publishers would like to apologise for any acknowledgement omissions):

Carl Andre, 138, © Carl Andre/VAGA, New York/DACS, London 2004
Giacomo Balla, 108–9, © DACS 2004
Georges Braque, 106, © ADAGP, Paris and DACS, London 2004
Andre Derain, 101, © ADAGP, Paris and DACS, London 2004
Max Ernst, 119, © ADAGP, Paris and DACS, London 2004
Dan Flavin, 139, © ARS, NY and DACS, London 2004
Alberto Giacometti, 118, © ADAGP, Paris and DACS, London 2004
Joseph Kosuth, 132–3, © ARS, NY and DACS, London 2004
Sol LeWitt, 133, © ARS, NY and DACS, London 2004
Edvard Munch, 93, © Munch Museum/Munch-Ellingsen Group, BONO, Oslo, DACS, London 2004
Francis Picabia, 111, © ADAGP, Paris and DACS, London 2004
Pablo Picasso, 96, 99, 102, 107, © Succession Picasso/DACS 2004
Jackson Pollock, 124–5, © ARS, NY and DACS, London 2004
Mark Rothko, 123, © ARS, NY and DACS, London 2004
Kurt Schwitters, 110, © DACS 2004
Gino Severini, 109, © ADAGP, Paris and DACS, London 2004
Kees van Dongen, 100, © ADAGP, Paris and DACS, London 2004
Georges Vantongerloo, 115, © DACS 2004
Andy Warhol, 128, 131, © The Andy Warhol Foundation for the Visual Arts, Inc./ARS, NY and DACS, London 2004

Thanks also to the following artists and/or their copyright holders:

© Georg Baselitz 136
© John Bratby 127
© Fondazione Lucio Fontana 120, 121
© Nan Goldin 126
© Peter Halley 134
© Damien Hirst 140–1
© Anselm Kiefer 137
© Jeff Koons 130
© Cindy Sherman 135
Wassily Kandinsky © 1912 104
El Lissitzky © 1922 112
Kasimir Malevich © 1918 113

AN IQON BOOK
This book was designed
and produced by
Iqon Editions Limited
Sheridan House
112–116a Western Road
Hove BN3 1DD

Publisher, concept and direction:
David Breuer

Designer: Isambard Thomas

Editor and Picture Researcher:
Elizabeth Bacon

Printed in Singapore by
Star Standard

First published in Great Britain in
2004 by the Herbert Press
an imprint of A&C Black Publishers
38 Soho Square
London W1D 3HB
www.acblack.com

ISBN-10: 0 7136 7011 8
ISBN-13: 978 0 7136 7011 0

Reprinted 2005, 2006 (twice), 2007

Cover Illustration details
(left to right, starting at the top):

Sandro Botticelli, *Birth of Venus*
(pp.22–23)

Gustav Klimt, *The Kiss* (p.88)

Andrea Mantegna, decoration for
the *Camera degli Sposi,* in the Ducal
Palace of the Gonzaga Family (p.35)

Paul Gauguin, *The White Horse*
(p.70)

Georges Seurat, *Bathers at Asnières*
(pp.86–87)

Paolo Uccello, *Episodes of the
Battle of San Romano* (pp.32–33)

Edouard Manet, *Olympia* (p.81)

Anselm Kiefer, *Parsifal I* (p.137)

Paul Cézanne, *Still Life: Flask,
Glass and Jug* (p.95)

The Wilton Diptych (p.17)

André Derain, *Bridge over the Riou*
(p.101)

Raphael, *The School of Athens*
(p.19)

Michelangelo Merisi da Caravaggio,
The Supper at Emmaus (p.59)

El Lissitzky, *Proun 19D* (p.112)

Juan van der Hamen, *Still Life with
Sweets and Glassware* (p.43).

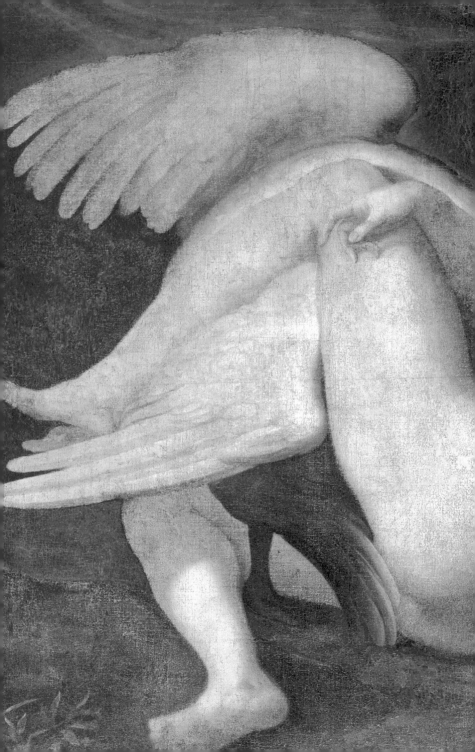